Kutlug Ataman
Margaret Barron
David Batchelor
Gillian Carnegie
Nathan Coley
David Cunningham
Dexter Dalwood
Ian Davenport
Richard Deacon
Peter Doig
Ceal Floyer
Richard Hamilton
Tim Head
Jim Lambie
Mike Marshall
Sarah Morris
Paul Noble
Cornelia Parker
Susan Philipsz
Nick Relph and Oliver Payne
George Shaw
Rachel Whiteread
Shizuka Yokomizo

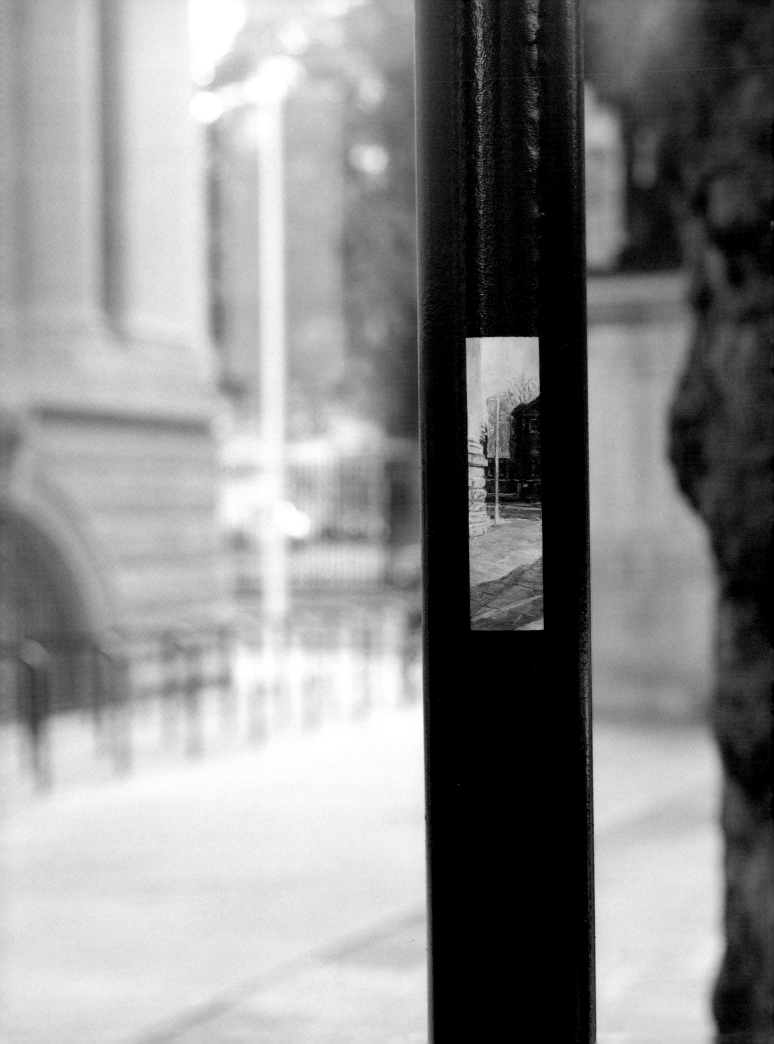

Tate Triennial Exhibition of
Contemporary British Art 2003

DAYS LIKE THESE

Judith Nesbitt and
Jonathan Watkins

With an essay by
Caoimhín Mac Giolla Léith

Contributions by Lizzie Carey–Thomas
Helen Delaney, Louise Hayward
Gregor Muir, Kathryn Rattee
Natalie Rudd Katharine Stout
Ben Tufnell, Clarrie Wallis and
Andrew Wilson

Tate Publishing

Sponsor's Foreword

Days Like These showcases the work of a number of artists working in Britain today. The project reflects Tate's continuing mission to bring art into everyday life, accessible to all.

Volkswagen is, and always has been, about making great cars accessible to everyone.

Recently, we've also been pursuing some more single-minded possibilities as well. Phaeton and Touareg are two new cars embodying a new level of excellence, which represent these developments.

So it is particularly satisfying for us to be involved with *Days Like These* at a time when we ourselves are exploring some new directions.

Volkswagen is delighted to become the first car manufacturer to be associated with the Tate Triennial. We are proud to be able to bring you this exciting new work as we celebrate the launch of Phaeton and Touareg. Enjoy the exhibition.

In partnership with Volkswagen for Phaeton and Touareg

Published by order of the Tate Trustees 2003 on the occasion of the exhibition at Tate Britain 26 February – 26 May 2003 by Tate Publishing, a division of Tate Enterprises Ltd, Millbank, London SW1P 4RG www.tate.org.uk

British Library Cataloguing in Publication Data
A catalogue record for this book is available from the British Library

ISBN 1 85437 457 5

Distributed in the United States and Canada by Harry N. Abrams, Inc., New York

Designed by 01.02
Printed in Italy

Front cover: Ian Davenport, *Untitled Poured Lines (Studio)* 2002 (detail)
Photo: Tate Photography/ Andrew Dunkley/ Marcus Leith
Frontispiece: Margaret Barron, *As it was now is* 2002–3 (no.2)
Photo: Tate Photography/ Rodney Tidnam

Measurements of artworks are given in centimetres, height before width, followed by inches in brackets.

Foreword

Days Like These is the second in the series of triennial exhibitions of contemporary British art that was launched as one of the cornerstones of Tate Britain's programme in 2000. The first Tate Triennial, *Intelligence*, curated by Virginia Button and Charles Esche, sought to identify and explore characteristics prevalent in the work of artists working in Britain at the very end of the twentieth century. *Days Like These*, curated by Judith Nesbitt (Head of Exhibitions and Displays at Tate Britain) and Jonathan Watkins (Director of the Ikon Gallery, Birmingham) has a similarly ambitious agenda, though it is pursued through different means. Foregrounding the work of twenty-three artists across several media and generations, the exhibition's didactic purpose is simply to reveal and project something of the vitality, breadth, humour, subtlety and complexity of art made in Britain today. Painting, drawing, photography, sculpture, video, film and sound are all represented, richly undermining that sometimes popular claim that the leading edge of British contemporary art is narrowly focused.

The show spreads beyond the confines of the exhibition space on level 1 at Tate Britain, extending confidently into the Duveen Galleries and emerging in episodes elsewhere within and beyond the building. It is conceived with the hope of reaching a large and broad public, an important objective of the Tate Triennial series, and thanks to the generous support of Volkswagen, the exhibition's major sponsor, we have been able this year to make it free of charge to visitors. We are very grateful to Alex Sainsbury for additional financial support. The series joins the other strands of Tate Britain's widely-ranged contemporary programme: *Art Now*, the biennial Duveen Galleries sculpture commission, the Turner Prize, and many regular monographic and thematic displays and exhibitions.

I am extremely grateful to those individuals and institutions who have kindly lent works of art to the show: Birmingham Museums and Art Gallery, Stuart Evans, Simmons & Simmons, Ranbir Singh, John A Smith and Vicky Hughes, Beth Swofford, Dianne Wallace, Anita and Poju Zabludowicz. I would also like to draw attention to the great achievements of Judith Nesbitt and Jonathan Watkins, who curated this show with crystal clear vision and incredible energy despite their fearsomely onerous responsibiltiies on many other professional fronts. And we all, of course, thank the artists – for their works and ideas, suggestions and contributions. We feel privileged to have worked with them.

Stephen Deuchar
Director, Tate Britain

Acknowledgements

The Tate Triennial is an opportunity to reflect on what is happening within contemporary British art. Given the breadth of the field, and the impossibility of offering anything more than a partial, subjective response to it, we have relied on our instincts, tested and tempered through discussion with a wider project team at Tate Britain and other professional colleagues. Our conversations with artists, not only those represented in the exhibition, but all those we've had contact with in the last year, have stimulated our shared sense of what this exhibition could be.

At an early stage, we decided against prescription, preferring to curate a theme-free exhibition. This was the only honest way we felt able to present the divergent, richly allusive, and independently minded work of the artists whose work we found so compelling. The twenty-three artists in the show are not all speaking the same artistic language. And there is no attempt on our part to translate or summarise contemporary practice, nor to point in one single direction at the future through the newest crop of artists. On the contrary, it's more illuminating to see new work by artists of several generations, since all of it belongs to the present moment, and the connections between them are fluid and don't need to be forced. Whatever stage in their careers, it is important to show their work to a wide audience, free of the constraints of a more narrowly focused group show. This corresponds to the fact that, on this occasion, the Triennial is happening not only in dedicated gallery spaces at Tate Britain, but also in the entrances and circulation areas, and outside the building. It is reaching out to audiences not intending to visit it, and entry is free. It is meant to be as accessible as it is rigorous, as easy-going as it is serious.

The process of forming the exhibition was also an essentially collaborative one, and we have greatly valued the involvement of Carolyn Kerr, Ben Tufnell, and Clarrie Wallis in developing and realising the exhibition. The wider project team includes Andy Shiel, Anna Nesbit, Ray Burns, Will Easterling, Ken Graham, Mikei Hall and the art handling team; Tanya Barson, Mary Bustin, David Dance, Laura Davies, Andrew Dunkley, Sionaigh Durrant, Mark Edwards, Claire Eva, Jackie Heuman, Sarah Hyde, Sioban Ketelaar, David Lambert, Marcus Leith, Ben Luke, Fran Matheson, Derek Pullen, Mary Richards, Jane Scherbaum, Rodney Tidnam, Piers Townsend and Emma Woodiwiss.

The artists' galleries have provided invaluable assistance: Jake Millar and Emma Robertson, The Approach; Gavin Brown at Gavin Brown's enterprise, Corp.; Martin McGeown and Andrew Wheatley, Cabinet; Sadie Coles and Pauline Daly, Sadie Coles HQ; Dale McFarland, Frith Street Gallery; Mark Francis, Lisa Carlson and Mollie Dent-Brocklehurst, Gagosian Gallery; Juliet Gray, Lehmann Maupin Gallery; Clare Simpson and Jill Silverman, Lisson Gallery; Ben Harland, The Modern Institute; Victoria Miro and Andrew Silewicz, Victoria Miro Gallery; Marie-Louise Laband, Anthony d'Offay Gallery; Maureen Paley and James Lavender, Maureen Paley Interim Art; Laura Mackall, Andrea Rosen Gallery; Caren Jones, Waddington Galleries; Anthony Wilkinson and Amanda Knight-Adams, Anthony Wilkinson Gallery; Susannah Hyman and White Cube.

Thanks are also due to: Adam Brown; Richard Cottrell and his colleagues at Cottrell & Vermeulen Architecture; Lizzie Carey-Thomas; Helen Delaney; Alan Dye, Ben Stott and Nick Vincent at NB: Studio; Simon Esterson; Matthew Gale; Louise Hayward; Caoimhín Mac Giolla Léith; Clare Manchester; Frances Morris; Gregor Muir; Kathryn Rattee; Natalie Rudd; Katharine Stout; Sheena Wagstaff and Andrew Wilson.

And to Sue Arrowsmith; Jin Kaur, B&Q; Tomski Binsert; Phil Brown; Colin Cina, Jeffrey Dennis and the student volunteers, particularly Alison Ballance and Thomas Legg, Chelsea College of Art & Design; Katy Dexter; Sarah den Dikken; EGM Architecten BV; Frank Moran, Europoint Display; Suzanne Freeman; Ann Gallagher; Tim Holmes; Angela Weight, Imperial War Museum; Conor Kelly; Robert Lambie, Fast Signs Scotland; M.C. Designers Ltd; Nigel McKernaghan; Neville Redvers-Mutton and Mark Harton, Momart Ltd; Kim Greenston, Red Consultancy; Deborah Bull and Phyllida Ritter, The Royal Opera House; Danny Saunders; Paul Schimmel, Museum of Contemporary Art, Los Angeles; Michael Smith and Nick Bourne, Mike Smith Studio; and Gregor Wright.

Our greatest debt is to the artists who have joined our sense of adventure in making an exhibition in the light of days like these.

Judith Nesbitt and Jonathan Watkins

DAYS LIKE THESE

Unbelievers
Jonathan Watkins

Many of the most interesting artists working today don't believe in art. There is an aesthetic atheism abroad – quite unlike previous anti-art gestures – which gives cause for optimism and hope for the future. Ideas of art as embodying extraordinary creativity, or as somehow transcendent or transcendental, occupying a higher place in human culture, are rapidly losing ground. Instead, it is becoming clear that art and artists are not necessarily special.

Current art practice is characterised by a remarkable openness. In Britain as much as elsewhere, there is an increasing acknowledgement of the dissolving distinction between art and its environment, between process and finished work, between artists and their audiences. It is now widely accepted that works of art are not self-contained, and that objects and/or gestures traditionally apprehended as art acquire their identity and meaning through what exists around them. Recent emphasis on audience participation, the continuing prevalence of photography and video, installation and readymades, as well as an increasingly frequent use of non-art (often public) space, are symptomatic of this new work. So too is an emphasis on directness and accessibility, the antithesis of the academicism and obscurantism which marred early Postmodernism.

The logical conclusion of this blurring of lines between previously discrete areas within and around artistic activity might eventually be the undoing of art as an institution. Meanwhile, we continue to witness manifestations of an all-too-human need for it and the kind of intense ambivalence described by British artist Ceal Floyer in a recent interview:

> I think that what informs my practice is a certain dissatisfaction with being an artist, with operating in this art context, even if it is the very situation that accommodates, and tolerates, my sort of cultural practice. I still don't trust it though … By admitting this scepticism I make myself vulnerable, and then, by manifesting this uncertainty as art, I compound the situation still further. It's a bit like being in a really crowded room, a party, say, and suddenly the music stops and you're the last one talking, and your words just sort of hang in the air. Often the art world seems like a place where the ambient noise has been removed, the background airbrushed out.[1]

Floyer's description of the art world as an insulated place, where creative gestures are detached from their context, could not be more poignant. It is exemplified by her *Nail Biting Performance* 2001, a live artwork in which she bit her fingernails, amplified through a microphone, alone on stage prior to a concert of classical music. The orchestra is off-stage, the audience full of anticipation for the advertised Mozart, Beethoven or Stravinsky, while the artist defiantly asserts her nervousness.

Nail Biting Performance, with its conflation of absurdity and a rigorous internal logic, is typical of the artist. Putting something under a spotlight which is not supposed to be there, it embodies Floyer's observations on spaces, both actual and metaphorical, dedicated to art.

This exhibition includes a number of British artists – namely Margaret Barron, Nathan Coley, David Cunningham, Richard Deacon, Richard Hamilton, Cornelia Parker, Susan Philipsz and Rachel Whiteread – whose work has oscillated significantly between dedicated art space and non-art space. However, there are also other artists here whose work is always imagined on a trajectory through galleries or museums, but they, equally, are insisting on a close scrutiny of life beyond institutional walls. They are sharing space inside this exhibition with the assumption of an osmotic relationship between art and everything else.

Richard Deacon's placement of work outdoors is not a gesture intended to make the world a more civilised place by filling it with art. Rather it is informed by the artist's ongoing preoccupation with the problem of identifying certain objects as art. 'Ordinariness', he once explained, 'is the ambition I have for my sculpture.'[2] For many years he has been making *Art for Other People* 1982–, small sculptures that are meant to co-exist with furniture and other (non-art) objects in private homes. The openness of his practice, literally manifested in the walk-through nature of much of his work, and his enthusiasm for collaboration with other artists – thus confusing notions of artistic authorship – is remarkable. In this vein, Deacon's ceramic sculptures (pp.78–9), here located outside, in front of Tate Britain's Clore Gallery, constitute a subtle challenge to conventional ways of seeing art. Their abstract shapes suggest an aesthetic formalism, but everything else about them, including their location and organic appearance, signifies that they are proposing an art which enjoys its unelevated place in everyday life.

Margaret Barron makes paintings on adhesive tape (pp.37–41). They are small cityscapes, painted from photographs taken by the artist and then stuck onto an existing surface, perhaps a gallery wall

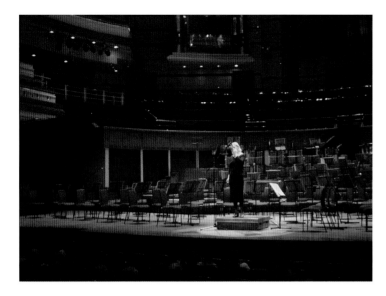

Ceal Floyer
Nail Biting Performance
7 February 2001,
Symphony Hall, Birmingham

or the base of a lamppost, in the vicinity of their subject. For this exhibition several are located either inside Tate Britain or nearby, outdoors around Millbank. In the latter case, the artist's carefully wrought and unique imagery is completely unprotected. Without invigilation, environmental control and insurance (or government indemnity) it could not be further from the cushioned existence of objects in the care of a national museum. More often than not, a painting by Barron enjoys the short life of a flyposter.

Barron's work corresponds, to some extent, with the notion of the 'anti-readymade' – conjuring up a Duchampian scenario in which a Rembrandt painting is used as an ironing board – whereby art, in this instance signified by sincere painterliness, is thrust into a world that has no respect for it. Context is everything, and clearly the reverence afforded Duchamp's stools, shovels, bottle racks, bicycle wheels and urinals, within dedicated art space, has its obverse. Almost a century later, confounding logic but conforming with habits that are hard to break, reaction to the implications of readymades is still often one of umbrage and incomprehension. Despite their introduction being among the most liberating gestures in the history of Western culture, readymades still don't look like art to a lot of people.

Richard Hamilton is the British artist whose work is closest to the spirit of Duchamp. His role in the development of Pop art, a movement intent on a fusion of art and ordinary life, was seminal and continues to reverberate through subsequent generations of artists.[3] He has always enthusiastically encouraged a two-way traffic through popular culture, taking its imagery in the direction of high art, for example, in the case of his famous collage *Just what is it that makes today's homes so different, so appealing?* 1956. Later, significantly, with a similar degree of seriousness, he undertook the graphic design for The Beatles' *White Album* (1968). As Hamilton explains, 'Its standards [were] those of a small edition print pushed … to an edition of millions.'[4] For this exhibition, among other works, Hamilton provides us with a diagram of Duchamp's *Large Glass* 1915–23 derived from the format of a Michelin road map (pp.92–3).

Cornelia Parker also refers to Duchamp in this exhibition through her treatment of Auguste Rodin's *Kiss* 1901–4, one of the most popular works in Tate's Collection. Parker has bound the sculpted heads of the two lovers in a mile of string. Sixty years previously one of Duchamp's contributions to a Surrealist exhibition had been an entanglement of the same amount of string that impeded visitors' movement

through the gallery space.[5] Parker's simple gesture suggests at once the original Surrealist context and a wealth of possible meanings consistent with her work overall.

Since her emergence as an artist during the 1980s, Parker has resisted the idea of the artistic monument, with all its literal and metaphorical heaviness. Her installations, such as *Thirty Pieces of Silver* 1988, *Cold Dark Matter: An Exploded View* 1991 and *Breathless* 2001, all involving distressed objects suspended by wire, embody a dream of the world without gravity, a floating place without a conventional order of things.[6] These works make it understood that value is invested rather than inherent, and nothing naturally makes a Rodin marble sculpture more precious than a piece of string.[7]

Parker's ongoing pieces with fireworks, such as *Meteorite Lands in Birmingham's Bull Ring* 2002, similarly conveys her preoccupation with such relativism. Working in collaboration with a pyrotechnician, she incorporates a pulverised meteorite into the chemical mixtures of a fireworks display in order to create a kind of meteorite shower. She gives a heavenly body another landing on earth and thereby evokes at once ideas of an unfathomable cosmos – from whence meteorites come – as well as memories of childhood fun. Beyond this, there is the appeal of fireworks, their vivid colours, abstract and constantly changing, felt by almost everyone. It is the appeal of what Dave Hickey has referred to as 'the language of visual affect – the rhetoric of how things look … the iconography of desire – in a word … *beauty*.'[8]

Beauty no longer has a special relationship with art. Conversely it exists, as always, in countless situations which, like fireworks displays, have nothing to do with art – unless involving an artist such as Cornelia Parker. In his recent book *Chromophobia*, David Batchelor is concerned with the perception of colour, crucial to the 'language of visual affect', and comes to a similar conclusion:

I was expecting to write a book about art, if only because most other things I have written have been about art, and one would think there is a lot to say about art in a book about colour. It just hasn't turned out that way. The more I have written, the more art has got pushed further and further back …[9]

Batchelor goes on to discuss Andy Warhol, Yves Klein, Frank Stella, Donald Judd and Dan Flavin, none of them artists who paint on canvas, all working through the 1960s, when 'something important

David Batchelor
Studio
2002

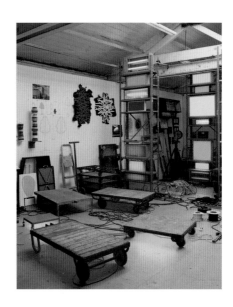

happened to colour in art'. Quoting Stella, who had famously wanted to keep the paint he used 'as good as it was in the can', Batchelor suggests that the artist 'knew it might be hard to improve on the materials in their raw state, that once the paint had been put to use in art, it might well be less interesting than when it was "in the can" ... [And that] ... at that time and since ... painting has been tested against that which stands outside painting-as-art: the photograph, the written word, decoration, literalness or objecthood.'[10] In other words, this was painting not aspiring to the condition of art.

This idea has considerable bearing on our understanding of the milieu within which Richard Hamilton was operating as he began to develop his interest in Duchamp and pop culture, and provides an important key to the philosophy which informs the work of younger British artists represented here. Their work, with its 'in-the-can' realism, is an antidote to the poses of early Postmodernism. Against a strong 'new wave' of Neo-Expressionism and overtly theory-based imagery predominant during the 1980s, Ian Davenport was one of the first to make a break back into abstraction. His continued use since the late 1980s of household paint straight from the can signifies an undeviating pragmatism and a phenomenological approach. For this exhibition he ejects different colours through syringes from the top of an fourteen-metre-long wall, letting them spill onto the floor at the bottom. The final enveloping result, ultimately the effect of gravity on fluid, is a striated panoramic painting of paint: *Untitled Poured Lines (Tate Britain)* 2003.

Similarly, Tim Head's projection *Treacherous Light* 2002 (p.97), is a vast field of abstract colour, with a moving pattern derived from the computer technology involved. A program randomly designates a particular colour, from a choice of several million, to each of the hundreds of thousands of pixels making up the screen image. The movement of the pixels on a monitor is almost imperceptible to the human eye, but projected onto a large wall as they are in this exhibition, the systematic, twitchy progress of the pixels is very visible. Head, an artist whose work previously has been representational, is now subscribing to an essentialism based on visual information and the means by which it is communicated. It is at once the compelling subject and object of his work.

David Batchelor makes various kinds of structures, often assemblages of second-hand components, which function as foils for the lightness of light. They are, in effect, vehicles for the phenomenon of colour – so fugitive and insubstantial – which

preoccupies him. For this exhibition Batchelor has made a tower of light boxes. From the other end of the vast Duveen Galleries where it is located, it resembles a multi-coloured zip of light, but a closer look reveals its nuts and bolts, its wiring and other means of construction. Batchelor thereby resists a theatrical seamlessness and dispels any sense of mystery, opting instead, like Davenport, to communicate a no-nonsense fascination with his medium.

The pervasiveness of light, essential to Batchelor's aesthetic proposition, undermines any apprehension of his work as sculpture. Reference to its dimensions – discrete measurements of height, width and depth, for example – is misleading in that it fails to take into account the nature of its most significant quality which, incidentally in this respect, is not unlike the transparency of Duchamp's *Large Glass*. Many works in this exhibition point up the problem of exactly where a work of art stops. Is Margaret Barron's work, for example, embodied just in a piece of tape, or that of Cornelia Parker just in a firework container? In the case of David Batchelor's light boxes, the work actually creates a kind of visual interference, here most particularly with Jim Lambie's expansive, concentrically striped floor. Sharing its gallery space and, to a significant extent, sharing its kind of abstraction by making patterns of light reflected in it, Batchelor's work thus becomes inextricably fused with that of another artist.

The question of spatial dimensions is even more absurd when applied to work involving sound. David Cunningham's ongoing project, *The Listening Room* 1993–, an electronic circuit consisting of a microphone, amplifier, 'noise-gate' and speakers, is an installation that implicates its audience. A wave of ambient sound builds up through feedback only to break as soon as a certain volume is reached; it then subsides to quietness only to begin the whole process again, *ad infinitum*. Sounds that are introduced to the space, such as walking and talking, are echoed distinctly at first and then absorbed into an accumulating symphony. The audience in this 'listening room' hears itself integrated into the sensitive and constantly changing soundscape in contradistinction to the party scenario Ceal Floyer describes.

The inclusiveness (and pervasiveness) of Cunningham's installation is consonant with the nature of his other musical activities. These include Top 40 hits such as 'Money' (1979) with The Flying Lizards, and numerous collaborations with other musicians such as Michael Nyman, and with visual artists such as Hayley

Newman and Martin Creed. Creed's famous equation 'the whole world + the work = the whole world' might equally have been arrived at by Cunningham. Essentially an experimental musician, Cunningham makes work that is about engagement with the 'whole' world. His interest in popular music in particular reflects its relevance for current visual arts practice, evident in the work of other artists selected for this exhibition, including Jim Lambie, Dexter Dalwood, Peter Doig, Susan Philipsz, George Shaw and Richard Deacon. Among these, first of all, was Richard Hamilton.

George Shaw acknowledges Hamilton as a profoundly formative influence on his generation, at the same time paraphrasing the Smiths: 'Hang the artist. [He] says nothing to me about my life.'[11] *Morrissey vs Francis Bacon* (2000) is the title of one of Shaw's self-published booklets – photocopied A4 sheets covered by his intense upper-case writing – which describes an overwhelming desire to go shopping for records instead of studying old masters in London's National Gallery. Shaw unashamedly describes the pleasure he derives from popular music in terms not unlike those used by Dave Hickey on beauty. Pop (Shaw prefers this word to 'rock' and current alternative nomenclature) is the soundtrack for his paintings. It is the kind of music, much more often than not, that accompanies the lives lived in the suburban council estates and New Town semi-detached houses he depicts. It is the kind of music he listens to in his studio.

Shaw also shares Hamilton's literary interests, in particular the writing of James Joyce, for the thoughtfulness it draws from the everyday.[12] There is a strong emphasis on domestic life, which in turn constitutes a major theme in this exhibition. Shaw effectively conveys a yearning melancholy through his unpopulated scenes and Hamilton, illustrating Joyce, superimposes a map of the universe onto the image of a sleeping couple (*The heaventree of stars* 1998–9, p.95). Likewise, through her ostensibly simple gesture of casting void spaces, Rachel Whiteread touches on enormous facts of life.

Whiteread's work here, *Untitled (Rooms)* 2001 (pp.145–9), consists of the plaster casts of a five-room flat and the staircases leading to it. Still and massive, the work translates the trace of domestic habitation of a space in all its human flux and complexity into the Duveen Galleries. Not a single room, like *Ghost* 1990, this is the fossilised interior of an entire home, like *House* 1993, and compartmentalised according to the various common needs – eating, sleeping, toilet etc.

Mike Marshall
Days like These 2002
(no.44)

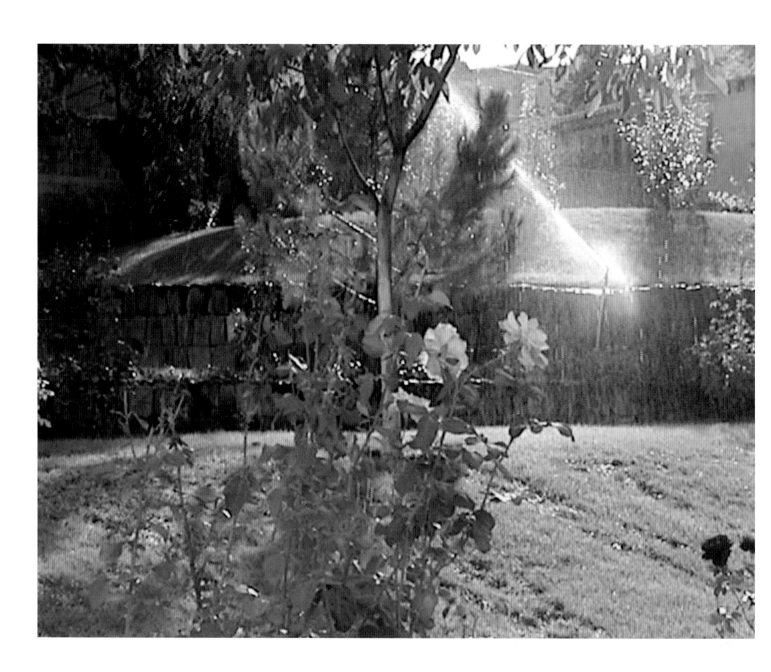

14

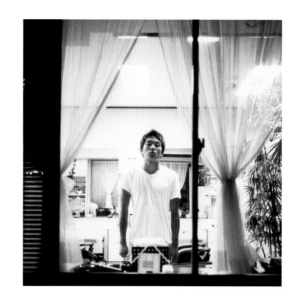

Shizuka Yokomizo
Stranger (1) 1999
(no.59)

– of its occupants. Much more than a symbol or a representation (artistic or otherwise), *Untitled (Rooms)* is like a three-dimensional photograph, a negative contact print of an interior really and thoroughly lived in.

The directness of the relationship between the object and its subject is an important key to the impact of Whiteread's work. It has this in common with the ready-made and the realism David Batchelor describes, and the recent strength of photography, film and video (as unmanipulated as possible) as art forms is thus very consistent with an overall picture of contemporary art healthily sceptical with respect to itself.

Like Whiteread, Shizuka Yokomizo is concerned with the occupancy of domestic interiors. Each photograph in her series *Strangers* 1999, depicts an individual looking outwards through a window, a person the artist hasn't met before, who can be seen inside their house or flat from street level outside. Yokomizo writes them a letter simply asking them to stand at a particular window with the room's lights on at an appointed (night) time. The resulting portraits reflect a mixture of confidence and uncertainty – due to the nature of the project and the kind of person who would be prepared to participate in it – enhanced by the silhouette of the window frame. From inside, the subjects would be seeing their own reflection as much as anything else. In the photographs we see them clearly, alone, surrounded by various objects, bits of furniture and so on, which convey clues as to their identity and self-image. Yokomizo is aware of art-historical precedents, such as those found in traditional portraiture, devotional pictures of saints (likewise surrounded by attributes) and imagery arising from nineteenth century *flânerie*, but her choice of medium means that she 'takes' pictures that somebody else has 'made'. What we see – is it the artwork? – the poses struck and the *mises-en-scène*, is determined by strangers, undirected by the artist beyond her instructions concerning time and place.

Mike Marshall's videos have a similarly compelling artlessness. They are extremely economical in terms of the technology involved, editing or other production techniques and presentation. *Sunlight* 2000–1 (p.109), seen here on monitor, for example, is the result of the artist's camera being focused on patches of ground during a cloudy day. The only action involved is that of a cloud moving off the face of the sun, thereby throwing shadows onto the ground of objects, like trees, out of the frame. Another work, *Days Like These* 2002,

depicts close-up views of a garden being watered by a sprinkler. At intervals, water hits the plants like an invisible force, and their leaves and stems quiver violently as they get what they need to survive. Marshall is communicating an epiphany in the Joycean sense, with the lightest touch, an unexpected moment when something profound or beautiful occurs. His videos, paradoxically, celebrate the fact that we don't need art for this.

On Being Sane in Insane Places
Judith Nesbitt

In the interests of scientific enquiry, David Rosenhan, a respected American psychiatrist, once became a fake.[1] His serious purpose was to test whether psychiatric diagnosis said anything reliable about patients, or more about the environment in which an observer finds them and the assumptions the observer brings with them. As sane as you and me, Rosenhan presented himself at a mental hospital complaining of hearing voices. He was diagnosed schizophrenic and admitted. Once inside, he stopped feigning symptoms and behaved normally. He protested his sanity, and openly made notes about what he saw and the way he was treated. Seven others (with various occupations, including an artist) took part in the same experiment at other institutions. Not one of them was subsequently declared sane. After between seven and fifty-two days, all were eventually re-diagnosed as 'in remission' and discharged. In a companion study, staff at similar institutions were warned that other 'pseudo-patients' would present themselves. Although none in fact did, up to 50% of legitimate patients were declared to be fakes.

In a sense, Rosenhan and his colleagues had made artworks of themselves. They had invited projections, and then blown them away. Their trickery had made visible – and risible – our tendency to see what we expect to see. Common assumptions, normally dissolved in intuitive habits and judgements, had been laid bare. Is that the discomfiting service that contemporary artists – those included in this show, for instance – are performing for us? Are they 'con artists', not in the sense of the familiar tabloid accusation, but in tricking us into reappraising our own taken-for-granted views of the world? Interestingly, the only people to see through Rosenhan's pretence were the regular inmates of the mental hospital who claimed: 'You're not crazy. You're a journalist, or a professor [referring to the continual note-taking]. You're checking up on the hospital.'[2] Such inversions are often to be found in the world when viewed through the lens of contemporary art.

The artist Nathan Coley entered a similarly closed arena, not a mental hospital but a courtroom. He applied to be admitted to the Lockerbie Trial. The authorities were baffled by his interest in being there with no concrete purpose other than to witness the proceedings as an independent observer. He was accepted, not as an artist but a journalist, since this was the only category in which they could place him. He was in any case intrigued by the idea that a building could itself inscribe and impose on visitors submission to authority. But was Coley's enforced false identification as a journalist denying that press pass to a *bona fide* journalist who might have had other questions to ask and other stories to tell? Funded by a grant from the Year of the Artist scheme in Scotland, what were his responsibilities, and to whom? This kind of conceptual conundrum was exactly what drew him to the trial in the first place. It was being held in a Scottish court, in a site legally designated as Scotland, but geographically in The Netherlands. The staff included Dutch workers, who would wake up in Holland and cycle a mile down the road to this place that had become Scotland. There were Scottish workers, who were working abroad, in Scotland. Equipped with his press pack, which included digitised images of the evidence, Coley sat watching the trial, wondering right up to its final days what exactly he *was* doing there. Staring at the witness box, he realised that his interest in the trial was contained in the object he was looking at. A constructed space charged with revealing the 'truth', the witness box was a physical symbol of the ideas of truth and conviction that so intrigued him. So much so, that he has collaborated with the Imperial War Museum in London to obtain permission for it to enter their collection.[3]

Coley had an exact replica of the witness box made, which is presented in the exhibition together with his drawings of the evidence made in his studio in Dundee and video-taped interviews on the subject of identity and certainty. Reflecting on the trial, he says, 'As an artist, I'm not interested in justice, I'm not necessarily all that interested in revenge, and I'm actually not that interested in the truth either. I'm much more interested in taking on the role of the artist and lying, working with ideas of doubt and uncertainty. I think that's a valuable role for us to take. There are other people who can deal with the truth.'[4] His interest as an artist is in questioning the ways in which philosophical values and beliefs become inscribed in the infrastructure of social and political systems. The ostensible purpose of the Lockerbie Trial was to establish whether the accused men had planted the bomb. But at a deeper level it symbolised and enacted a confrontation between Christian America and Islamic Libya. At the centre of the trial was the witness box – a conceptual device used to elicit truth. Yet it invites *projections* of truth, both in the courtroom, as well as in the exhibition space where Coley re-presents it. In both situations, the truth will be subjectively constructed. How are we to look at Coley's drawings of the 'evidence', which is made up of ordinary objects and ordinary faces made ominous by the context? Evidence of what exactly?

Nathan Coley
Below: Research image
taken in the Lockerbie
Trial Courtroom, Kamp
van Zeist, Netherlands
Right: *Lockerbie Evidence #16*
2003 (no.14)

Coley's act of infiltration is an act of scrutiny which peels back the veneer of certainty.

And what are we doing when we look and talk about the works presented in this exhibition, or indeed any other? Are we, as viewers, in the role of judges or psychiatrists deciding on the truthfulness of these accounts of reality? Are we looking for evidence that the world is indeed how we believe it to be? Though the exhibition itself is a construct every bit as much as the individual works themselves, it doesn't attempt to 'diagnose' or 'convict' the viewer or society as a whole. It doesn't demand specialist knowledge but invites the same spirit of curiosity and creative, critical thinking that took Nathan Coley to the Lockerbie Trial. His attendance was not a stunt, but an open-ended reflection on what it all meant. Artists are not interested in being psychiatrists, judges or politicians. They play with the truth of things. There is something intentionally seductive about those words that describe the world of fakery: hoodwink, counterfeit, cook, sham, bamboozle, con, swindle, dodge. The point is to enjoy being bamboozled. We don't know what we might learn.

Sarah Morris's paintings and films are preoccupied by the appearance of things, and manage to unsettle our sense of what we know about what we see. Intrigued by the aesthetics and politics of why things look the way they do, her films have portrayed iconic American cities: New York, Las Vegas, Washington and, most recently, Miami (pp.111–14). Her paintings deploy the same devices of repetitive, abstract structures as are found in urban, Modernist architecture, and suggest an uneasy relationship between conformity and control, surface and depth. 'Architecture just happens to be one very persuasive way to do that, and it uses every trick in the book to manipulate you', she says. 'I became interested in looking at these strategies – not just as subject matter, but also as issues of distraction, dislocation and intoxication in my art.'[5]

Adopting these strategies of distraction in her film *Miami* 2002, Morris presents a hermetic vision in which the city is seamlessly but confusingly constructed. Long stretches of shiny whiteness are punctuated with colour which is applied like a controlled substance for maximum effect. A short sequence of sharp-shooting Feds storms into the film, touching a nerve of urban paranoia as they rehearse their manoeuvres in an abandoned stadium. With no narrative explanation, it disrupts the rhythm of the film, interrupting the ordered cycle of work and leisure. Did we *really* see what we think we just saw? Morris's work contends that our twenty-first-century

Sarah Morris
Miami
2002 (no.45)

exposure to the mass media and its manipulation of reality profoundly affects individual behaviour and consciousness.

> I think that we're all so influenced by film and television. The drama and stories that are integral to those media affect not only how we retell a story but also how we act out events as they're happening. I am always extremely aware of this whether I am taking photographs or going to the bank.[6]

Some years before making her film, Morris became fascinated by the work of architect Morris Lapidus (1902–2001), whose buildings helped define the image of Miami and Las Vegas. His mid twentieth-century Fontainebleau Hotel on Miami Beach was reviled by critics at the time as 'the nation's grossest national product', a 'pornography of architecture'.[7] Lapidus, later hailed as an early Postmodernist, eschewed the rectilinear hegemony of Modernism in favour of seductive curves and theatrical flourishes. Pattern, fabric, lighting and colour were deployed in fantasy architecture dedicated to fun and luxury. In a career flush with ironies, his style later became much imitated and revered, powerfully influencing corporate architecture and ubiquitous in the kitsch hotel architecture of Las Vegas. Such flights of fancy (he called the Fontainebleau 'the world's most pretentious hotel') appealed to the human need for fantasy. Morris comments:

> Lapidus understood the importance of distraction and fantasy and most importantly understood that architecture is communication and ultimately cinema itself … His method and buildings can be understood in terms of capitalism and situationism and it is not unlike how I perceive my audience while I am making my paintings or films. Thus it is not simply about subject matter [e.g.architecture] but about a technique or strategy of engaging and manipulating the viewer.[8]

Sarah Morris's film is a fiction, but is constructed using reality, shot like a standard documentary. Nothing is scripted. The tableau she creates presents this state of alienation, where the identity of corporate power and the identity of the individual are seductively confused. She presents the city as a projection, where paradigms of normality and reality are disjointed, where turning a camera on reality, what we see is an artificial construction.

Dexter Dalwood perpetrates similarly elaborate deceptions. His paintings depict places belonging to famous people, although the people are never seen. What we see is Bill Gates's bedroom, Ludwig Wittgenstein's bathroom, Ulrike Meinhof's bedsit, Captain Beefheart's desert trailer. The environments are entirely fictional – a figment of the artist's (and our) imagination. Lately Dalwood has set himself the challenge of making contemporary history paintings, going straight to the traumatic moments in recent history, when certainties failed, icons were unmasked and despots dethroned. *Nixon's Departure* 2001 (p.65) and *Ceaucescu's Execution* 2002 dramatise this evacuation of power and control. Though as paintings they have a strongly assertive presence, there is some uncertainty as to their veracity. With what authority do they command our attention? Composed like a collage with different orders of representation and reality butted together, each painting is a carefully calibrated mirage, with a nonetheless powerfully physical and auratic appeal.

In *Ceaucescu's Execution* there is a cocktail of imagery, each component having its own derivation, but coerced into artificial coexistence on the painting's surface. Appropriating other artworks (the brushy abstraction imitating a painting by Georg Baselitz made in 1989, the same year the Ceaucescus were executed), and incorporating mediated images, Dalwood acknowledges the inherently false search for authenticity and authority in art, as in politics. The image is a con, but the painting is an honest lie. The Ceaucescus' execution was broadcast live on Romanian television. What can a painting add to the morbid documentation of the camera? Disavowing the false certainty of empirical evidence, Dalwood's history paintings depend instead on gratuitous speculation. The propositions in his paintings can only be responded to subjectively. They give free licence to an equivocal imagination.

The philosopher Theodor Adorno wrote: 'In the world, fake identity is forcibly imposed on objects by the insatiable subject'.[9] Gillian Carnegie's work embodies this struggle between seeing and knowing, between perception and identity. Though she paints traditional still lifes, landscapes, portraits, figures and what she calls 'bum' paintings, her pictures wrong-foot the viewer at every turn. Aware of the freight of painting within art history, and its contested position within modernism, Carnegie has nonetheless taken a guerilla-like stance in detonating the preconceptions that litter our approach to looking at painting. Disarming our expectations (for example, that a sunset or a still life belong on greeting cards

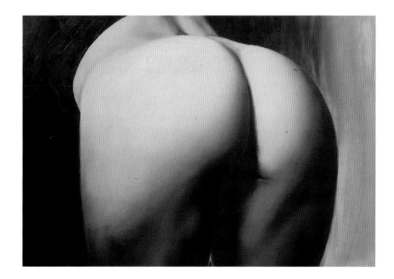

rather than contemporary paintings), she offers no systematic
approach to her range of subjects nor unifying stylistic gesture.
It sometimes appears as if the subject is a cover for something
altogether more shifty. In *Black Square* 2000 (p.49) the subject is
cloaked under the weight and density of black paint. A tree is only
slowly revealed, as if by default, as we scan the furrows of the
brushstrokes and matted paint. Carnegie does not so much adopt
these traditional genres, as take them on, duelling with them in the
making of a painting. And the viewer too has to engage with them,
taking nothing as given. For there is a sense of estrangement in her
treatment of even the most ostensibly straightforward subject.
Carnegie's work suggests that fake identities are all around us and
painting, paradoxically, is as much an art of dissembling as of
revelation.

Sometimes an artist's project inspires awe and disbelief in equal
measure. Paul Noble has spent the last seven years making epic
drawings of a place called Nobson, an absurd exercise in town
planning on a Babylonian scale. The buildings in Nobson are
constructed from letters, in a font designed for and named after the
town. Complete with job centre, factory, slums, park, hospital and
many other facilities, Nobson presents every evidence of lived life,
except its inhabitants. Musing on the fact that Nobson new town
doesn't have a centre, in *An Introduction to Nobson Newtown* 1998,
the unreliable narrator of the artist's publication states cryptically,
'maybe it was a belief that the only perfect thing is a flawed thing'.[10]
Noble's vision of Nobson is skewed between fantasy architecture and
consensual civic planning, between scabrous irony and diversionary
delights. Just as the viewer gets lost in the detail, so the guidebook
takes a nonsensical tone in describing the oddity of the town:

> The architects of the slums were very sensitive to accusations
> of fuddy-duddyism and didn't want to be seen to be merely
> repeating tried and tested formulas. What resulted was a very
> modern slum that perfectly combined the dual directions of time.
> On the one hand, the very modernity of these slums suggests
> a progressive, and positively redemptive aspect to this kind of
> living. On the other hand, the obvious calculated neglect and
> creeping seediness could be taken to suggest that despite youthful
> optimism in the goodness of mankind and that all change is for
> the better, the truth is that wherever man goes, destruction
> and sadness aren't too far behind.[11]

Paul Noble
Acumulus Noblitatus
2001 (no.47)

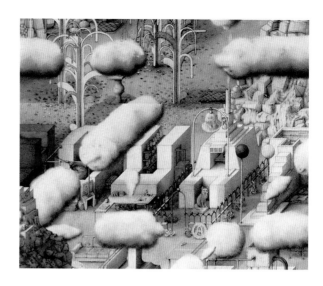

In the drawing exhibited here, *Acumulus Nobilatis* 2001, Noble has planted a biblical text favoured by the Diggers, early English radicals who advocated a proto-communist doctrine. Their songs and poems envisioned a 'world turned upside down, where the poor shall wear the crown'.[12] In Noble's drawing, as if to right the wrongs of short-term tenancies which typically govern the spaces in which artists live and work (and to which Noble is no stranger), is an ideal studio floating in the clouds. *Nobson Newtown* is not a manifesto, but in its fanciful way provokes reflection on imposed and evolved kinds of social control and anarchy. Drawn with great deliberation, it insistently side-steps reality – or what Adorno refers to as 'reality's spell':

> Even the most sublime work of art takes up a definite position *vis-à-vis* reality by stepping outside of reality's spell, not abstractly once and for all, but occasionally and in concrete ways, when it unconsciously and tacitly polemicizes against the condition of society at a particular point in time.[13]

Confusion and disruption are also effective means by which an artwork can alter conceptions of reality. Ceal Floyer talks about her work 'gazumping reality', as it occupies the uncertain state between assumption and actuality. 'There is a fine line', she comments, 'between making sense of the world and making nonsense of it.'[14] In the psychological experiment conducted by Rosenhan, he walked the fine line between sense and nonsense to test the supposedly routine procedure for distinguishing between sanity and insanity. 'However much we may be personally convinced that we can tell the normal from the abnormal, the evidence is simply not compelling', he concludes.[15]

Kutlug Ataman's film *The 4 Seasons of Veronica Read* 2002 (pp.30–5) is a study in the kind of extreme commitment that could easily be seen as pathological. Comprising four interviews made over the course of a year with a woman called Veronica Read, it chronicles a life cycle from procreation to death and rebirth. Her passion and dedication to the Hippeastrum bulb is such that her suburban home is given over to hundreds of varieties which she tends 'like children', assisting in their pollination, monitoring their growth, noting their peculiar likes and dislikes, even (the film suggests) becoming infected by their diseases. Ataman's film shows the obsessive commitment of one person to one flower, around which her life is arranged. Is it more

absurd or inspiring than any other commitment? No one, it seems, could have a deeper attachment to the Hippeastrum than this woman. Taken as a manifestation of any kind of belief, the work vividly demonstrates the limitless human capacity for inventing a reality to live in.

Distinct from such artworks that implicate the viewer in assessing value and meaning, are others that appear to invite the viewer's direct, sensory perception. In different ways Ian Davenport, David Batchelor and Tim Head, for example, present their materials like evidence to be taken at face value. Their work takes a phenomenological approach to investigating the material properties of things in the world: emulsion paint, office shelving, shop-sign light boxes, even the pixels of a computer image. But presented in the environment of an art exhibition, it is hard for us to let these things be real in a world of artifice. Our assumptions and expectations kick in, and we turn a subjective, transformational eye on them. These artworks provoke the same dilemma of knowing what it is that we are looking at, and what we bring to our looking by other means, not least visual seduction. Just as Rosenhan demonstrated that a psychiatric hospital 'creates a reality of its own in which the meanings of behaviour can then easily be misunderstood', so the reality of the gallery may determine our responses.[16] And artists themselves are adept at side-stepping the reality of the gallery to confound us still further.

This exhibition demonstrates the plethora of visions and voices in the work of just twenty-three artists. Does it matter that we notice how these artworks take positions in relation to reality? Perhaps only in as much as it helps us position ourselves. And if understanding the work of contemporary artists is often difficult, that is hardly surprising. Rarely does an artist set out to confirm common assumptions about what we think we see and know. More often, we are left questioning the very terms by which we understand the world and ourselves. Are artists infiltrating the asylum? I do believe so.

Dreambases and Datascapes
Caoimhín Mac Giolla Léith

The value of information does not survive the moment in which it was new. It lives only at that moment; it has to surrender to it completely and explain itself to it without losing any time. A story is different. It does not expend itself. It preserves its strength and is capable of releasing it even after a long time.
Walter Benjamin[1]

[As] we pass from the dark enveloping spaces of cinematic storytelling into the brightly lit "o" and "1" signals of the digital age, an alteration of the components of vision and storytelling – a shift in historical compulsion – can be detected.
Thyrza Nichols Goodeve[2]

Walter Benjamin's general account of the challenge posed to a traditional culture rich in storytelling by a Modernist culture fuelled by information is both absolutely of its time – 1936, to be precise – and pertinent to a discussion of contemporary art. Thyrza Nichols Goodeve's specific account of the work of Sarah Morris, one of the artists included in this exhibition, is both thoroughly of this moment, concerned as it is with notions of immediacy and instantaneity, as well as judiciously historicising. Both writers register a profound change in the nature of our habitual perception of the world during the course of the twentieth century. Goodeve's essay is specifically informed by Jonathan Crary's magisterial survey of the course of this perceptual evolution, or indeed revolution, from which she draws the opening quotation of her essay: 'For the last 100 years perceptual modalities have been and continue to be in a state of perpetual transformation, or, some might claim, a state of crisis.'[3]

The argument of the present essay is that, despite this indisputable transformation of our ways of viewing the world, one which was well under way in Benjamin's day, we might best view Benjamin's contrast between a storytelling culture and an information culture other than in terms of an inexorable and irreversible transition from the former to the latter. Rather we might usefully view it as a set of polarities between which contemporary visual art in particular continues to shuttle productively to this day. For, as much of the work in this exhibition attests, our traditional need for stories and our contemporary fascination with information are by no means incompatible.

Peter Doig and Sarah Morris may be taken to epitomise these two opposing tendencies within the field of painting. Whereas Doig's

work registers the dogged persistence of narrative in contemporary visual art, Morris's rehearses its ultimate annihilation. The title of Doig's *100 Years Ago* 2000 rhetorically returns us to an era preceding the information revolution at the very dawn of the age of cinema. The large canvas depicts a long-haired man, haggard and dishevelled, adrift in a canoe in a wide expanse of water. There is an island in the distant background, bearing clear traces of human habitation, to which the man's back is turned as he stares intently and disturbingly out of the canvas at the viewer. Shrouded in mystery and bristling with vague menace, the painting has the feel of a hazy freeze-frame gleaned from some obscure and troubling narrative. The key to its invocation of Goodeve's 'dark enveloping spaces of cinematic storytelling' is the disconcertingly familiar motif of the canoe, a motif that also appears in several of Doig's earlier paintings, for example, *Swamped* 1990 and *Canoe Lake* 1997–8, which are derived from a still from the closing scenes of the 1980 classic horror movie *Friday the 13th*.

Morris's *Department of Energy (Capital)* 2001, also a fairly large painting, depicts a flat, complex, distended grid with an indication of recessive perspective suggestive of a close-up of the facade of a contemporary high-rise. Numerous glossy shards of colour appear to be held in place by this criss-crossing armature of bright green lines. The painting is rendered in a sharply delineated, high-octane visual style that speaks of sensory and information overload and the hypostasisation of pure contemporaneity, visually seductive and ungiving in equal measure. The filmic parallel for Morris's painting may be located, not in the history of Hollywood cinema, but rather in her own short films, in this specific instance *Capital* 2000. Morris's films chart, in nervily edited sequences of a seemingly random order, the constant blur of human movement through the 'non-places' of the consumer-driven contemporary city.[4] The crisp colours and sharp edges in her paintings contrast with Doig's toxic palette and dissolving outlines. Whereas Morris' world is one 'consumed by proximity', as Goodeve puts it, Doig's world recedes from us in a sulphurous haze of dystopian nostalgia. Their characteristic pictorial modes are contrasting epitomes of energy and enervation, respectively. With Morris everything seems impossibly strange and new, despite the instantly recognisable signature style. With Doig it often seems as if we have somehow been here before. This atmosphere of uncanny familiarity is merely heightened by the recurrence of key motifs, such as the canoe, and compositional

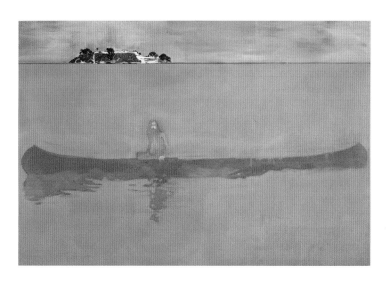

gambits, such as the division of the picture plane into three more or less equal horizontal bands.

In the particular context of this exhibition, the paintings of Morris and Doig are, as already suggested, emblematic of the polarities of an art enthralled by information and an art haunted by stories. While certain artists included incline obviously towards one or other of these extremes, others are more difficult to situate along this spectrum. The self-reflexive systematics of Tim Head and David Cunningham, for instance, tend towards Morris's end of the spectrum. So too, though in a very different way, do the playful literalism and ludic tautologies of Ceal Floyer. George Shaw and Paul Noble, on the other hand, share with Peter Doig that sense of nostalgic dystopianism to which I have already referred. This can take the form of a tainted memory or a travestied repetition of what was once the brave new project of Modernist architecture and urban planning. Yet there is one thing notably missing from Shaw's meticulously painted vignettes of life – or, more to the point, the manifest lack thereof – in suburban Coventry. What this gloomy landscape of sodden concrete lots and walkways and unkempt wooded hinterland patently lacks is the presence of *people*. Similarly, in Noble's impossibly detailed aerial views of his imaginary Nobson Newtown, everything is painstakingly laid out for our examination apart from the town's mysteriously absent inhabitants. Noble has observed of his panoramic drawings that 'a map is just a useful device for incorporating different sorts of information'.[5] What is withheld from us in the otherwise densely detailed vistas of Shaw and Noble alike is that indispensable basis on which to build an engaging narrative – the promise of meaningful human interaction.

Of course it is often this very humanity, and the empathy it arouses, that impedes, or at the very least complicates, the free flow of information. Kutlug Ataman's video installation, *The 4 Seasons of Veronica Read* 2002, which charts the four seasons of the Hippeastrum bulb, is a documentary that mixes the ostensible objectivity of scientific enquiry with the subjective idiosyncrasies of private obsession. Veronica Read is apparently the owner of Britain's definitive national collection of this bulb, which is both exotic in its tropical origins and an everyday staple of suburban supermarket flower stands. This miniature botanical facility is housed in Read's suburban West London apartment, in which Ataman filmed her as she enthusiastically charts in lovingly minute detail every aspect of these plants' life cycle. While Read is undoubtedly a mine of

information, this information is delivered in anything but the detached and impersonal manner implied by Benjamin. In fact it is largely, if endearingly, beside the point. Rather than function as an immediate end in itself, the purveying of information functions here primarily as a pretext for artist and viewer alike to ponder at length a more intriguing question, which might be colloquially phrased as follows: What exactly is this woman's story? In this *The 4 Seasons of Veronica Read* is in keeping with previous works by Ataman, in which the lives of various marginalised and/or larger-than-life members of society are presented to the viewer in a torrent of narrative self-revelation, the shifting truth-values of which it is virtually impossible to assess.

Ataman's animated and garrulous interlocutors contrast starkly with the mute immobility of Shizuka Yokomizo's apparently inscrutable subjects in her series *Strangers* 1999 (pp.152–3). Yokomizo anonymously contacted a variety of people she had never met and arranged to photograph them standing at their front window at night. We might envisage the artist, crouched in the shadows of a front lawn or dark pavement, having minimal purchase on the personality of her subjects, that is to say, no inside information with which to inform or inflect her portraits. We, as curious voyeurs, are systematically deprived of even the most rudimentary information that might normally accompany an exhibited portrait, such as the subject's name. Yet, tellingly, this has the effect of enhancing our readiness to invest with personalities of our own concoction this series of strangers who are at once uneasily exposed to the outsider's scrutiny and vacuum-sealed in the privacy of their own domain.

Comparable inducements to idle personal reverie are persistently offered in the work of Susan Philipsz. Much of this work consists in smuggling her disembodied singing voice into various public locations where its restrained melancholia slowly insinuates itself into the consciousness of an unexpecting public. On one occasion, for the duration of the Manifesta 3 in the summer of 2000, her voice could be overheard softly crooning the once blood-stirring socialist anthem, *The Internationale*, from a loudspeaker installed in a pedestrian underpass in post-communist Ljubljana. Another time she could be heard delivering a selection of doleful songs from a repertoire ranging from the Rolling Stones to Radiohead, over a public address system amid the hubbub of a Belfast bus station (*Filter* 1998). Philipsz regularly invites her (often inadvertent) audience to respond to the emotional tug of a familiar refrain. Yet, given the

evident incongruity of the situation within which these songs are re-encountered, the audience is at the same time invited to reflect upon the mechanism by which that response is elicited. Her focus on the enduring power of music calls into question the putative waning of affect perceived by many as characteristic of the Postmodern world. Popular song functions here as a prompt to the retrieval of personal memories and the reanimation of half-forgotten events and narratives – what exactly were we doing the summer that song was first released? – as well as an inducement to reflect on the specifics of the here and now. As Philipsz has stated: 'With my work I am trying to bring an audience back to their environment, not the opposite. What I am trying to do is make you more aware of the place you are in, while heightening your own sense of self.'[6]

Philipsz shares a penchant for the unabashedly nostalgic invocation of popular music from the relatively recent past with Jim Lambie. Lambie is quick to point out that the prime motivation for his sculptural concatenations of elaborately glam-rock-glitter decorated turntables and customised speakers, records and record sleeves, is formal. His concern is not with contemporary club culture *per se* but with the problem of how to make an achieved contemporary sculpture. In fact his debt to music culture since the 1970s should not overshadow a significant debt to the visual art of the previous decade. It has been noted, for instance, that his signature *Zobop* floors 1999– (pp.102–3), which are made of numerous, thin strips of adhesive vinyl, either in grey and black or in a psychedelic range of bright colours, owe something to the metal floor works of Carl Andre, as well as to Frank Stella's shaped and striped canvases of the early 1960s.[7] The legacy of 1960s Op art, and its extension into popular fashion and design, is also relevant. Like Andre's sculptures, these works invite, even require, the viewer to walk over them; and just as the shape of Stella's canvases mechanically determined the pattern of his painted stripes, so the compositional contours of Lambie's floors are dictated by the shape of the room's perimeter, as well as whatever architectural disruptions, such as floor-to-ceiling columns, there are within it.

Similarly, it is difficult to address David Batchelor's use of pre-fabricated industrial neon lighting as the sole components of many of his best-known works without acknowledging the precedent of Dan Flavin. Whereas Stella famously wanted his paint to look as good on the canvas as it did in the can, so Flavin was happy for his light fixtures to look as good in the gallery as they did in the supplier's

Susan Philipsz
Victory 2001
Sound installation
on the Joyce
Passenger Boat,
River Lagan, Belfast

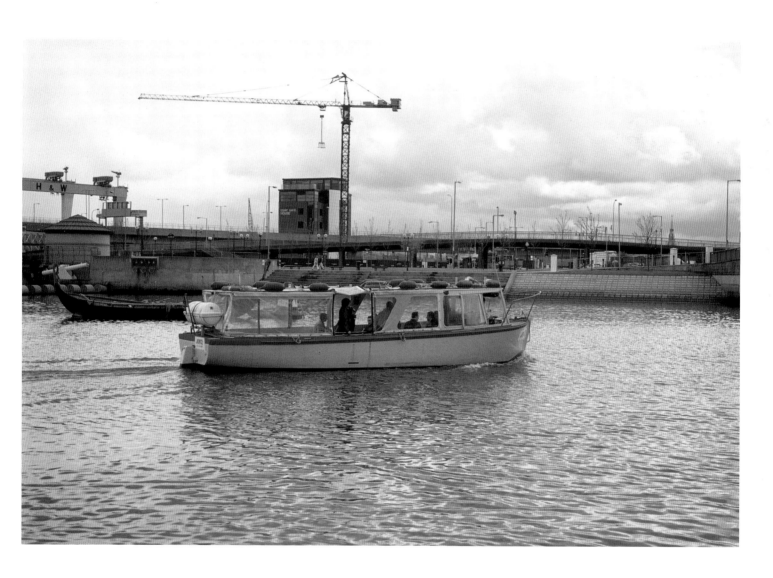

Rachel Whiteread
Untitled (Rooms)
2001
(no.57)

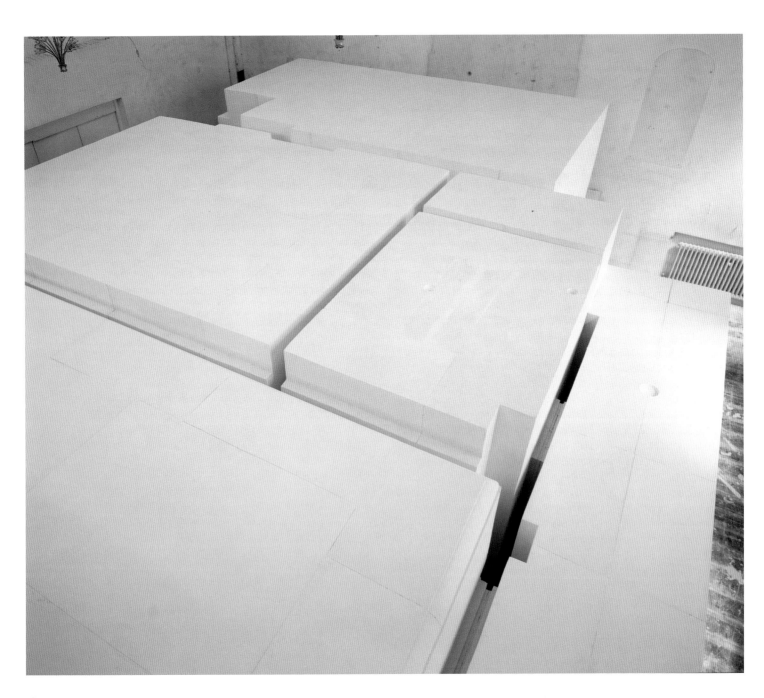

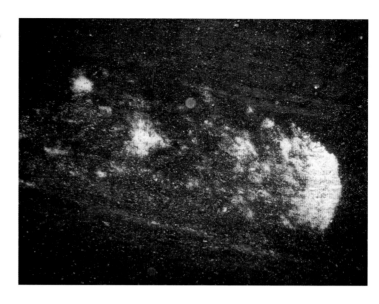

Cornelia Parker
Einstein's Abstracts 1999
Photomicrograph
(x 50) of the blackboard
coverered with
Einstein's equations
from his lecture on the
theory of relativity,
Oxford, 1931

shop. Batchelor's monumental neon stacks (pp.43–7), however, are made up of light fixtures that are anything but pristine. On the contrary, they invariably display the scuffs and scrapes, bashes and dents of protracted use. In this they bear comparison with Lambie's choice of scruffy strips of coloured sticky tape, in contrast with Andre's precisely machine-produced metal tiles which form the basic components of his floor sculptures. In the art of both Batchelor and Lambie, Minimalism's rhetoric of purity has been usurped by a poetics of reconstitution or dilapidation.

Rachel Whiteread's work, on the other hand, seems to be informed by both these modes of sculptural expression. To favour a primarily formal or phenomenological reading of her sculpture is to risk occluding the persistent aspect of social memorialisation that has been evident throughout its development. This informed her early replicas of discarded worn-out mattresses, a regular sight at the time on the streets of London's East End, as well as her life-size negative cast of a condemned Victorian home, *House* 1993, and her more recent *Holocaust Memorial* 2000 in Vienna. The object's physical accretion of significance over a protracted period incidentally marks the sculpture of Lambie, Batchelor and Whiteread. The power of an indexical link to the past is, however, thematised in certain works by Nathan Coley and Cornelia Parker. It underwrites to some extant, for example, Coley's efforts to acquire the actual courtroom witness box in which those accused of the Lockerbie bombing were questioned, a box originally sited in The Netherlands on what was, judicially speaking, Scottish soil for the duration of that trial. It is also at the heart of Cornelia Parker's practice, which includes elevating to the status of artworks such disparate objects as a child's doll, a pair of gloves and a pack of cards cut by the guillotine that beheaded Marie Antoinette; a slide projection that physically incorporates dust and fibres from Sigmund Freud's couch; and a series of 'drawings' on handkerchiefs made with the tarnish gathered from various sources such as Davey Crockett's fork, Charles Dickens's knife or the spurs of Charles the First. These artefacts have more than a hint about them of the carefully preserved saint's relic (Parker has specifically referred to her collaborative installation with the actor Tilda Swinton, *The Maybe* 1995, as a reliquary) or a star's memorabilia.[8] They are, among other things, 'conversation pieces', props for the spinning of elaborate yarns.

It is clear that, despite the dazzling allure of 'the brightly lit "0" and "1" signals of the digital age', much contemporary art still contrives to propel us speculatively and imaginatively back into past, both recent and distant, while retaining a firm purchase on the present. An apparent shift, for instance, in Dexter Dalwood's recent work from imaginary invasions of celebrity privacy toward an art-historically allusive form of mutant history painting, evidenced in a work such as *Nixon's Departure* 2001 (p.65), is yet another example of the fascination still exerted by stories of the past in a culture saturated by media-driven novelty. The quality by which Benjamin originally distinguished between a story and mere information, i.e. the fact that a story 'preserves its strength and is capable of releasing it even after a long time', is a quality the story shares with the auratic artwork, whose status Benjamin famously perceived to be equally endangered by the forces of technological modernisation. Contemporary art provides ample evidence of the remarkable resilience of what we might call 'vision's back-story'. In light of this evidence we might as well reconcile ourselves to the prospect of an ongoing, kaleidoscopic ordering and reordering of 'the components of vision and storytelling'.

Kutlug Ataman
Margaret Barron
David Batchelor
Gillian Carnegie
Nathan Coley
David Cunningham
Dexter Dalwood
Ian Davenport
Richard Deacon
Peter Doig
Ceal Floyer
Richard Hamilton
Tim Head
Jim Lambie
Mike Marshall
Sarah Morris
Paul Noble
Cornelia Parker
Susan Philipsz
Nick Relph and Oliver Payne
George Shaw
Rachel Whiteread
Shizuka Yokomizo

Kutlug Ataman

Kutlug Ataman was born in 1961. He lives and works in London and Istanbul. In the 1980s he studied film at the University of California, Los Angeles. Between 1988 and 2000 his films were screened in numerous film festivals including Berlin, New York and Edinburgh. In 1997 he took part in the 5th Istanbul Biennial where he presented *kutlug ataman's semiha b. unplugged* 1997. Ataman's third feature film *Lola and Bilidikid* 1998 received widespread acclaim and won awards at international festivals including the 1999 Berlin International Film Festival where it opened the Panorama section of the festival. Ataman participated in the 48th Venice Biennale (2001) where he presented *Women Who Wear Wigs* 1999. His work has been exhibited worldwide and featured most recently in Documenta 11 (2002) where he presented *The 4 Seasons of Veronica Read* 2002, and in a solo exhibition at the Serpentine Gallery, London (2003).

Turkish artist Kutlug Ataman's films combine documentary-style filmmaking with the intimacy of the home-movie genre. Ataman's films are often excessive in duration allowing for an in-depth study of a central character who, with little or no direction, drives the film. For the most part, Ataman shoots his subjects in domestic settings where they relay highly personalised accounts of their life's experience and present-day occupation. His work is presented either as a single-screen version or multi-screen video projection that enables viewers to surf a number of interviews taking place at any one time. Each film betrays a fascination with individuals who, either by choice or through circumstance, find themselves on the margins of social acceptability. The central characters are aesthetically motivated; their entire lives have been devoted to the appearance of things, notably themselves. Having spent much of his life on the outskirts of mainstream society both in Turkey and the West, Ataman brings to his subjects a sensitive directorial understanding, and encourages them to bare all.

As part of the 5th International Istanbul Biennial, Ataman presented his 465-minute video *kutlug ataman's semiha b. unplugged* 1997 (p.34). The film stars legendary Turkish diva Semiha Berksoy (born in 1910) who talks of her life and loves, some real, some imagined. The film exudes a profound sense of intimacy between subject and artist, and, by extension, the film's audience. Not only does the viewer experience an entire life unfolding before the camera, but Berksoy's recollections also touch upon the social and political upheavals of the twentieth century. Appearing in a range of extraordinary outfits, she recalls childhood feuds with her mother as well as her entry into male-dominated society where she rebelled as a *femme fatale* and a bohemian artiste. She talks of her performances as Leonora in Beethoven's *Fidelio* and her privileged ascendance in the eyes of high-ranking Turkish and German politicians. It is through these recollections that it becomes possible to chart the fortunes of a society in conflict with its past. Berksoy's anecdotes culminate in an account of her performance in the 1930s before President Atatürk, the founder of modern Turkey.

Ataman's multi-screen installation *Women Who Wear Wigs* 1999 features four individuals who wear hairpieces for varying reasons. Barred from wearing her religious headscarf to university, a devout Muslim student opts to wear a wig that covers her head in much the same way. Another woman, Melek Ulagay, recounts how, as a young political activist, she was once mistaken for the bomber 'Hostess Leyla', a fictitious flight attendant working for Turkish Airlines. In order to avert constant suspicion Ulagay feels the need to disguise herself, and for a time this included wearing a blond wig that made her even more conspicuous in Ankara, a city where blonde women were thought to be of dubious morals. Having undergone chemotherapy Nevval Sevindi, a well-known Turkish journalist, reflects on her temporary baldness, while Demet Demir, a transsexual prostitute and activist, relays astonishing encounters with the Turkish police. Presented on screens side-by-side, these very personal accounts draw attention to the unspoken and prejudicial dictates that govern our everyday lives. Having focused on what may seem like the innocuous topic of wigs, Ataman touches upon issues of social intolerance, not as an essay in the politically correct, but through the language of transgression.

Never My Soul 2001 (p.35) follows the life of Ceyhan Firat, a Turkish transvestite whose outward appearance is that of a glamorous young starlet. Filmed in the confines of Firat's cramped apartment in Switzerland, Ataman inadvertently reveals himself as an off-screen character. Teasing Ataman, Firat talks directly to him, and in one memorable encounter demands that he buys her new shoes. All the while Ataman tries as hard as he can to remain as discreet and unobtrusive as possible, only passing comment when pushed to do so. *Never My Soul* climaxes when Firat and a wolfish French admirer known as Jessie, re-enact a scene from *Little Red Riding Hood*. The fable is subject to a perverse ending, revealed in the film's title and which is the clichéd line of many a Turkish screen heroine: 'You can take my body, but never my soul!' Ataman teases out the inner fictions of his subjects who blur the boundaries between fact and fantasy.

It took Ataman over a year to make *The 4 Seasons of Veronica Read* 2002 (pp.31–3), such is Veronica's dedication to the Amaryllis Hippeastrum bulb which buds into one of the more phallic tropical blooms. Veronica Read is distinctively English, with an authoritative and penetrating voice. The viewer is left in no doubt that she is the owner of the British national collection of Hippeastrum bulbs and that her suburban home is given over to the cultivation of these flowers. At times she comes across as though she is hosting her own gardening show, supplying Ataman with questions which she then answers with considerable glee. The outside world, kept at bay throughout, finally makes itself known through the catastrophic invasion of a despoiling mite. The timing of the invasion coincides with the spread of foot-and-mouth disease elsewhere in Britain which resulted in the wholesale slaughter of livestock. 'The culling has begun', declares Read mournfully over her brood of infected plants, confounding the viewer as to whether her obsessive dialogue with her bulbs has taken a more sinister turn as she sets about dissecting them with nervous conviction.
Gregor Muir

The 4 Seasons of Veronica Read
2002 (no.1)
Stills from four DVD multiple
screen video projection
Courtesy the artist and Lehmann
Maupin Gallery, New York

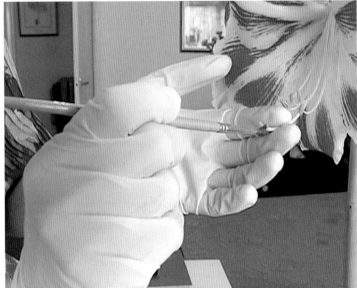

The 4 Seasons of Veronica Read
2002 (no.1)

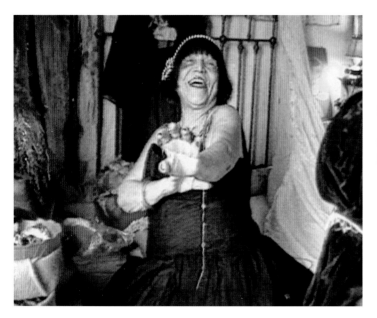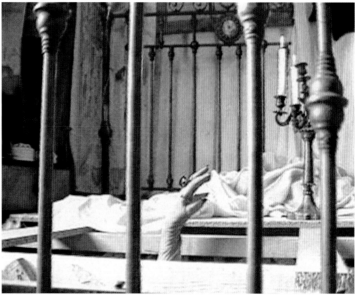

kutlug ataman's semiha b.
unplugged 1997
Stills from hard disk single screen
video projection
Courtesy the artist and Lehmann
Maupin Gallery, New York

Never My Soul 2001
Stills from six DVD multiple
monitor or single screen
video projection
Courtesy the artist and Lehmann
Maupin Gallery, New York

Margaret Barron

Margaret Barron was born in Ireland in 1971. She studied Fine Art at Crawford College of Art in Cork, Ireland, from 1990 to 1994. In 1994 she attended Glasgow School of Art where she completed an MA in Fine Art. Barron has shown in a number of solo and two-person exhibitions in both Britain and Ireland including: *Prospect*, Assembly Room Gallery, Glasgow (1995); *Three Hundred and Sixty Degrees*, The Economist Plaza, London (1998); *Site-Specific*, DNA Textiles Print Workshop, Glasgow (1998); Temple Bar Gallery, Dublin (2000); *Placed*, Intermedia Gallery, Glasgow (2001); and *is where the is*, a Switchspace Project at Killearn St, Glasgow (2002). Her work has also been included in the following selected group exhibitions: *Glasgow/Berlin – Exchange*, Kunstlerwerk Bahnhof Westend, Berlin (1996); *Made in Glasgow*, De Markten Arts Centre, Brussels (1997); *EAST International*, Norwich Gallery (1997); *Evolution Isn't Over Yet*, Fruitmarket Gallery, Edinburgh (1999); *Richard Wentworth's Thinking Aloud*, National Touring Exhibitions (1999); *On Land*, Travelling Gallery, City Arts Centre, Edinburgh (2000); *as it is*, Ikon Gallery, Birmingham (2000); and *Two Weeks in Another Town*, Catalyst Art, Belfast (2001). Barron lives and works in Glasgow.

For *Days Like These*, Margaret Barron has produced a series of fifteen diminutive paintings that are dispersed throughout Tate Britain and its immediate neighbourhood. All the works are painted onto small strips of adhesive vinyl tape. While the works inside the gallery are attached to the wall, the outdoor works are stuck onto such prosaic street furniture as lamp posts and road signs. Each of these tiny yet robust paintings is sited in close proximity to the scene it represents, and so is inextricably linked to the environment in which it is placed.

Barron's projects usually begin with photographing the vicinity in which she plans to site her work. Using these photographs as source material, Barron paints onto an adhesive vinyl. Returning to the streets for what she describes as the 'peel and stick moment', Barron selects surfaces that are orientated in the direction of the view the paintings depict. These works relate in size and permanence to the club stickers that appear and disappear with regularity on urban street furniture. The works located inside Tate Britain show the scene that would be visible if there were a window to the outside in that place.

Barron deploys traditional materials and methods while putting pressure on painting's privileged status in the art market: 'I use the medium of oil paint due to its historical values and associations of permanence to create temporary works that question the emotional and monetary value placed on painting.'[1] Her work takes on the idea of painting as the traditional, self-contained, pictorial rectangle, the so-called 'window on the world', to produce representational urban landscapes. However, the work frustrates common expectations about how painting functions, particularly in terms of spectatorship and its role as a commodity.

Barron conceives of her paintings, both inside and outside the gallery, as strictly site-specific. It is essential that they are shown only at their intended site. Attempts on the part of the viewer to 'match' the painted image to the immediate surroundings recall the process of finding one's bearings in an unfamiliar place with map in hand. Like an invisible arrow pointing to the viewer's feet, the paintings proclaim 'you are here', thus securing one's sense of place and time, the here and now. Yet Barron's representational style allows one to project oneself imaginatively into the pictured scene.

She thus sets up a dialectic between a sense of oneself in a physical and very immediate environment and the projection of oneself into a depicted landscape.

It is also significant that the work has a temporary existence, frustrating the impulse to collect and preserve works of art. At the end of the exhibition, the paintings inside the gallery will be peeled off and destroyed. However, the paintings outside will be simply left to decompose over time. For Barron, it is fitting that 'what is intended to be a temporary piece should be subject to the same forces as its surroundings, undergo the same wear and tear, change in the same way that the city is always changing'.[2] She has described how meaning is generated in her work by the relationship between two kinds of location: the physical location of the work in and just outside the museum, and a notional location outside the systems of institutional display and collection.

Barron has also talked about her work as having 'an in-built inequality … between provision of labour and net gain'.[3] By this she means that there has been a substantial investment of time on her part to develop and hone the specialised skill of oil painting, itself a time-consuming technique, to make work that can never be preserved or sold. This inequality seems to be a witty reversal of the logic of Duchamp's readymade. Whereas the readymade is an object of little or no aesthetic value bearing little or no evidence of the artist's hand or labour, which is placed in the gallery and thus 'transformed', given a price tag and conserved for posterity, Barron's work, on the other hand, is very obviously coded as 'art'. It lays bare her years of study and her skill as a painter, yet takes its place outside the gallery and is allowed to slowly disintegrate alongside the debris of urban life, resisting any recuperation by the market. Like Duchamp, Barron explores relationships between the art institution, the art market and the attribution of artistic value, although she approaches the issue very differently. She uses the ultimate art commodity, oil painting, with its associations of permanence, value and easy exchange, and invites us to witness its slow demise each time we walk past it on the street.

Helen Delaney

Placed 2001
Oil on adhesive tape
Courtesy the artist

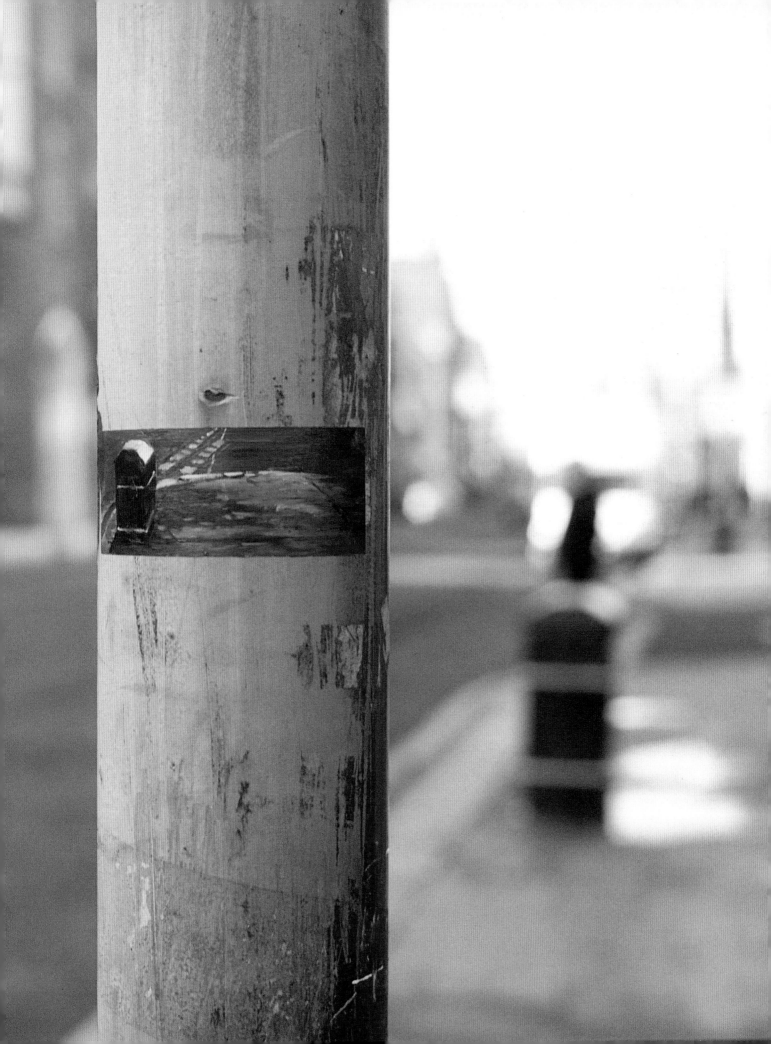

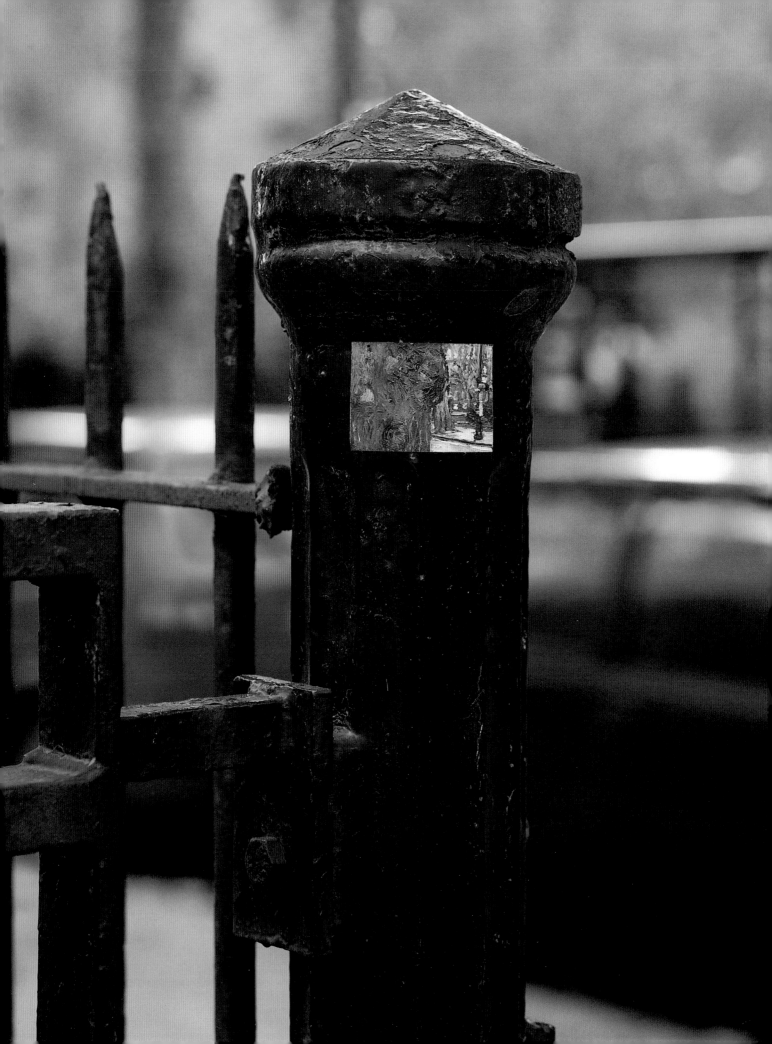

As it was is now 2002–3
(no.2)
Oil on vinyl
Courtesy the artist

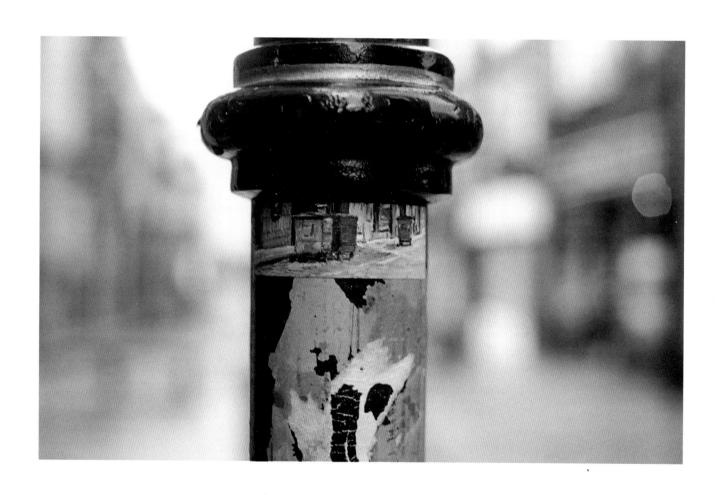

As it was is now 2002–3 (no.2)
Oil on vinyl
Courtesy the artist

Placed 2001
Oil on adhesive tape
Courtesy the artist

David Batchelor

David Batchelor was born in Dundee in 1955. He studied at Trent Polytechnic, Nottingham from 1975 to 1978 and then attended the Centre for Contemporary Cultural Studies, University of Birmingham, between 1978 and 1980. Recent exhibitions include *Postmark: An Abstract Effect*, Site Santa Fe, New Mexico (1999), *The British Art Show 5* (2000), *The Magic Hour: Art and Las Vegas*, Neuelandesmuseum, Graz (2001), *Another Britannia*, Tecla Sala, Barcelona (2001) and *Ruby*, Pearl, London (2001–2). David Batchelor is also a writer who has contributed to a number of journals including *Artscribe*, *Frieze* and *Artforum*. He is the author of *Minimalism* (1997) and *Chromophobia* (2000).

For much of the last decade, David Batchelor's work has been concerned with the use and understanding of colour. This engagement extends from an interest in the way our experience of colour has been, and is continually, transformed by the modern city, to an exploration of the prejudices that surround colour in the cultural imagination. Batchelor embraces colour as a positive value and encourages the viewer to encounter it as an entity in its own right, not as a secondary consideration or effect. To this end, he is drawn to the 'vivid, bright, impure colours' associated with cosmetics and commerce rather than the more conventional hues of painting.[1]

Much of his earlier work occupied a space between painting and sculpture, being both wall-based and three-dimensional. Colour was first used in a series of flat-fronted free-standing constructions and it quickly became one of the principal subjects of the work. Between 1992 and 1996 Batchelor experimented with a number of ways of combining intense monochromatic colour with a range of supports. The most successful of these was the series of small works begun in 1995 entitled *Shelf-Like*. Made from up to a dozen transparent acrylic sheets painted with household gloss, each work is supported by a simple wall-mounted steel or aluminium shelf. Colour takes on a structural role in these works; they appear to be built from one or more shiny, saturated hues. The work involves an emphatic separation of surface and support, and the combination of ready-made and monochromatic abstract elements had substantial conceptual and physical implications for Batchelor's subsequent work.

These ideas are extended in his three-dimensional works in which intensely coloured surfaces are supported by found and discarded objects such as steel shelving units, broken road signs and second-hand commercial light boxes scavenged from the city. The *Monochromobiles* 1997– for example, integrate monochrome panels with discarded, often broken, warehouse dollies. They are collectively titled *I Love Kings Cross and Kings Cross Loves Me* both in a nod to the German artist Joseph Beuys, and also in reference to the specific part of London where many of the dollies were found.[2] At the time, a conscious concern was to make a work that did not take the form of a coloured object but rather had the appearance of solid colour. Exploration of this concern revealed that placing the monochrome panel on the horizontal significantly increased the intensity of colour – taking on an almost liquid quality it appears 'as good as it was in the can'.[3] This highlights a theme that Batchelor has identified in art of the last thirty years: 'the anxiety that materials of the modern world might be more interesting than anything that could be done with them in the studio'.[4] The horizontal surface of the *Monochromobiles* appears almost fluid, and their physical and metaphorical

mobility allows for any number of configurations.

Batchelor's fascination with the predominately unnatural colours of modernity – petro-chemical, electrical or fluorescent – and the types of experiences these materials generate, is further reflected by his ongoing series of glowing electric towers. As the artist states, 'Most of the colour we now see is chemical or electrical; it is plastic or metallic; it is flat, shiny, irridescent, glowing or flashing (or it is broken, switched off and as if it was never there). This colour is intense but also ephemeral; it is vivid but also contingent.'[5] *Electric Colour Tower* 2000, realised for the foyer of Sadler's Wells Theatre, London, conveys something of the intensity of the urban encounter. Standing ten metres high, the tower was assembled from used industrial steel shelving on which were stacked found commercial light boxes. These rose up through the centre of the building; each box contained one or more fluorescent lights, masked by a coloured acrylic sheet – acid pink, lime, orange, turquoise. The combinations of different colours and degrees of transparency or opacity defied any obvious pattern or structure. As with *Barrier* 2002 (pp.46–7), which filled a large double doorway between two rooms, *Electric Colour Tower* was a wall of humming electrical colours from one side, while from the other it was revealed as a pile of battered steel boxes, cross struts and cables. As in the case of *The Spectrum of Brick Lane* 2003, the experience of the two different views of the work mirrors the artifice present in the city, where surface appearance is often the antithesis of the structures that support it.

In the stress on the separation of front and back – which the artist refers to as a 'billboard effect' – there are echoes of architect Robert Venturi's writings on the architecture of Las Vegas.[6] For Batchelor the notion of 'in the round' derives from our experience and expectations of the natural world, whereas the flat frontality of the billboard is quintessentially an urban experience. This interest in the entirely unnatural and impure beauty of the city is derived from an extended interest in artifice and cosmetic beauty – a theme that runs from Charles Baudelaire and J.K. Huysmans to Andy Warhol and Dave Hickey. 'This for me is where colour begins, not in traditional colour theory or in oil painting but in the swatch books for commercial paints, lighting gels and Plexiglas. And this is where the problems begin: it is difficult to do anything to make these materials look better than they do in their raw state. These colours and surfaces are so intrinsically interesting that most of the time work in the studio feels like minor acts of well intentioned vandalism. For the most part I have found the best way to work with these materials is to combine them with some very unshiny and uncolourful supports, found objects that are often broken and usually abandoned. Dirty readymades for shiny monochromes.'[7]
Clarrie Wallis

Pastoral 2001
Dimensions Variable
Mixed media
Installation at Tecla
Sala, Barcelona
Courtesy Anthony Wilkinson
Gallery, London

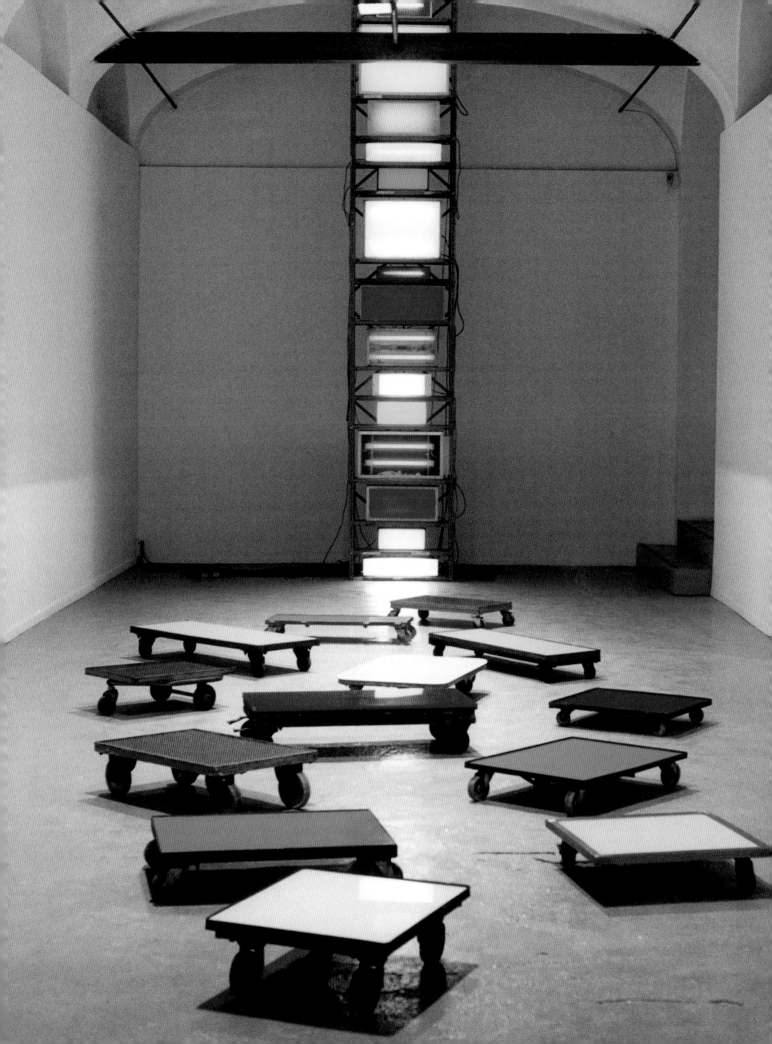

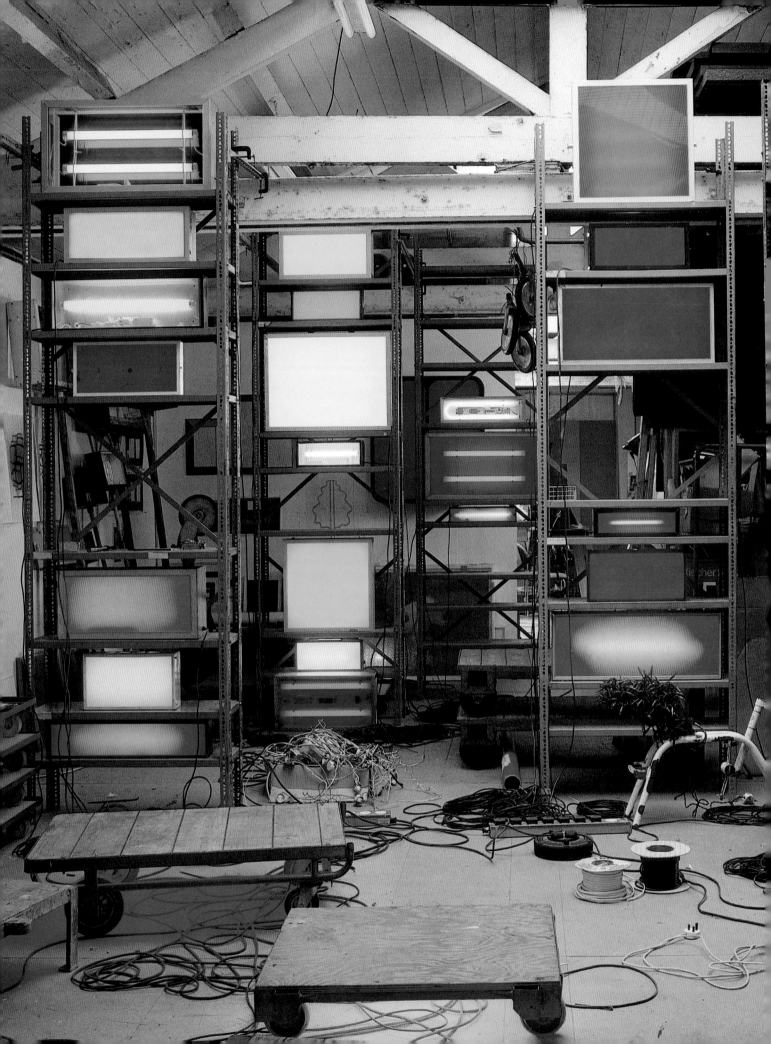

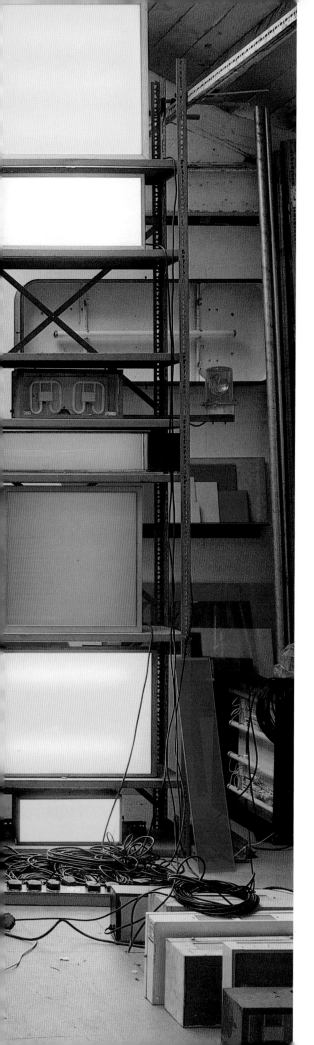

Above and left:
Studio
2002

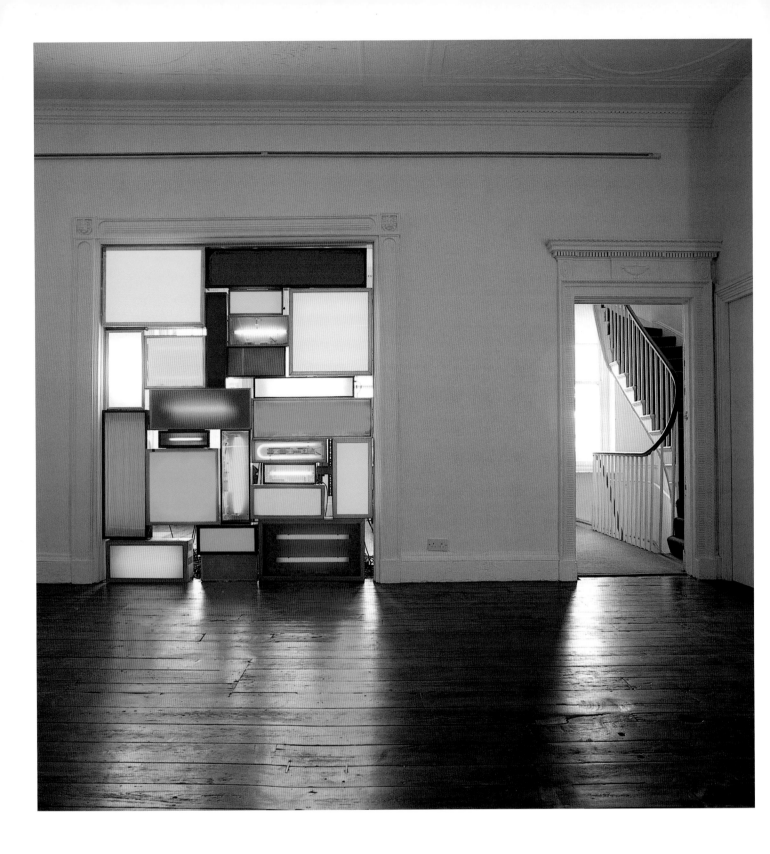

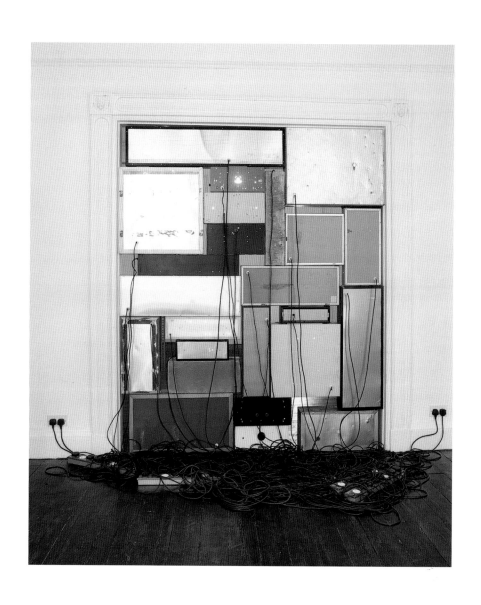

Barrier 2002
Mixed media
285 × 267 × 25 (112 ¹/₄ × 105 ¹/₈ × 9 ⁷/₈)
Installation at 38 Langham Street, London
Courtesy Anthony Wilkinson Gallery,
London/38 Langham Street, London

Gillian Carnegie

Gillian Carnegie was born in London in 1971. She studied at Camberwell School of Art, London, from 1989 to 1992 and the Royal College of Art, London from 1996 to 1998. Carnegie has had solo exhibitions at Cabinet Gallery, London (1999 and 2000) and Andrea Rosen Gallery, New York (2000 and 2003). She has participated in group shows including *New Contemporaries '98*, Camden Arts Centre, London (1998); *Surfacing*, ICA, London (1998); *Scorpio Rising*, Contemporary Fine Arts, Berlin (1999); and *Extended Painting*, Galleria Monica de Cardenas, Milan (2001).

In 1955 Georges Bataille suggested that Edouard Manet's unique achievement was to have forged a new and modern form of art: a kind of painting in which the manner of the execution was as, if not more, important as the subject; in which, indeed, the artist would adopt an attitude of *indifference* to the subject. He wrote: 'What Manet insisted on, uncompromisingly, was an end to rhetoric in painting. What he insisted upon was painting that should rise in utter freedom, in natural silence, painting for its own sake, a song for the eyes of interwoven forms and colours.'[1] He concluded: 'To some extent every picture has its subject, its title, but now these have shrunk to insignificance; they are mere pretexts for the painting itself.'[2]

Gillian Carnegie (an admirer of both Manet and Bataille) has found a way out of the impasse faced by many young painters – what to paint when, seemingly, everything has already been painted, how to paint when one feels the burden of the history of modernism and its dogmatic enshrinement of the notion of 'progress' – by returning to that year zero of modernism. She has taken Manet's position – as articulated by Bataille – as a starting point for a free-ranging and un-dogmatic exploration of the fundamental properties of painting. To do this she has chosen to work within the traditional genres of painting. This limitation has, surprisingly, allowed for great freedom of action. By adopting this approach she is able to address a wide range of subjects in a variety of styles.

Carnegie works with landscape, still life, the nude (the 'bum paintings' also functioning as a kind of surrogate self-portraiture) and, recently, portraiture. In many respects her subjects are conservative and conventional, but her treatment of them reveals a complex and subversive vision. Her use of the varying textures and densities of paint, brushstrokes that both emphasise and contradict the subject they describe, colour that is on the one hand realistic in the most traditional sense, on the other highly artificial, creates paintings that seem at once engaging and evasive. Whereas in the work of Leon Kossoff and Frank Auerbach (two painters she admires) the thick paint is visceral, an equivalent or substitute for flesh or the matter described, in Carnegie's painting this is never the case. The paint seems divorced from the subject it describes. Her virtuosity is playful, and seemingly to its own ends. The dense excrescences of paint in her Manet-esque still lifes have little or no descriptive value, seeming to erupt in the centre of the painting of their own volition. If anything they provoke a crisis of confidence in the ability of paint to represent the world.

Nevertheless, we should not discount the importance of the subject in Carnegie's work, despite the fact that some paintings seem to approach abstraction. Carnegie works from photographs that she takes herself, and the compositions are often worked out in advance before the models are found, the locations identified and the preparatory studies made. Other works represent a more opportunistic response. In *Green Mountain* 2002 (p.53), for example, the figure in the lane and the mountain in the distance are derived from different sources; photographs taken many years apart. The subject itself is ambiguous – who is this figure, are they approaching or retreating – but the paint is even more so. The thin washes of paint and thick slabs of impasto all contribute to create an image of worrying instability.

Instability is a fundamental precept in her work. In many of her landscapes she fixes on that most clichéd symbol of romantic landscape painting, the sunset, but uses it to subvert the very thing she depicts. She makes the sublimity of nature appear absurd. In many of these paintings the colours are forced into the realm of kitsch and her handling of the paint is deliberately overdone. Yet she also creates exhilarating images of the play of light through trees, or across a landscape.

Perhaps the extreme opposite of the sunsets and one of the most extraordinary aspects of Carnegie's recent work is a series of black paintings. *Black Square* 2002 is an imposing monolith of paint. At first we see only a solid mass of black matter, quite literally a black square. But closer inspection reveals that this is a forest scene, painted almost in relief, with a surprising amount of colour to be found within the dense impasto – blue in the sky, greens and reds in the forest floor. The original impetus for these works – of which *Honer* 2000 was the first – was the challenge of depicting a night scene, rather than as a conscious referencing of the monochrome tradition in painting. That Carnegie had this historical precedent in mind however, is made explicit by the title. *Black Square* was the title given by Kasimir Malevich to his ground-breaking abstract Suprematist composition of 1913.[3] Monochromes, and specifically black or white monochromes, have often been put forward as representing a final advance, or an assertion of the death of (representational) painting. Thus Alexander Rodchenko could claim in 1921, after exhibiting a series of monochromes, that 'It's all over ... and there is to be no more representation',[4] and forty years later Ad Reinhardt was still able to make a series of black abstracts that he called the 'last paintings'. Yet the opening up of possibilities that Carnegie's practice entails means that she can approach the monochrome from a radically different direction and playfully subvert this heroic tradition of final statements. Her *Black Square* actually contains within itself that most traditional of subjects, a landscape, and a wooded glade at that.

Ben Tufnell

Black Square 2002 (no.7)
Oil on canvas
193 × 193 (76 × 76)
Courtesy Andrea Rosen Gallery,
New York and Cabinet, London

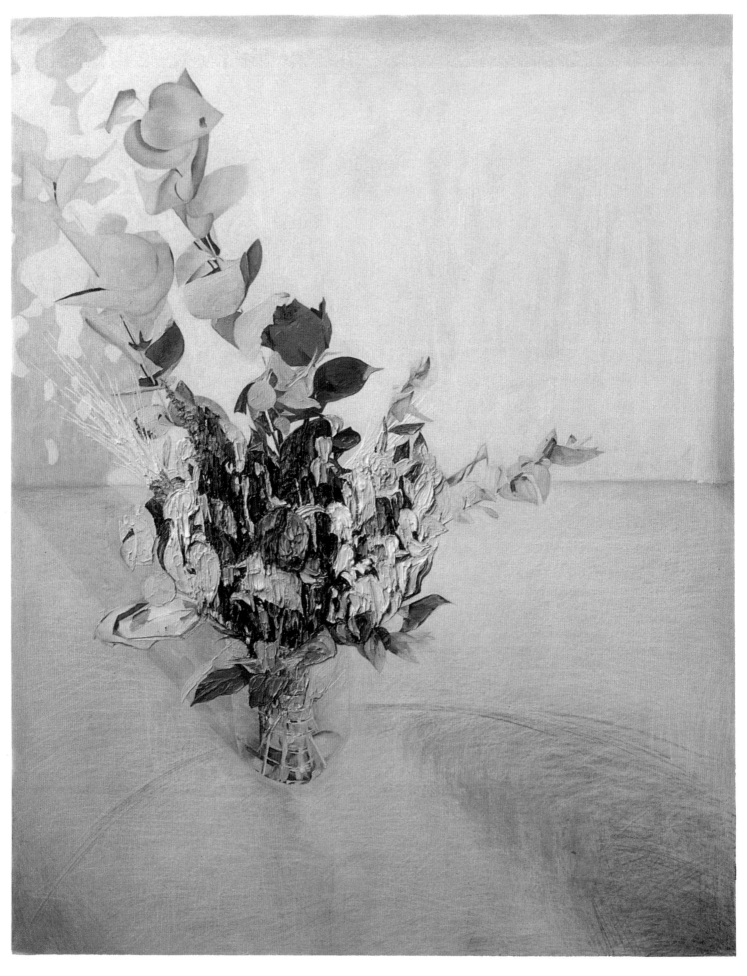

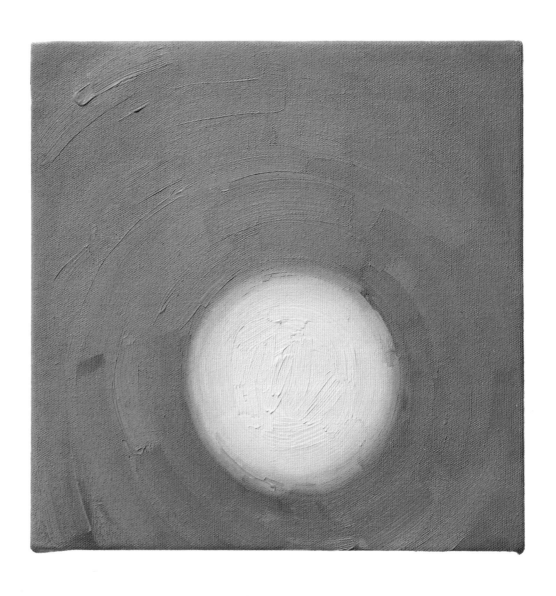

Fleurs d'Huile 2001
Oil on board
88 × 47 (34 ⁵/₈ × 18 ¹/₂)
Courtesy Andrea Rosen Gallery,
New York and Cabinet, London

Untitled 2001 (no.5)
Oil on canvas
22.9 × 22.9 (9 × 9)
Courtesy Andrea Rosen Gallery,
New York and Cabinet, London

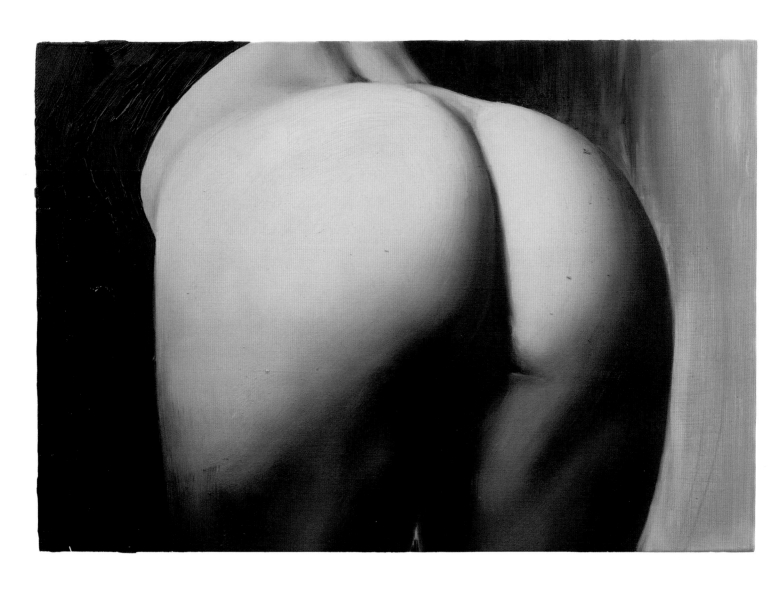

Mabel 1999 (no.4)
Oil on board
22.9 × 33 (9 × 13)
Private Collection,
New York

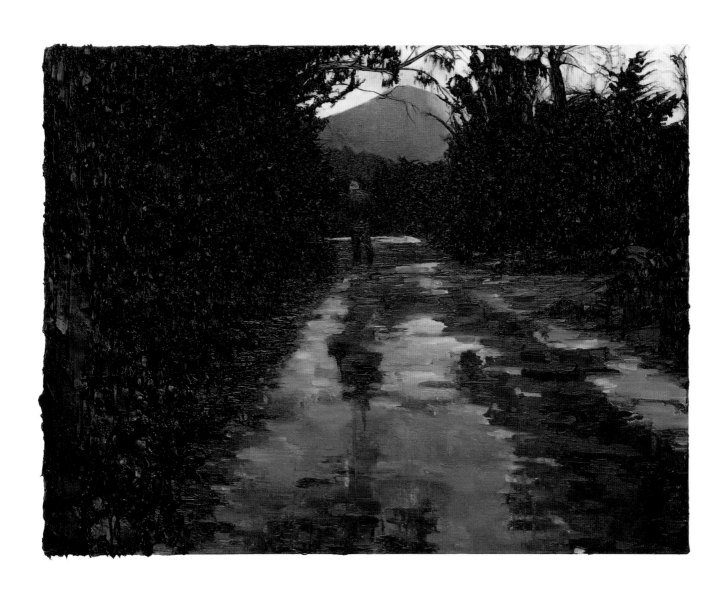

Green Mountain 2002
Oil on canvas
66 × 86.4 (26 × 34)
Courtesy Andrea Rosen Gallery,
New York and Cabinet, London

Nathan Coley

Nathan Coley was born in Glasgow in 1967. He studied at Glasgow School of Art from 1985 to 1989 and has since exhibited nationally and internationally. Notable solo projects include *Urban Sanctuary*, a publication for the Stills Gallery, Edinburgh (1997), *Fourteen Churches of Münster*, Westfälischer Kunstverein (2000), and *The Black Maria*, which he presented at The Physics Room, Christchurch, New Zealand, as part of *Scape: Art & Industry Urban Biennial* (2002). Coley has contributed work to a number of group exhibitions including *artranspennine98*, Tate Liverpool (1998), *as it is*, Ikon Gallery, Birmingham (2000), *Here and Now*, Dundee Contemporary Arts (2001), and *Fabrications: New Art & Urban Memory in Manchester*, CUBE, Manchester (2002). He has held a number of residencies and awards, most notably in 2000, when, as part of the *Scotland's Year of the Artist* initiative, he proposed to become the unofficial artist-in-residence at Kamp van Zeist, site of the Lockerbie Trial in The Netherlands. In 2001 he received a Creative Scotland Award with which he is currently investigating the relationship between several urban and wilderness locations; his research will result in a forthcoming book published by Bookworks. Nathan Coley lives and works in Dundee where he is currently the Henry Moore Fellow in Sculpture at Duncan of Jordanstone College of Art and Design.

Lockerbie Evidence #3
2003 (no.10)
Pencil on paper
84 × 59.5 (33 × 23 3/8)
Courtesy the artist

Research occupies the heart of Nathan Coley's practice. He undertakes in-depth investigations into particular spaces, buildings and locations, so as to examine the ways in which the built environment embodies often conflicting systems of social value, religious and political belief. Coley looks at the particular to reveal it as multifaceted, takes the matter-of-fact and makes it less so. His intention is neither to obscure our assessment of the world nor to impose fixed answers, but rather to highlight the need for an active, informed engagement with our inherently complex surroundings.

To increase his knowledge of a situation over time, Coley employs a wide variety of experiential research methods including site visits, interviews and photographic documentation. The way in which he then presents these findings is similarly open. In earlier work he tended to favour photography, video, slide presentation and book formats, which allowed for a sequential unfurling of ideas. His more recent work has assumed an assured physicality, a certain monumentality. Time remains an important consideration but it is inferred in increasingly subtle ways. Using simple materials such as cardboard and plywood Coley has constructed scaled-down versions of buildings that exude the precision of the architectural model maker and the physical effort of the builder. Although seemingly workaday, these buildings are invested with symbolism and loaded with human concerns. As part of the *as it is* exhibition at the Ikon Gallery, Birmingham, he undertook *The Lamp of Sacrifice, 161 Places of Worship, Birmingham* 2000 (p.59). Using the gallery as both studio and showroom, he re-made every church, synagogue, temple and preaching hall listed in the city's *Yellow Pages*. Working via digital photographs taken of this most multi-cultural of British cities, he constructed four 'Places of Worship' per day: a time-based performance of mock-martyrdom that played out John Ruskin's assertion 'It is not the church we want, but the sacrifice'.[1]

Although there is something utopian in this harmonious multi-faith cityscape, trauma has since emerged as a key theme of Coley's work. The non-combative targeting of buildings undertaken to make *The Lamp of Sacrifice* prompted him to consider its sinister counterpart. During the past year he has made a number of sculptures based on buildings that have suffered a violent clash of interests. *I Don't Have Another Land* 2002 (pp.58–9) is based on Manchester's old Marks & Spencer's building which was destroyed as a result of the IRA bomb damage in 1996. In researching and re-presenting this lost building, Coley has given new consideration to a structure erased from collective memory by the rush of redevelopment. The work effectively becomes a blackened monument to loss and absence, one that embodies the notion of buildings as political pawns, symbols of individual states and, consequently, targets for attack from oppositional forces.

It is within this context that Coley's interest in the Lockerbie Trial (2001) marks a natural development. Although the artist is quick to acknowledge the human tragedy of the event, his interest resides in the physical and political impact of one land upon another. According to some accounts, the terrorists had intended the bomb they had planted on Flight 103 to explode over mid-Atlantic no-man's-land on 21 December 1988, but terrible timing rendered Lockerbie the accidental target, thus causing a legal battlefield between the Libyan, British and American governments. Political sensitivity demanded that the trial of the suspects take place in the agreed neutrality of The Netherlands, where a special Scottish court was set up within the guarded enclosure of Kamp van Zeist. And so Scotland moved, hauled to a site far beyond its geographical borders into the centre of Europe. This situation lent force to Coley's research into the possibility of a conceptual and spatial transportation of one place to another.

The experience of undertaking research within a court context was entirely new to Coley; with so many rules and restrictions to negotiate, it took time for him to conceive of a way to articulate his response. He wanted any outcome to reflect his carefully-maintained position as an impartial observer, while embodying the complexity of the situation. His eventual focus on the witness box seemed entirely apt. The witness box is a controlled space in which we must swear allegiance to religious and/or legal systems in order to authenticate our position within it. Furthermore, the witness box at the Kamp van Zeist court not only formed the centrepiece of this new Scotland, but also seemed charged with a feeling of human presence and absence. Even the form of the box is richly referential: its distinct 'bullishness' has the pseudo-functional bulkiness of an Artschwager sculpture; its mute, precise simplicity not unlike Coley's previous constructions.[2] Coley has collaborated with the Imperial War Museum in London to obtain permission for the original witness box to enter their collection, and has also commissioned a replica of the box to be made for exhibition use. The process of re-presentation, so much a part of Coley's recent sculptural practice, only seemed to intensify the issues of authenticity and signification that he wanted to address. Furthermore, replication has allowed the witness box to assume a double life, to resonate simultaneously within the distinct contexts of the museum and the gallery.

Accompanying the reproduction witness box, and in addition to a video in which anonymous testifiers are cross-questioned, is a series of twelve drawings based on crucial pieces of evidence presented at the trial. These highly charged fragments have a similar capacity to signify far more than their mundane materiality might at first suggest. The drawings exude a sense of temporality: they operate as still lifes, portraits, even, of the objects themselves, but they also serve as a kind of diary, documenting Coley's presence in court and reflecting his desire to examine the evidence in all its minutiae. The coloured-pencil hues, so redolent of the traditional court artist, have a certain softness, yet there is something inherently hard about these drawings. The lines scratch the surface of the paper with the insistence of a shocking news broadcast that etches its harsh imagery into our minds. We are transported back to the site of the atrocity, to the moment when a town, entirely unrenowned, became a site of international significance. As backwaters become frontlines, notions of sanctuary begin to dissolve.

Natalie Rudd

PI/911 PI/1232 PI/1353

PI/1806

PK/2075

PK/1310A

PI/1808 PI/1807 PI/1803

PI/1388 PI/1420 PI/1431 PI/1466 PI/1487 PI/1488 PI/1538

PI/1545 PI/1548 PI/1552 PI/1564 PI/1565 PI/1589 PI/1590 PI/1591

PT/22

PI/1643 PI/1644 PT/24 PT/25 PT/68

PT/23

CMS 10 20

PP8932

55

Lockerbie Evidence #15
2003 (no.13)
Pencil on paper
59.5 × 84 (23 3/8 × 33)
Courtesy the artist

Lockerbie Evidence #4
2003 (no.11)
Pencil on paper
59.5 × 84 (23 3/8 × 33)
Courtesy the artist

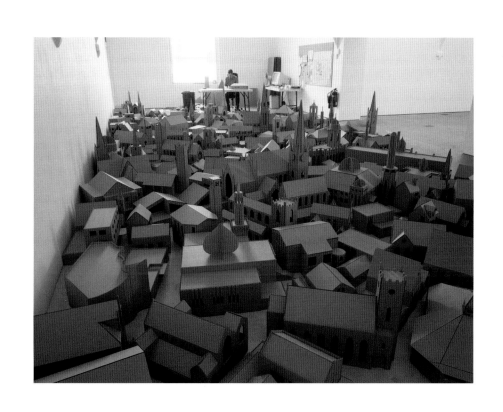

I Don't Have Another Land 2002
Stained wood and
mixed media
130 × 160 × 160 (51 1/8 × 63 × 63)
Courtesy the artist

*The Lamp of Sacrifice, 161 Places
of Worship, Birmingham* 2000
Installation at the Ikon Gallery,
Birmingham
Courtesy the artist

David Cunningham

David Cunningham was born in Ireland in 1954. He studied at Maidstone College of Art from 1973 to 1977. Specialising in work with sound and recording processes, his work as a composer and performer has ranged from pop music to gallery installations. In 1979 Cunningham achieved commercial success with The Flying Lizards' record 'Money'. He worked as a record producer from 1982 onwards with Michael Nyman and a range of musical genres from rock groups (This Heat, Owada) to improvisors (David Toop, Steve Beresford). Live work has involved collaboration with John Cage, Kathy Acker, Peter Gordon, Panasonic, Michael Giles, Scanner and others. He has produced music for film and television, and undertaken a series of television collaborations with visual artists including John Latham, David Hall, Stephen Partridge and Bruce McLean. Solo exhibitions include Chisenhale Gallery, London (1994). Group exhibitions in London include Anthony Reynolds Gallery (1994), Mall Gallery (1996) and Three Colt Street (2000). International group shows include Copenhagen (1997) the Biennale of Sydney (1988) and Helsinki (2001). Recent work has included the production and treatment of sound for installation and broadcast artworks by Ian Breakwell, Martin Creed, Susan Hiller, João Penalva, Sam Taylor-Wood, Gillian Wearing and others. Cunningham is currently AHRB Research Fellow in Creative and Performing Arts in the School of Arts and Cultures at the University of Newcastle. He lives and works in London.

A position between
two curves 2003 (no.23)
Amplified space
Courtesy the artist

David Cunningham is perhaps best known as a musician and music producer. As composer, producer or performer he is driven by a strong impulse to collaborate, which is directed in his artwork not only at the musicians or artists he has worked with, but crucially at the audience as well.

It is tempting, if partially misguided, to connect Cunningham's work with the chance operations used in the work of John Cage and the New York Happenings and Fluxus artists of the late 1950s and early 1960s. Cage challenged definitions of artistic authorship and with works like 4'33" 1952 he provided a structure for sounds produced by the audience. George Brecht, one of his students at New York's New School for Social Research in the late 1950s, held the view that music was not just what could be heard or listened to, but was in fact everything else as well. Other members of Cage's class proceeded to further break down the barriers between the idea of audience and performers so that they became one and the same; one didn't listen or watch but instead took part.

For these artists the sounds found in the streets provided material for their presentation of a contemporary urban realism. Cunningham, in contrast, does not appropriate sound in this way but structures often barely audible sounds as a critical practice. There is no metaphorical dimension; his work is a presentation of fact. He relies on isolating sonic or other sensory elements from the conditions of their sources and through subtle framing makes us aware of that which would otherwise be disregarded. This hum that surrounds our lives, by being isolated, is also magnified and the dynamism and effect of everyday actions made clear. Like Brecht and other members of Cage's class at the New School more than forty years ago, Cunningham joins together the work's perception and its production; but where the former conceived their work as fragments of a larger narrative, Cunningham's work functions through the dynamics of the loop or the production of sound waves which articulate conditions of self-referentiality.

The Difference Room, a work proposed by Cunningham for the Tate Triennial but not actually constructed, would have been an apparently empty module in the gallery. An air conditioning unit in the room would have heated the air to a temperature significantly hotter than the air elsewhere in the gallery. Temperature would have been felt by the viewer to be defined spatially as a volume of air markedly different to other volumes throughout the gallery building (or outside it). Similarly, A position between two curves 2003, a work that has been installed in the two alcoves of the Manton Street entrance of Tate Britain, presents the space not as temperature but as a cycling wave of sound that is affected as much by its solid architectural characteristics as it is by the transient nature of the audience's bodies passing through the space and disturbing the air between the two alcoves. This particular work is part of a series titled The Listening Room which Cunningham first presented as an installation at the Chisenhale Gallery in 1994. He has described the mechanics of the work in the following way: 'The installation consists of a microphone connected to a noise gate, amplifier and speakers in a highly reverberant room. The system is arranged in such a way that when the microphone and loudspeaker begin to feed back, the amplitude of the sound causes the noise gate to cut off the signal. The feedback notes resonate through the space accentuated by the long reverberation time of the gallery. As the sound falls below the threshold of the noise gate, the system switches back on and the process continues.'[1]

With this work Cunningham has initiated a structural process, the actual outcome of which he has little control over as people or things cause the air to move and so alter the acoustic space which is being inhabited and framed by the work's operation. The work is not just about listening to space but embodies a critical function that is inherently social; it provides the conditions and equipment for understanding how the sound of an architecturally bounded volume of air can be altered by moving through it. Karl Marx's visionary declaration of modernity seems remarkably apt to the facts embodied by Cunningham's Listening Room: 'All fixed, fast-frozen relations, with their train of ancient and venerable prejudices and opinions, are swept away, all new-formed ones become antiquated before they can ossify. All that is solid melts into air, all that is holy is profaned, and men at last are forced to face … his real conditions of life and his relations with kind.'[2]

There are no objects as such in this work other than changing volumes of air. Something has been set in train and left to fulfil its processes. On the face of it, the appearance of Cunningham's computer monitor work, Colour 0.8 1996 (pp.62–3) refutes this judgement concerning a lack of objects. A randomly occurring series of colour rectangles appears on a group of computer monitors. Each computer runs the same program generating the coloured rectangles, but out of sync with each other. The colours, green, yellow, red, magenta, orange, dark blue and light blue, are basic computer screen colours. Although a connection can be made to similar work such as Tim Head's Tragic Dawn 2002, in which two computer monitors cycle randomly through the over 16.7 million possible screen colours over a three month period, Simon Patterson's Colour Match 1997–2001, in which Pantone colours are matched up with football teams (first as an audio work and then a projection work and a screensaver), or David Batchelor's coloured lightbox sculptures, this is a mistake. Colour 0.8 is not an endurance test like Head's work, or concerned with creating a structural narrative like Patterson's, nor is the material object important as it is for Batchelor. With this work Cunningham attempts a deconstruction of the computer whereby the computer code is both the work and its situational aspect.
Andrew Wilson

Collections
2003–1500

BP Displays at Tate Britain
bp

BRITAIN
TATE

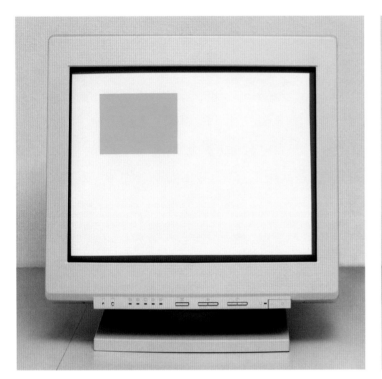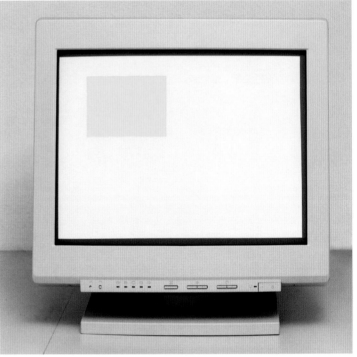

Colour 0.8 1996 (no.22)
Computer program
Courtesy the artist

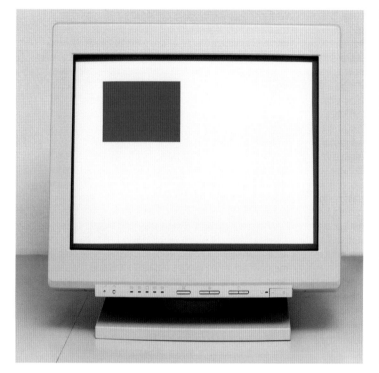

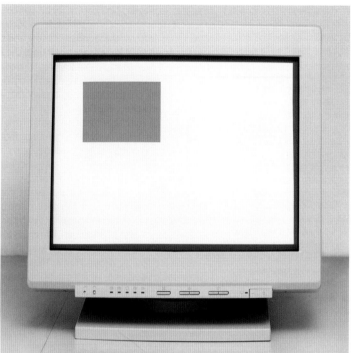

Dexter Dalwood

Dexter Dalwood was born in 1960 in Bristol. He studied at St Martin's School of Art, London, from 1981 to 1985 and the Royal College of Art, London, from 1988 to 1990. Dalwood has had solo exhibitions at Gagosian Gallery, London (2000) and Gagosian Gallery, Los Angeles (2001). He has participated in a number of group exhibitions including *Die Young Stay Pretty*, ICA, London (1998); *Neurotic Realism: Part Two*, Saatchi Gallery, London (1999); *Caught*, 303 Gallery, New York (1999); *Twisted: Urban and Visionary Landscapes in Contemporary Painting*, Stedelijk Van Abbemuseum, Eindhoven (2000); *Remix*, Tate Liverpool (2002) and the Sydney Biennale, *(The World May Be) Fantastic* (2002). In 1999 *Flash Art* commissioned Dalwood to produce a cover for the March-April issue of the magazine, for which he painted *Queen Elizabeth's Bedroom*.

Dexter Dalwood is best known for his paintings of interiors which, through their furnishings, form portraits of personalities from the worlds of culture and politics, much in the way that in Renaissance paintings the saints are identified by their attributes. Figures treated in this way have included rock stars (for example Jimi Hendrix, Ian Curtis and Kurt Cobain), political leaders and revolutionaries (including Mikhail Gorbachev, Che Guevara and Ulrike Meinhof), the philosopher Ludwig Wittgenstein and media figures such as O.J. Simpson. Collectively these paintings make up a group portrait of twentieth-century culture, filtered through a very contemporary interest in personality and, in particular, celebrity in its many and varied forms.

Dalwood's portraits are not achieved through description but rather through allusion, by obscure and unexpected echoes and suggestions created by a witty and sophisticated plundering of art history. These references also create a context for each personality by evoking the period in which the subject lived and found fame. Thus *Brian Jones' Swimming Pool* 2000, which ostensibly depicts the pool in which the former Rolling Stone drowned in 1969, also evokes the cracked façade of the end of the 1960s – the decade of optimism – by using a Clyfford Still painting to represent the flaking plaster of the swimming pool wall. Similarly *Mao-Tse Tung's Study* 2000 calls forth the intense seriousness of two projects from the 1960s – Mao's cultural revolution and American post-painterly abstraction – through the claustrophobia and heaviness of the Frank Stella black abstract painting from which the panelled decor is derived (by way of Antonello da Messina's iconic *St Jerome in his Study* c.1475–6 in the National Gallery).

Dalwood's paintings are realised through a process of research allied to a keen visual imagination. He builds up a mental picture of his subject by reading biographies, histories and memoirs, and then searches for the visual triggers that will evoke a particular personality, period, style or philosophy. He makes a small-scale collage and this is what he paints from, taking care to mimic the varying textures of photographic reproduction and painterly facture and leaving the joins clearly apparent. He is essentially building on the language of Postmodernism (the magpie aesthetic of painters such as David Salle) but with a stronger emphasis on *subject*. He creates a space which is convincing enough to draw us in, but not so convincing as to hide the sources and manner of its construction.

Recently Dalwood's work has begun to move in a new direction. While an important part of his earlier work was the recreation of time and place, this was intended to render character or personality. Now Dalwood has applied the same principles to summon forth the atmosphere and implications of particular historic events. His new work might be characterised as contemporary history painting.

The paintings in *Days Like These* exemplify this approach. *Nixon's Departure* 2001 depicts the moment when, the day after his resignation on 8 August 1974, Richard Nixon left the White House. The image is constructed from photographs of the White House and two late works by Picasso, *Seated Nude* 1971 and *Landscape* 1972, which were painted just before the events described.[1] Dalwood's large painting, which copies the disjointed effects of his original small-scale collage, depicts a White House that is cracked open, situated within a dark and turbulent landscape comprised of vigorous brushstrokes. It is a powerful metaphor for the corruption and disgrace that were rending American politics at the time.

Dalwood is interested in chronology and how specific events and people often seem to exist in separate times. The bringing together of Picasso and Richard Nixon, for instance, is surprising. The notion that 'Picasso was alive when Nixon was in office and could have watched the Vietnam War on TV' – yet in the early 1970s was making luxurious nudes and landscapes such as the two that Dalwood has drawn imagery from – is perhaps more so.[2] Dalwood is not concerned with accurate historical conjunctions but with the feelings and memories that the images evoke. To this end the dates are 'loose'. Picasso had actually been dead for two years by the time Nixon resigned, but Dalwood still felt that the dates of the last paintings were close enough to Nixon's departure to create a surprising and revealing juxtaposition.

Ceaucescu's Execution 2002 (p.66) also brings together seemingly disparate worlds. The starting point for this extraordinary painting was Francisco Goya's *The Shootings of May Third 1808* 1814 in the Prado (Dalwood's painting has exactly the same dimensions as Goya's masterpiece). However, the main visual component of the painting is Georg Baselitz's *Der Krug (The Pitcher)*, painted 25–28 May 1989, just months before the execution on live television on Christmas Day, 1989, of the President of Romania, Nicolae Ceaucescu, and his wife Elena. Of these bloody events though, we see only a setting. The violence will happen, or has happened, only in the mind's eye. Whereas previously Dalwood would marshal a wider range of visual material into a single image – for example, in *Mary Shelley, Frankenstein* 2001 – here he has restricted the number of sources, displaying a greater confidence that the visual triggers are the right ones. The expressionistic smears of blood-red paint, the desolation of the setting and the title are all the information we are given.

Ceaucescu's Execution is a powerful statement because it succeeds in delivering an emotional charge appropriate to its subject matter. It is a supremely bleak image. Crucially it gives us the space needed for our own imagining of the events it represents. Dalwood has declared his interest in analogy, in 'painting that depicts something that isn't the thing depicted'. With these new works he has found a way to use painting to evoke the seismic events of the last century without having to weaken his imagery by depicting *actual* people and *actual* events. What Dalwood presents us with is evocation rather than description. His version of history is accessed via the imagination.

Ben Tufnell

Nixon's Departure 2001 (no.24)
Oil on canvas
257 × 231 (101 1/8 × 90 7/8)
Courtesy Gagosian Gallery

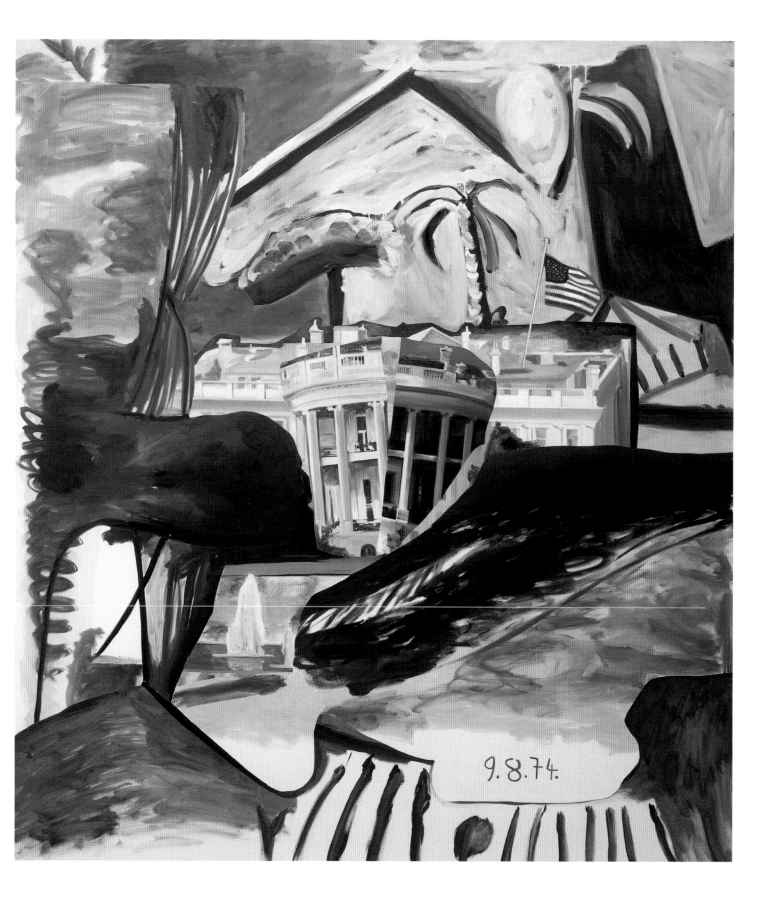

9.8.74.

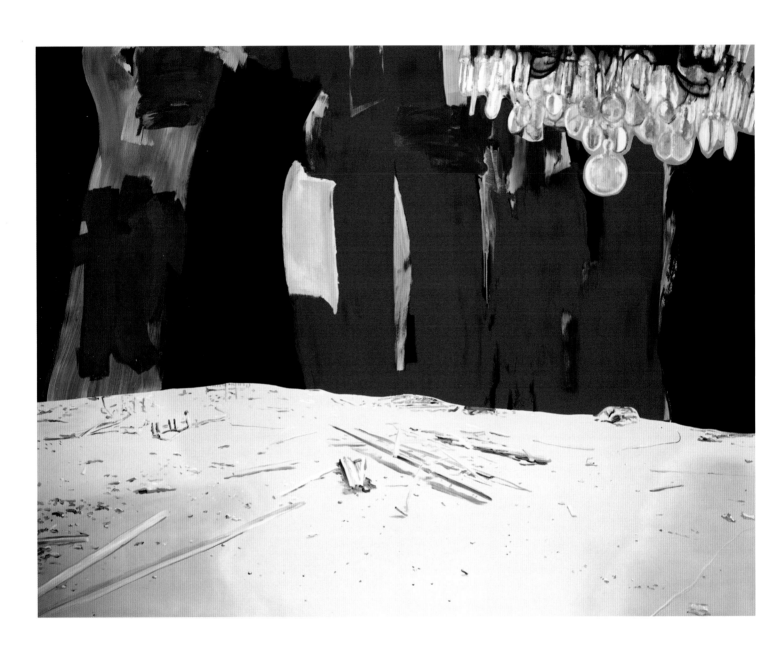

Ceaucescu's Execution 2002
(no.25)
Oil on canvas
268 × 347.5 (105 ¹/₂ × 136 ⁷/₈)
Courtesy Gagosian Gallery

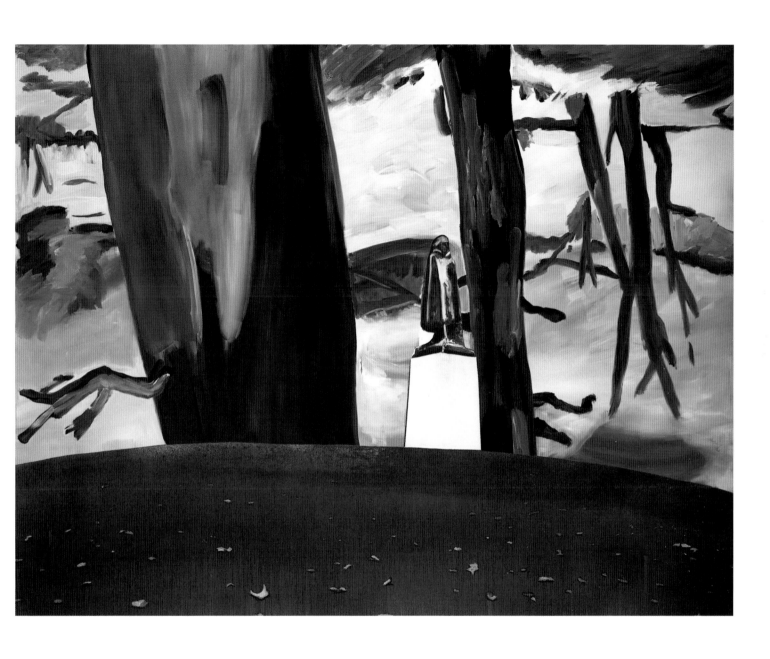

Grosvenor Square 2002
(no.26)
Oil on canvas
268 × 347 (105 ¹/₂ × 136 ⁵/₈)
Courtesy Gagosian Gallery

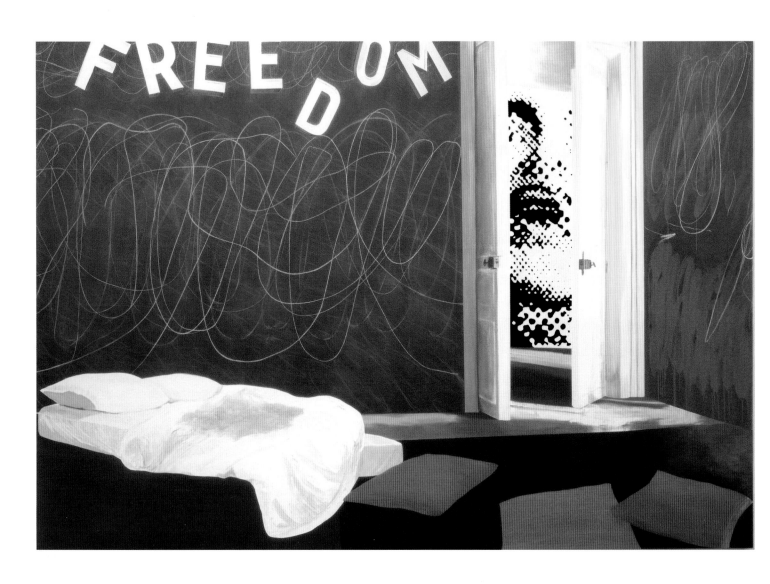

Situationist Apartment May '68
2001
Acrylic and oil on canvas
246 × 355 (96 7/8 × 139 3/4)
Tate. Purchased 2002

Brian Jones' Swimming Pool
2000
Oil on canvas
275 × 219 (108 1/4 × 86 1/4)
Courtesy Gagosian Gallery

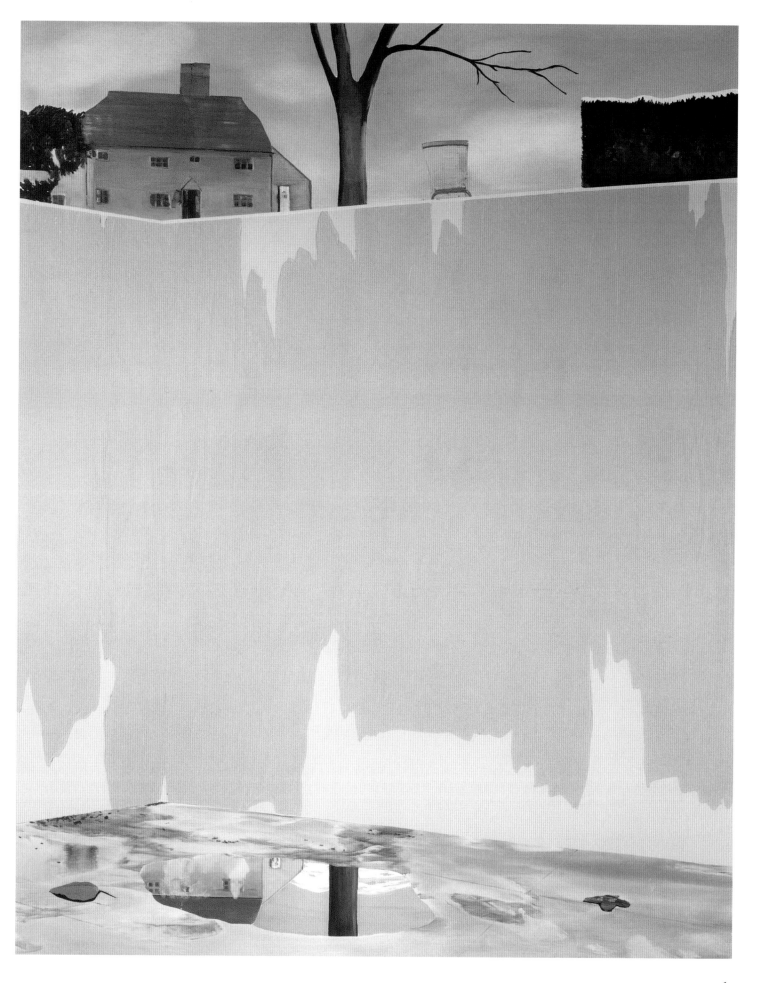

Ian Davenport

Ian Davenport was born in 1966 in Kent. He studied at Northwich College of Art and Design, Cheshire, from 1984 to 1985 and Goldsmiths College of Art, London, from 1985 to 1988. He was nominated for the Turner Prize in 1991 and was a Prize winner in the 21st John Moores Liverpool Exhibition in 1999 and the Primo del Golfo, La Spezia, Italy, in 2000. He was short-listed for the Jerwood Painting Prize in 2001. Davenport has had a number of solo exhibitions including Waddington Galleries, London (1990, 1993, 1996, 2000); Galerie Xippas, Paris (1998 and 2001); Dundee Contemporary Arts (1999) and Project Space, Tate Liverpool (2000). He has taken part in group exhibitions including *Freeze*, London (1988); *The British Art Show*, McLellan Galleries, Glasgow and touring (1990); *Real Art – A New Modernism: British Reflexive Painters in the 1990s*, Southampton City Art Gallery and touring (1995–6); *Nuevas Abstracciones*, Palacio de Velasquez, Museo Nacional Centro de Arte Reina Sofía, Madrid, and touring (1996); *About Vision: New British Painting in the 1990s*, MoMA, Oxford, and touring (1996–8); *Treasure Island*, Fundação Calouste Gulbenkian, Lisbon (1997); and *Examining Pictures*, Whitechapel Art Gallery, London, and touring (1999).

Untitled Poured Lines (Studio) 2002 (detail)
Household emulsion
Courtesy Waddington Galleries, London

Untitled Poured Lines (Tate Britain) 2003 is the largest work Ian Davenport has made to date and represents a significant development in his practice. The artist has increasingly conceived his exhibitions in architectural terms – as a totality within a space rather than as a succession of single paintings – but his new wall paintings are the first works which engage directly with the architecture of the gallery. They are also Davenport's first works using only matt surfaces. The seemingly perfect, highly reflective surfaces of his recent *Poured Paintings* can be seen as resistant and impersonal. In contrast *Untitled Poured Lines (Tate Britain)* has a more open character. It invites closer inspection.

Using a syringe, Davenport pours paint down the wall from its top edge. Running from top to bottom, the thin lines of paint may be diverted by inconsistencies on the surface of the wall. Some lines may run more smoothly and evenly than others according to the viscosity of the paint, some may run together: thus a series of unexpected and unpredictable incidents are introduced into the painting, in contrast to its defining structure. As Davenport moves across the wall from right to left spacing the lines, he works intuitively with the colours, making progressive adjustments; he does not go back over what he has already done. He uses only a single layer of paint, albeit a single layer that, through its changing colours, has a shimmering complexity and gives the impression of many layers receding and advancing.

The intricacy of the work arises not just from the character of the lines but also from way in which Davenport deploys his palette of over two hundred colours. The combination of pale pastels with more intense colours gives the wall of paint a chromatic intensity and reinforces the illusion of space. While Davenport's early paintings were dominated by muted greys and drabs, colour has come to occupy an increasingly important role in his work. Davenport's initial choice of such a muted palette was motivated in part by a desire to emphasise the seriousness of his endeavour and pre-empt any accusations of 'decorativeness', as well as to focus attention on the material qualities of the house paints and varnishes he was using. In this new work, colour is given a free rein, yet the pooling at the base of the wall still reminds us that fundamentally colour is matter: paint.

Increasingly, texts about Davenport's painting have questioned the extent to which it can be said to reference contemporary urban life. A number of readings of his work stress the everyday D.I.Y. materials and the smooth 'surface beauty of industrial production' he achieves.[1] At the outset Davenport was keen to distance himself from such readings, emphasising the abstract qualities of his work: 'One of the biggest problems I have is to get to where ... there are no real-life associations at all.'[2] Now he is happy to concede such references. He has spoken of different colour combinations being inspired by, variously, a commercial delivery van, and cartoons such as *The Simpsons*. *Untitled Poured Lines (Tate Britain)* is inspired, in part, by aspects of the décor of a local kebab shop. These references are implicit in the work, yet bright decorative colour and seductive surface can also function as invitations; to look closer and discover how the painting has been made, how the paint has been applied, what kind of paint it is; and it is this aspect which is crucial for Davenport.

This approach to painting, in which the creative process is foregrounded in the finished work, has been a fundamental precept of Davenport's work since the late 1980s. Characteristically working in series, he creates a set of conditions which predetermine the appearance of the paintings, yet which allow a potentially wide range of variation. What he does is very simple – as he himself puts it, 'I always try to do very little but a lot of it' – yet the results are complex and beautiful.[3]

Davenport's first abstracts grew out of a series of paintings of paint pots made in 1988. While making these works, loading his brush from the can at his feet before raising it to make contact with the canvas and leaving a trail of dripped paint as a trace of his gesture, Davenport realised that the process of what he was doing was more interesting than the image he was making. Or rather, that the aspect of the image that interested him was that derived from the process; namely, the irregular skeins and trails of paint that had run from the brush in the process of lifting it to the canvas.

In his first solo exhibition in 1990 Davenport showed two types of work. In the first group the image was created by the rhythmic movement of loaded brush from the paint can to the top of the canvas, and the resulting drips and runs of paint. The second group was made by pouring paint directly from a container onto the canvas and letting it run. In these paintings Davenport dictates the shape of the pour and the character of the work through his physical movements – the pouring of the paint and then his subsequent manoeuvring of the canvas – but the final image is still determined by unpredictable factors: the condition of the surface and the exact viscosity of the paint, and the interaction of these factors with gravity. These two modes, the drip and the pour, have remained the essential components of Davenport's work ever since.

Indeed, much of what Davenport said in his first published statement about his work still holds true today, in particular his insistence on 'chance within a highly structured system'.[4] Fundamentally, a consistency of approach to the making of paintings can be seen from the earliest dripped paintings to the new work. Chance – and his attempts to control or direct it, and the subsequent surprises it can offer – remains at the heart of his work. *Untitled Poured Lines (Tate Britain)* extends Davenport's vocabulary, yet remains true to a distinctive abstract aesthetic, rooted in contemporary life.
Ben Tufnell

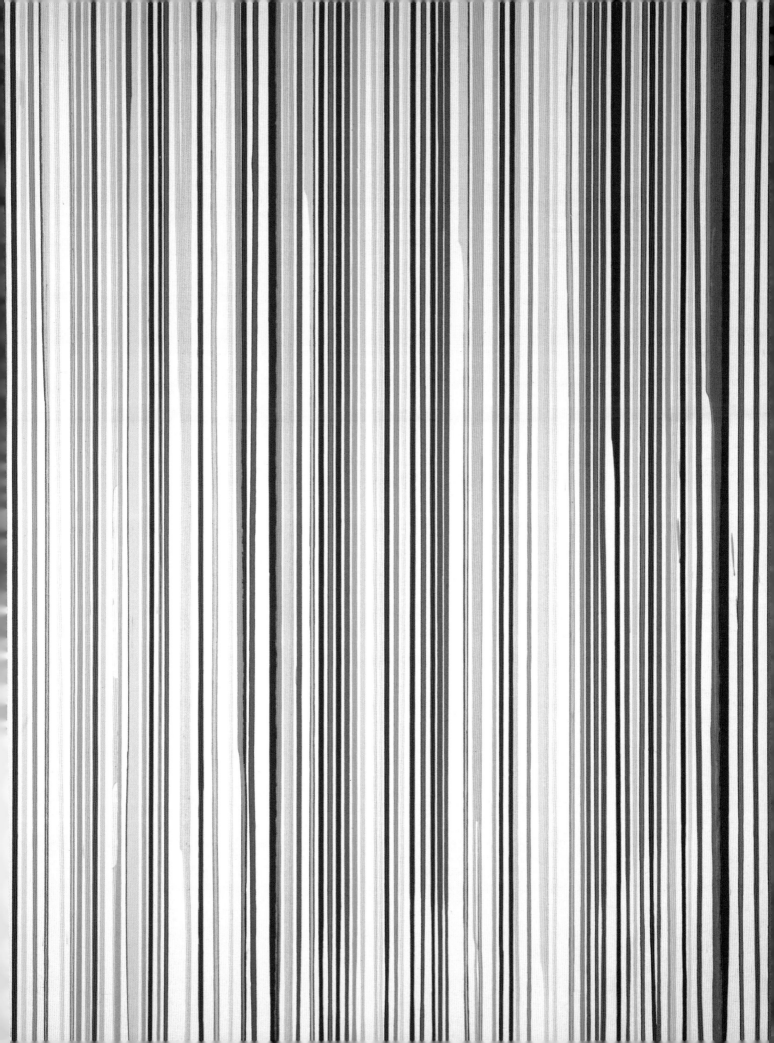

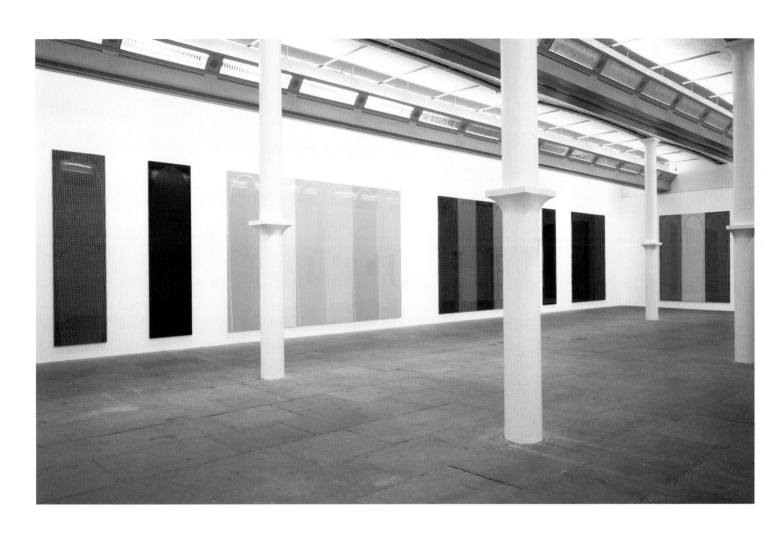

Installation at Tate
Liverpool Project Space
2000–1
Courtesy Waddington
Galleries, London

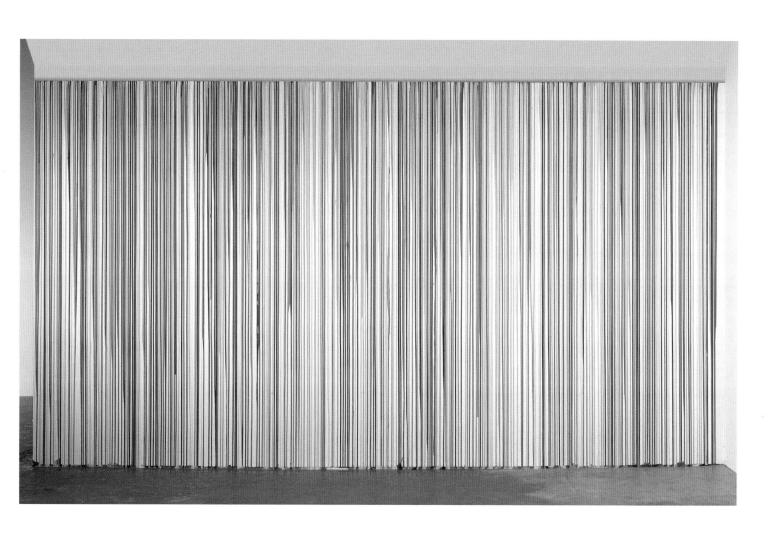

Poured Lines 2002
Household emulsion
318 × 594 (125 $^{1}/_{4}$ × 233 $^{7}/_{8}$)
Installation at Essor Gallery Project Space, London
Courtesy Waddington Galleries, London

Richard Deacon

Richard Deacon was born in Bangor, Wales, in 1949. He studied at Somerset College of Art, Taunton, in 1968 and then attended St Martin's School of Art in London from 1969 to 1972. From 1974 to 1977 he studied for an MA in Environmental Media at the Royal College of Art and then subsequently pursued part-time studies in art history at Chelsea School of Art. In 1981 he participated in the seminal exhibition *Objects and Sculpture* at the ICA, London, and his first solo show with the Lisson Gallery, with whom he continues to exhibit, was in 1983. The same year his work was included in two major exhibitions of British sculpture: *The Sculpture Show* at the Hayward Gallery and Serpentine Gallery, London, and *Transformations: New British Sculpture from Britain, XVII Bienal de São Paulo*, organised by The British Council. Since then he has been the subject of major solo exhibitions at Whitechapel Art Gallery (1988); Kunstverein, Hanover (1993); and *New World Order*, Tate Liverpool (1999), among others. He has also participated in international survey exhibitions, such as the Carnegie International, Pittsburgh (1985 and 1991), Documenta IX in Kassel (1992) and Sculpture Projects, Munster (1987 and 1997). In 1987 he was awarded the Turner Prize. He was appointed Chelvalier de l'Order des Arts et des Lettres in 1998 and honoured with a CBE in 1999. He is a member of the Royal Academy.

Richard Deacon is acknowledged as a leading figure among the British sculptors whose work first achieved international acclaim in the 1980s. As a student at St Martin's School of Art between 1969 and 1972, Deacon concentrated on performance based work, for example, *Stuff Box Object* 1971–2, an experimental piece documented with text and photographs. Starting as a plan to make a material and realised over a period of months, it consisted of a series of actions and tasks. These included the artist climbing into a wooden box, experiencing the interior space, climbing out and then working with plaster on the exterior to produce a process-based sculptural work. During his time studying on the MA Environmental Media Course at the Royal College of Art (1974–7), Deacon became interested in the theories and writing of William Tucker and Donald Judd. Both artists, albeit in different ways, sought to question the nature of sculpture. As a result, Deacon moved away from ephemeral work and began to make objects which explore relationships between the literal and the metaphoric, issues which continue to influence his practice today.

In the early sculptures, form is often described not by its shape but by its boundary or edge. It is the interface between interior and exterior that is important, the divide between surface and edge, form and image, the real and imagined. The work brings to mind the material world of everyday objects while the titles encourage a more metaphorical interpretation. His use of vernacular titles such as *This, That and the Other* 1985 and *Struck Dumb* 1988 (p.77) help to reinforce visual and verbal connections. As such, Deacon's sculptures are rendered spatially as a dense network of related features. In a work such as *Double Talk* 1987, these different elements are brought into being. The sculpture's contour lines, while charting the terrain between space and structure, also emphasise the discrepancy between different viewpoints. Neither figurative nor abstract, the form takes on associations relating to apertures and organs. The shaped laminated wood conjures up images of a mouth, tongue and speech bubble. The title alludes to the dual capacity of language, both spoken and written, and to the expression 'double dutch', which describes nonsensical speech or writing.

If the contours of *Double Talk* describe an open shape in space, large wooden works of the mid 1990s, for example *Laocoon* 1996 and *After* 1998 (p.77) articulate the dialectic of inside and outside in a new way. These works highlight the artist's desire to create an object which somehow balances volume and space. He has described this attempt as 'knitting', to give shape and structure to something that was more whole than solid, 'more weave than basket'.[1] With hindsight this interest can be traced back to an essay Deacon wrote in 1977 on a painting by Poussin, *Landscape with a Man killed by a Snake* 1648, in which he explored compositional issues relating to depth, surface and structure and the relationship between representation and the experience of spatial illusion.[2] This curiosity with looking at how imagery can help explain spatial concerns is further probed by his collages of photographs and ink on paper drawings.[3] For example, the series of prints *Show and Tell* 1997 investigate the idea of deep and shallow space within two dimensions.

Working both on a domestic and monumental scale Deacon deliberately employs ordinary materials which are skilfully manipulated into shape, often combining wood, cloth, aluminium and rivets in a single work. This fresh approach to materials has extended to graphic works, for example *The Interior is Always more Difficult A–F* 1991, a series of drawings embedded in plastic sheets, as well as his use of asphalt and gravel in *Where is Man and Where is Death?* 2001, a work realised for P.S.1's outdoor galleries. More recently his interest in 'material diversity', and dissatisfaction with materials commonly associated with outdoor works, has led him to use the workshop of Niels Dietrich in Cologne to produce experimental new works in ceramics. Challenging assumptions about material, structure, function and place, these highly finished hand-built sculptures offer no clue as to their means of fabrication, but rather have the appearance of idealised forms. As the artist explains, 'All of them basically begin with a small lump which is pushed, pulled, squeezed, twisted, rolled, poked, carved, etc ... The resulting sculptures are very much unitary objects, although not lumps, and I find the question of their identity compelling. The contrast between this unity and the very open structure that recent wooden pieces have had has been particularly important.'[4]

Throughout his career Deacon has placed importance on language itself. This interest is deep-rooted and stems in part from his reading of poetic, philosophical and linguistic texts. For example, the series of drawings collectively titled *It's Orpheus When There's Singing* 1978–9 is based upon his readings of the Austrian poet Rainer Maria Rilke's *Sonnets to Orpheus* (1922). He has explored the different idioms of object making, the written word, performance and the conjunction of these with his set designs for the Ballet Rambert (1987) and Factory, a dance production choreographed by Hervé Robbe (1993–5). He has also regularly collaborated with other artists and performers and has published a number of texts including 'In Praise of Television' (1997), an essay on the nature of representation. An early work, *Between the Two of Us* 1984, reflects Deacon's conviction that form can be extrapolated from a single line of narrative text. It is this tension between the visual and the linguistic that is so characteristic of Deacon's work. His belief that 'sculpture mediates and models a notion of what the world is like' owes as much to sculpture's embodiment in language as to its physical identity.[5] As the title of the work suggests, language is always 'between us', the defining boundary between individuals, yet the common ground of communication.

Clarrie Wallis

Tomorrow, tomorrow, tomorrow B 1999 (no.28)
Ceramic
161 × 110 × 72
(63 1/4 × 43 1/4 × 28 1/4)
Courtesy Lisson Gallery

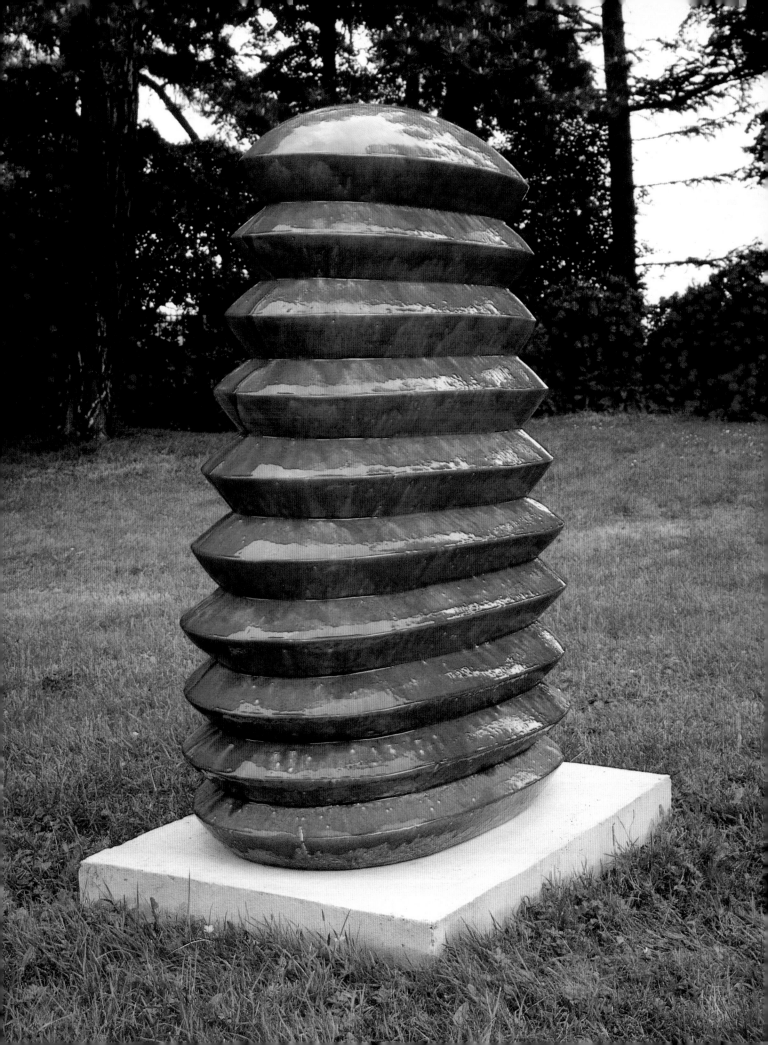

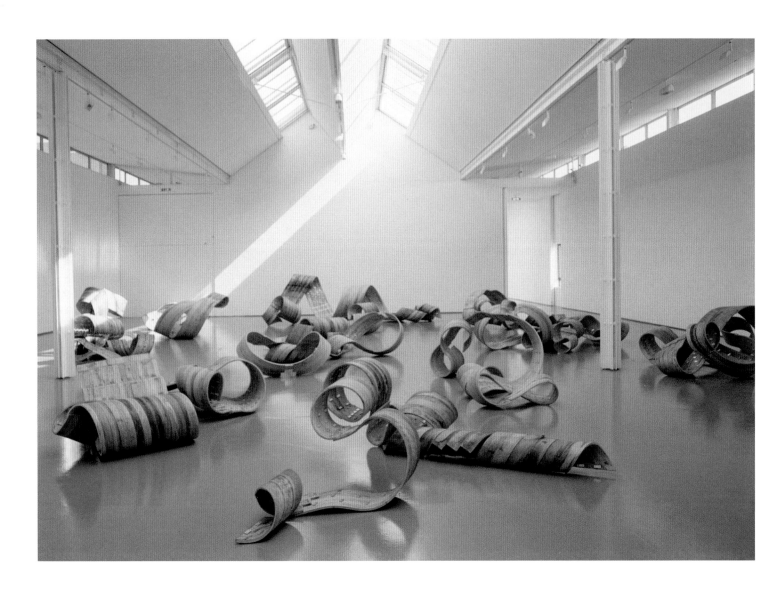

UW84DC 2001
Ash and aluminium
Dimensions variable
Courtesy Lisson Gallery
Installation at Dundee
Contemporary Arts, 2001

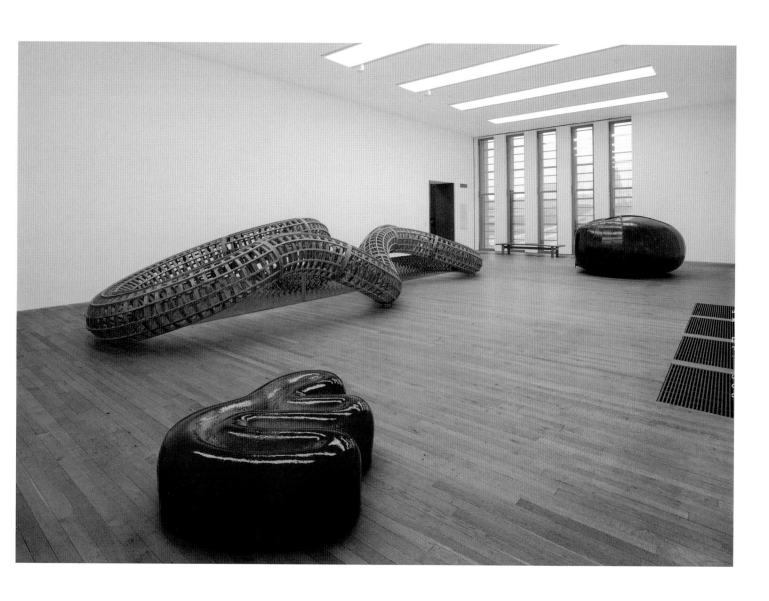

Clockwise from front:
*Tomorrow and Tomorrow
and Tomorrow (K)* 2001, *After* 1998
and *Struck Dumb* 1988
Installation at Tate Modern, 2002
Courtesy Tate and Marian
Goodman Gallery, New York

Overleaf:
Installation at Gutspark Böckel,
Germany, 2002

Peter Doig

Peter Doig was born 1959 in Edinburgh. He moved with his family to Trinidad in 1960 and then to Canada in 1966. In 1979 Doig moved to London and studied at Wimbledon School of Art from 1979 to 1980 and St Martin's School of Art from 1980 to 1983. In 1987 he returned to Canada to live in Montreal. He returned to London in 1989 and studied at Chelsea School of Art (1989–90). In 1991 he was awarded the Whitechapel Artists Award, and in 1993 won first prize in the 18th John Moores Exhibition. In 1994 he was awarded first prize (jointly with Herbert Brandl) in the Prix Eliette von Karajan, Salzburg, and was shortlisted for the Turner Prize. He was Trustee of the Tate Gallery 1995–2000. Doig has had many solo exhibitions including *Blizzard seventy-seven*, Kunsthalle, Kiel and touring (1998); *Echo Lake*, Matrix, University of California and touring (2000); Morris and Helen Belkin Art Gallery, Vancouver and touring (2001–2); and a retrospective at the Bonnefantenmuseum, Maastricht (2003). He has taken part in a number of group shows including *Twisted: Urban and Visionary Landscapes in Contemporary Painting*, Stedelijk Van Abbemuseum, Eindhoven (2000); and *Dear Painter...*, *Painting the Figure since late Picabia*, Centre Pompidou, Paris and touring (2002–3).

A man sits alone in a canoe, rudderless, drifting on a vast expanse of blue water. His haunted face looks out at us, but his expression is unclear and he is only just something more substantial than the paint which stains the canvas: faint, dissolving, like a ghost. Is this a painting of a predicament or an idyll? For all the lightness of the paint and the slightness of the image, the atmosphere is oppressive. The sky is a strange bruised pink, suggesting a dirty storm-laden sunset in the tropics. On the horizon is an island. Is the figure coming from or on his way to the island? Like all of Peter Doig's paintings, *100 Years Ago* 2000 (pp.82–3) presents us with an image that entices at the same time as it resists understanding. Doig's unusual imagery, hallucinatory colours and allusive titles seem to offer the revelation of excavated experience or recovered memory. Yet while his paintings offer us myriad narrative possibilities, they remain equivocal, enigmatic and evocative.

Doig has been a central figure in the British art world for the last ten years, and can be said to have carried a banner for a particular kind of committed, serious and, crucially, *sincere* figurative painting. His has been an important example for a younger generation (including Chris Ofili, George Shaw and Gillian Carnegie, all of whom were taught by him at the Royal College of Art).

Doig characteristically paints landscapes. His paintings sometimes depict actual places or autobiographical events, but more usually they represent a very personal combination of elements drawn from a number of sources, combined in such a way as to stimulate a memory or a sensation associated with a particular place or time. The artist takes a photographic image as a starting point – either taken by himself or friends, or drawn from holiday brochures, magazines, newspapers or record covers – and subjects it to a process of alteration: painting onto it, photocopying it, re-photocopying it, distressing it, re-photographing it, collaging it together with other images. At some point the image reaches a point where it seems to offer a new meaning and Doig can begin to paint. That the image is turned into something completely new, and paradoxically perhaps more real and more evocative than the original source is the crux of Doig's work. As Johanne Sloan has pointed out: 'It is known that *Ski Jacket*, like most of Doig's paintings, is based on a photograph, but this knowledge doesn't do much to explain the painting's alluring evocation of nature.'[1]

In recent years Doig's technique has developed still further. Whereas earlier works, such as *Cabin Essence* 1993–4 or *Ski Jacket* 1994 (p.84), were heavily worked, the imagery veiled by whorls and globs of clotted paint which represented snow or created the impression of visual interference or static (perhaps interpreted as reproducing the sensation of memory or, possibly, forgetfulness), the recent works are painted in thinner washes. Whereas the thickly encrusted surface of the

earlier work served to counter the illusory quality of the image, the same is achieved now through the drips, tide marks and stains which reveal the liquid quality of the paint and the weave of the canvas support. At the same time the images have been emptied. 'Increasingly I am leaving more out of the paintings, I am trying – at least in some of the paintings – to use "less" material, to represent the same sensations that "more" did in the past. I'm trying to simplify both the content and the use of the material.'[2] The version of *100 Years Ago* in *Days Like These* exemplifies this new approach.[3]

The title of this work 'refers back to paintings made around that time', such as post-impressionist works by Paul Gauguin and Pierre Bonnard.[4] The weird colours and the extreme flatness of the picture recall in particular Gauguin's anti-naturalistic *cloisonnisme*. The bright orange canoe spans the canvas from edge to edge and the painting is effectively cut into four horizontal bands of colour – blue, orange, blue, pink – which bind the image to the picture plane and again reinforce the painted nature of the image. While the work references older paintings it also alludes to a more recent counter-culture, and offers another kind of relationship with the past. 'It's a painting of a kind of hippy ... someone who seems burnt out. And in a way it seems almost a hundred years since the early 1970s – the idealism is so lost!'[5]

The figure in a canoe in *100 Years Ago* is derived from a photograph of the Allman Brothers Band from the inside sleeve of *Duane Allman: An Anthology* (1972). In the original the band sits in a row in what appears to be an extraordinarily elongated canoe. They all paddle except for Berry Oakley, the bassist, who sits second from the front of the canoe and stares out of the image. Doig has isolated Oakley and then collaged both figure and canoe onto a photograph of Carrera, the prison island off the north-east coast of Trinidad, to create his composition. This information provides us with another reading of the resulting painting; in particular the knowledge that the island is a prison introduces notions of flight and escape.

However, it doesn't bring us any closer to understanding Doig's painting, which in its finished state is far removed from its original sources. Doig presents us with a classic paradox – a painting that invites narrative interpretation but which resists that same impulse. Berry Oakley (or the figure who once was Berry Oakley) is quite literally trapped in a kind of limbo, halfway between Carrera and the present. His condition seems indicative of a state of mind that evades elucidation; it mirrors the state of Doig's painting. As the artist has said, 'you can ask what the paintings are about but I can't really tell you. They're really just ciphers for your own imagination.'[6]

Ben Tufnell

Driftwood
2001–2
Oil on canvas
330 × 200 (129 7/8 × 78 3/4)
Courtesy the artist and
Victoria Miro Gallery, London

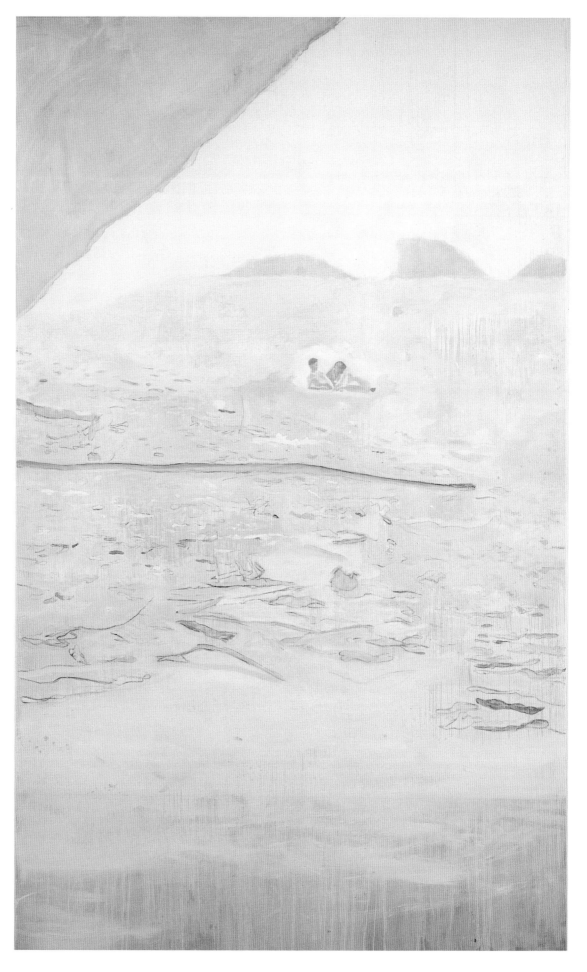

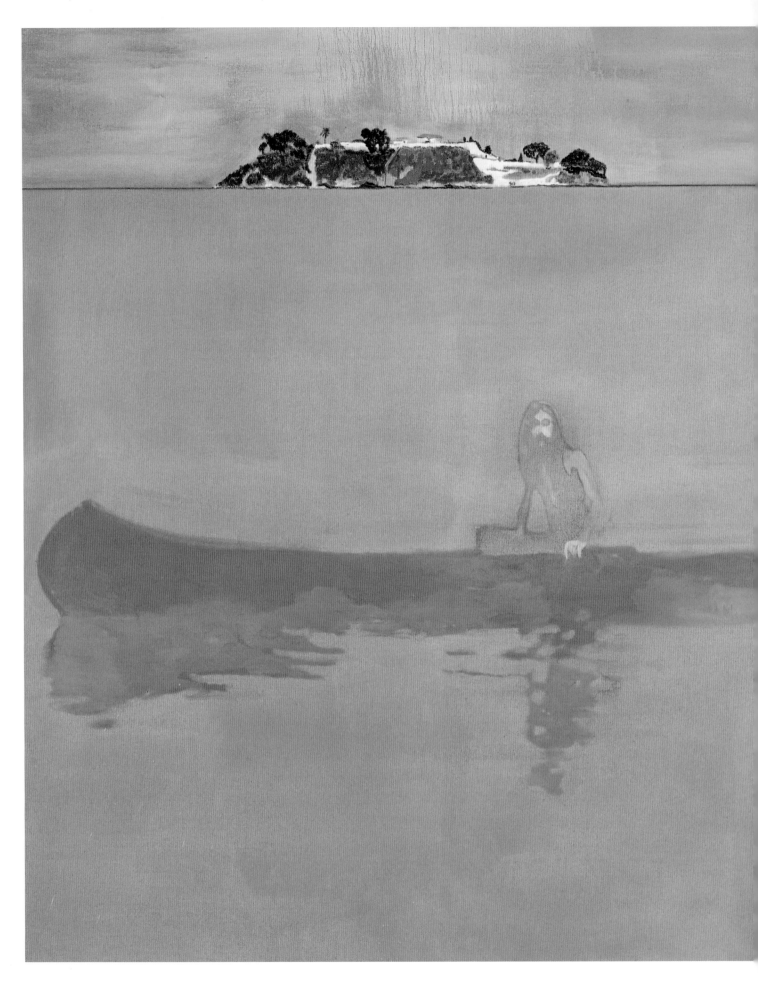

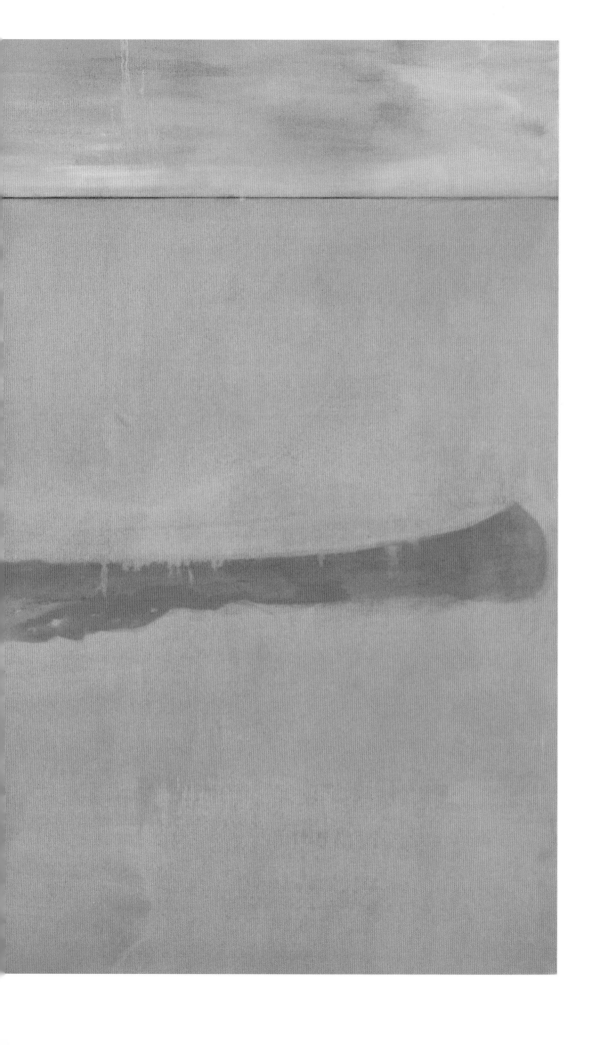

100 Years Ago 2000 (no.32)
Oil on canvas
200 × 295.5 (78 3/4 × 116 3/8)
Collection of Beth Swofford,
Los Angeles

Ski Jacket 1994
Oil on canvas
295 × 350 (116 1/8 × 137 3/4)
Tate. Purchased with assistance
from Evelyn, Lady Downshire's
Trust Fund 1995

Gasthof zur Muldentalsperr
2001–2
Oil on canvas
196 × 296 (77 1/8 × 116 1/2)
Courtesy the artist and
Victoria Miro Gallery, London

Ceal Floyer

Ceal Floyer was born in 1968 in Karachi, Pakistan and currently lives and works in Stockholm and Berlin. She studied at Goldsmiths College of Art, London from 1991 to 1994. Floyer has exhibited in numerous solo shows, including the CCA, Berkeley, and the Künstlerhaus Bethanian, Berlin (1998) after being awarded the Philip Morris Scholarship in 1997. Recent exhibitions include the Ikon Gallery, Birmingham (2001) and Index, Swedish Centre for Contemporary Art, Stockholm (2002). She has also shown in a number of international group exhibitions including the 4th Istanbul Biennale, Turkey (1995), *Life/Live*, Musée d'Art Moderne de la Ville de Paris (1996-7), *Dimensions Variable*, British Council touring exhibition (1998), *Crossroads; Artists in Berlin*, Communidad de Madrid (2000), and *City Racing 1988–1998*, ICA, London (2001).

Why make a light switch or light bulb, a garbage bag or bucket the object of art? Why draw attention to objects in a gallery which would otherwise be left unnoticed? Ceal Floyer's work points out the obvious, proving the existence of what undoubtedly exists. She selects mundane objects, familiar emotions, everyday sounds and phrases and enigmatically transforms them with a sharp wit. Her work examines the processes of art – its making, viewing and deciphering – and consequently challenges ideas of representation and distinctions between 'art' and 'non-art'.

Floyer is acutely conscious of the significance of context in the reception of a work of art. Following in the footsteps of Duchamp's unassisted readymades, Floyer's work sometimes startles simply because it is seen in an art context where the presentation of mundane objects undermines idealist aesthetics. Such strategic use of ordinary things reveals how it is the physical, cultural and social context of a gallery that may confer the status of 'art' upon whatever is shown within it. Instead of immutable essence, art is shown as process: economic, physical, intellectual. Some of Floyer's titles make this explicit: *Sold* 1996, *Work in Progress* 1999, *Ink on Paper* 2002. *Light* 1994, illustrates the significance of the relationship between Floyer's work and the gallery. At first *Light*, as an artwork, seems strangely absent. We are asked to view what appears to be a functioning naked light bulb dangling from the ceiling. However, after further observation, it becomes apparent that there is no light emanating from the bulb, only light being shone onto it. The impersonation of an object or event is a strategy that recurs throughout Floyer's oeuvre. *Light* is not intended to be an illusion – all the elements of its construction are placed before the viewer – but an exposure of the 'tension between the cause and effect of representation'.[1]

Floyer's transformation of ordinary, existing objects into artworks emerges from a history of conceptual art practices – practices that philosopher Peter Osborne argues are 'about the cultural act of definition – paradigmatically, but by no means exclusively the definition of "art"'.[2] In 1969 Joseph Kosuth stated in his seminal essay, 'Art after Philosophy', that, 'All art (after Duchamp) is conceptual (in nature) because art only exists conceptually.'[3] He argued the importance of autonomy as a condition of art and that 'the "art idea" (or "work") and art are the same and can be appreciated as art without going outside the context of art for verification'.[4] The 'idea' is central to Floyer's work – she believes that 'art is just a manifestation, a Trojan Horse for ideas'.[5] What is *Garbage Bag* 1996, but a hold-all of ideas about the potential of art?

Humour is a defining factor of Floyer's work. Hers is a dry wit, acerbic in its intelligence. Like a good joke, the beauty of Floyer's work lies in timing. *Bucket* 1999 (p.89), momentarily fools us into believing that there is a leak dripping from the ceiling. However, trailing from the bucket is an electrical wire plugged into a nearby socket with the other end connected to a portable CD-player which emits the sound like a drop of liquid hitting an empty plastic bucket. The reproduction of the sound is convincing enough to force us to do a double take. Yet the sound is always the same, as if it is the first drop in the bucket.

In *Blind* 1997, a video work presented on a single monitor, for a long time nothing happens: the screen is a white monochrome, a void. The instinctual belief that something will happen holds our attention. Eventually the white haze is sucked back by a gust of wind into a window, outlining the window frame and revealing the blind. It is a beautiful revelation, an effortless flit from abstraction to figuration.

The first impression of *Monochrome Till Receipt (White)* 1999 is that it is neither purely white, nor simply a supermarket receipt from a local shop. However, on reading the shopping list it becomes clear that the 'white' refers to the items purchased: natural yoghurt, tampons, cotton wool, mint tic-tacs, mozzarella. This work is at once a contemporary still life (by proxi) and a homage to the genre of monochrome painting. It is a humorous play on artistic traditions and an ironic take on the precious aesthetic of high modernist painting.

Until recently, Floyer's practice has resisted autobiographical, emotional or narrative readings. However, *Nail Biting Performance* 2001 represents a departure in which the artist becomes the focus of the work. Despite the associations introduced by the title of daredevil feats – trapeze artists, knife throwers, lion tamers – this is literally a performance of nail biting. It took place at an established venue just before the programmed concert commenced. It featured the artist standing on an empty stage, surrounded by orchestral equipment, biting her nails into a microphone. She was making visible the off-stage pre-performance jitters of a member of the orchestra and thus personified the 'blind spot between events'.[6] It was an excruciating four minutes of nervousness made manifest. The performance re-affirmed a central theme in Floyer's work: looking at the overlooked.

Floyer has commented, 'there's something almost Sisyphean in my attempts to prove that something is really there, when there was no question about it in the first place. It's like mentioning the obvious but in a different tone of voice.'[7] The inherent simplicity of this is made apparent by the reduction of her ideas to a bare minimum as well as the Minimalist aesthetic used to manifest them. Floyer's work raises fundamental questions about the nature of cultural signification, the power of representation, and the fragile boundaries between 'art' and 'non-art'. Duchamp once remarked that one can look at seeing; Floyer achieves precisely this. Her work demands close attention and studied engagement, and asks that we think carefully about art's potential to transform the most banal of things.
Louise Hayward

Nail Biting Performance
7 February 2001,
Symphony Hall,
Birmingham

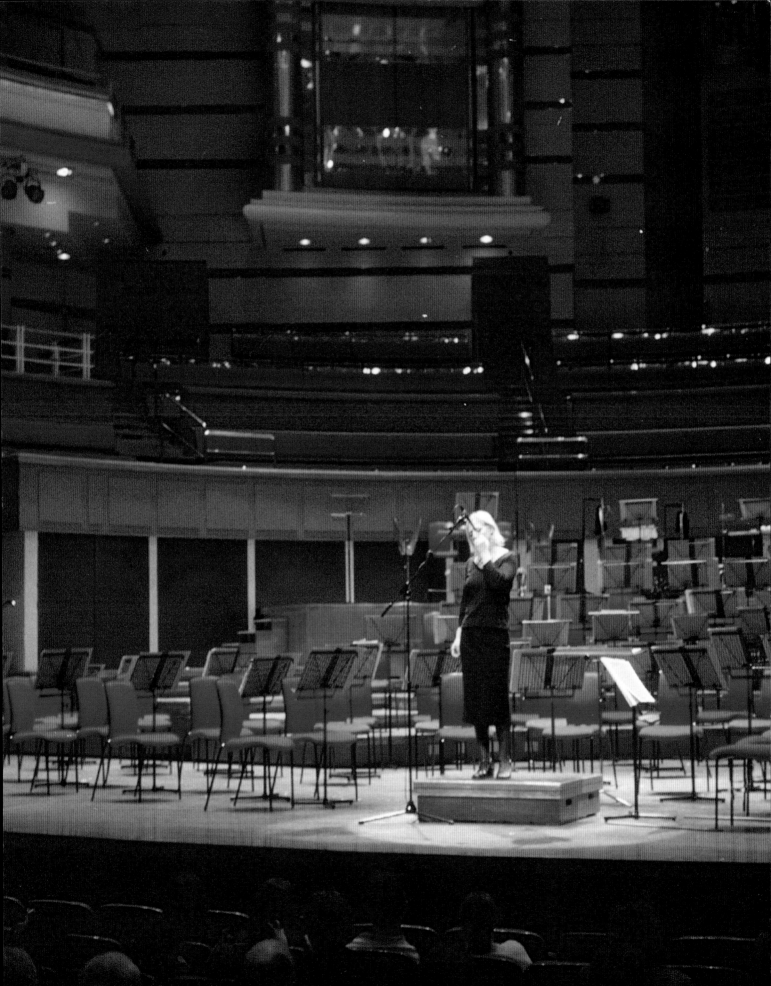

Wall 2002
Tape and adhesive tape
570 x 1300 (224 3/8 x 511 3/4)
Installation at Statens Museum
for Kunst, Copenhagen
Courtesy Lisson Gallery

Bucket 1999 (no.33)
Bucket, CD, CD player
and loudspeaker
Installation at Ikon Gallery,
Birmingham
Courtesy Lisson Gallery

Richard Hamilton

Richard Hamilton was born in 1922 in London. He studied at the Royal Academy of Art, London (1938–40) and at the Slade School of Art, London (1948–51). In the 1950s Hamilton worked on a series of seminal exhibitions including *Growth and Form*, ICA, London (1951), *Man, Machine & Motion*, Hatton Gallery, Newcastle, and ICA, London (1955), *This is Tomorrow*, Whitechapel Art Gallery, London (1956) and was a founder member of the Independent Group. From 1952 to 1953 he taught at Central School of Arts and Crafts, and from 1953 to 1966 he was a Lecturer at University of Newcastle-upon-Tyne where his students included Tim Head. Since his first one-man show at the Hanover Gallery, London, in 1955, Hamilton has had many exhibitions around the world, including retrospectives at the Tate Gallery (1970 and 1992), Solomon R. Guggenheim Museum, New York (1973), Nationalgalerie, Berlin (1974). Recent exhibitions include *Richard Hamilton/Dieter Roth – Collaborations, Relations, Confrontations*, Museu Serralves, Porto (2002), *Druckgraphik und Multiples 1939–2002*, Kunstmuseum, Winterthur (2002) and a retrospective at MACBA, Barcelona (2003)

Marcel Duchamp and Richard Hamilton
The Bride Stripped Bare by Her Bachelors, Even (The Large Glass) 1915–23, replica 1965–6 (no.38)
Mixed media
277.5 × 175.9 (109 1/4 × 69 1/4)
Tate

Overleaf: Details from
Typo/Topography of Marcel Duchamp's Large Glass
2001–2 (no.37)
Laminated inkjet print on aluminium, two panels
266.5 × 170 (105 × 67)
Courtesy the artist

Richard Hamilton is a key figure in post-war British art. Although best known as a painter, his activities as a curator, writer, designer and teacher have ensured a wide audience for his ideas and have meant that he has been extremely influential. While located primarily in the public consciousness as a 'pop' artist, in a career which spans fifty years Hamilton has ranged across an extraordinarily wide variety of subjects – including popular culture, advertising, politics, the work of Marcel Duchamp, the writings of James Joyce and computer technology – in a variety of media. His work is characterised by a commitment to research, experiment and innovation, while always remaining accessible; the often seemingly simple appearance of his work frequently belies the complexity of thought and visual calculation that has gone into its making.

One important aspect of Hamilton's career is his willingness to engage with the work and ideas of other artists and writers, and to make work with a collaborative basis. Thus a long-standing fascination with James Joyce's *Ulysses* (1922) has led to an ongoing series of innovative illustrations to a text that many would consider un-illustratable. Other notable collaborative work includes the recently completed series of *Polaroid Portraits* 1968–2001. For these Hamilton simply asked fellow artists, including figures as varied as Francis Bacon, Joseph Beuys, Henri Cartier-Bresson, Jan Dibbets and Colin Self, to take a portrait picture of him with his Polaroid camera (a new piece of technology when Hamilton began the series with a portrait by Roy Lichtenstein in 1968).

However, the visual artist whose work has provided the richest and most enduring source of inspiration for Hamilton is Marcel Duchamp. Hamilton first encountered Duchamp's work when fellow artist Nigel Henderson showed him a copy of the *Green Box* – Duchamp's facsimile hand-written notes, memos and sketches for the construction and meaning of his enigmatic masterpiece *The Bride Stripped Bare by Her Bachelors, Even* 1915–23, better known as *The Large Glass* – in Roland Penrose's library in 1948. Hamilton's fascination with Duchamp led him to spend three years (1957–60) working on a typographic version of the *Green Box*, and to a meeting with Duchamp in 1959. Since then he has made a number of works exploring aspects of Duchamp's thinking, as well as curating a major retrospective of Duchamp's work, *The Almost Complete Works of Marcel Duchamp*, Tate Gallery (1966), for which he made a reconstruction of *The Large Glass* (the glass of the original, which is now in the Philadelphia Museum of Art, was broken in 1926 and the work is therefore too fragile to travel).

Duchamp's influence on Hamilton first became apparent in his work of the late 1950s. Duchamp's exploration of eroticism and desire was an important example for Hamilton's series of paintings examining various forms of desire – sexual desire, desire for possessions, for status – through the use of the erotic forms of automobile styling and sexual imagery in advertising (see for example *Hers is a lush situation* 1958, *$he* 1958–61 and *AAH!* 1962). As in Duchamp's work, these paintings employ images of machinery and mechanical processes as metaphors for sexual desire and erotic acts. It is notable though, that while Duchamp's imagery is a starting point for Hamilton's work, he uses it very much to his own ends, rooting it firmly in the contemporary and rejecting the hermetic nature of Duchamp's project. Indeed, these are some of the most 'pop' (i.e. of and about contemporary popular culture) works in Hamilton's entire oeuvre.

However, it is not just the subject matter of *The Large Glass* that has been important to Hamilton but the example of Duchamp's working methods. Hamilton's use of the readymade is anticipated in his seminal collage *Just what is it that makes today's homes so different, so appealing?* 1956, but has expanded to encompass works as varied as *Epiphany* 1964, *Sign* 1975, *Carafe* 1978 and *Ashtray* 1979, and even the fully functioning *Diab DS-101 computer* 1985–9. This approach remains central in his work.

That Hamilton is still, forty-five years after his first encounter with the *Green Box*, finding Duchamp such a rich source of inspiration is telling. He has called *The Large Glass* at once 'an epic poem, a technical treatise and a pictorial masterpiece'.[1] His new work, *Typo/Topography of Marcel Duchamp's Large Glass* 2001–2 (pp.92–3), represents a culmination of sorts of his meditations on Duchamp's work and ideas. It is a further exploration of *The Large Glass*, taking Duchamp's imagery and commentary, and combining them to create a single complex indexical fusion of word and image.

Like Duchamp, Hamilton is fascinated by language and typography; indeed David Sylvester has asserted that 'Hamilton would have been known as a typographer if he had done nothing else'.[2] It was Duchamp's stated ambition to create a work of art that could only be understood in the conjunction of word and image – thus evading a purely aesthetic response – something which he perhaps only partially realised. Hamilton has, in a sense, completed this project by uniting Duchamp's diagrammatic imagery with his words, and in the process has created an extraordinary new work of art.
Ben Tufnell

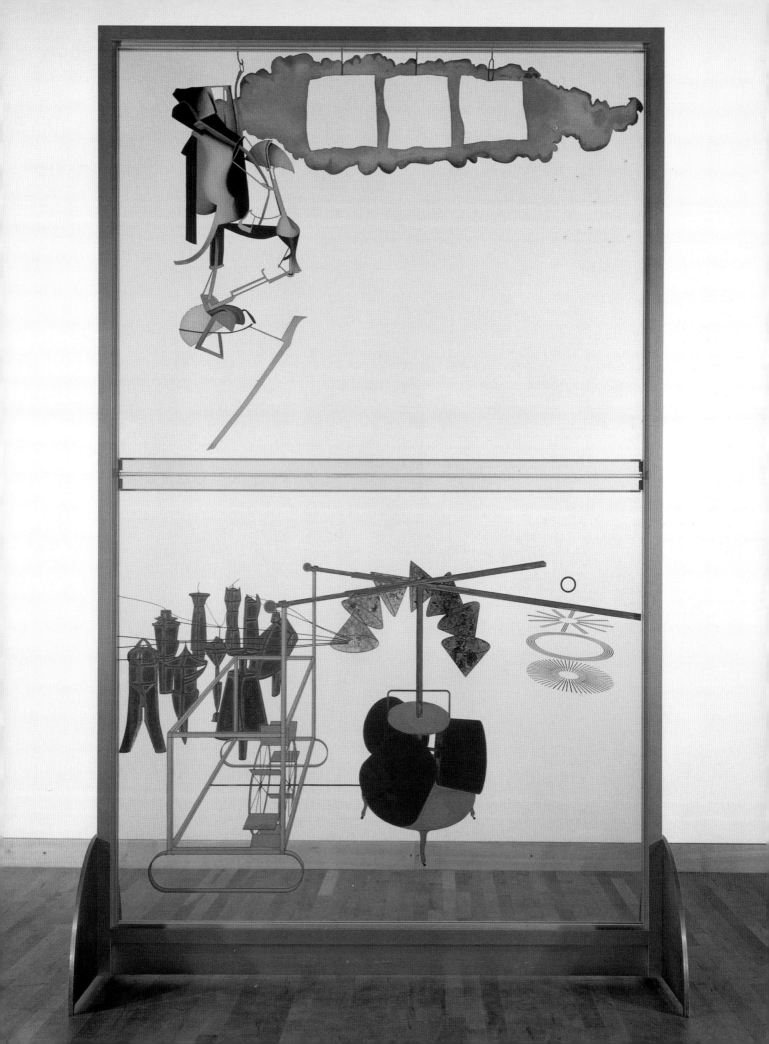

THE Bride stripped bare by her bachelors

— (Agricultural machine) — (even

(a world in yellow
preferably in the text ?)

In reply to your esteemed letter
of the . . . inst. I have the honor . . .

M Duchamp 1913.
**[this business] has
much to offer)**
not on the title page -

Apparatus
 instrument for farming

Kind of Sub-Title

Delay in Glass

Use "delay" instead of "picture" or
"painting"; "picture on glass" becomes
"delay in glass"—but "delay in
glass" does not mean "picture
on glass"—
 It's merely a way
of succeeding in no longer thinking
that the thing in question is
a picture—to make a "delay" of it
in the most general way possible,
not so much in the different meanings
in which "delay" can be taken, but
rather in their indecisive reunion
"delay"— a "delay in glass"
 as you would say a "poem in prose"
 or a spittoon in silver

(Preface) 1

Given I. the waterfall
 2. the illuminating gas,

one will determine
we shall (determine) the conditions
for the instantaneous State of Rest (or allegorical appearance)
of a (succession) [of a group] of (various facts)
seeming to necessitate each other
under certain laws, in order to isolate the (sign)
 the
of accordance between, on the one hand,
this State of Rest (capable of (innumerable eccentricities))
and, on the other, a choice of Possibilities
authorized by these laws and (also
(determining them)

For the instantaneous state of rest = bring in

the term: extra-rapid

We shall determine the conditions of [the] best
exposé of the extra-rapid State of Rest [of the
extra-rapid exposure (= allegorical appearance).
of a group etc.

nothing perhaps [in the dark]
(Notice)

Given: I. the wate
If, given 2. the illun
 consider ?
We shall determine (
organization allegorical Re
exposition (= allegorical ap

collisions seeming strictly t
[assaults]
each other (according) to cer
isolate the (Sign) of accordan
 the
extra-rapid exposition (capa
eccentricities) on the one ha
bilities authorized by these

Algebraic comparison

 a a being the exp
 —
 b b » the po

 the ratio $\frac{a}{b}$ is in no

 number c $\frac{a}{b}$ = c but l
 as soon as
 a and b; a and b
 new
 units and lose their nu
 of ratio
 ; the sign / which se

 accordance or rather o

—Provisional color = The malic forms. They are
provisionally painted with red lead while waiting for each
one to receive its color, like
croquet mallets.

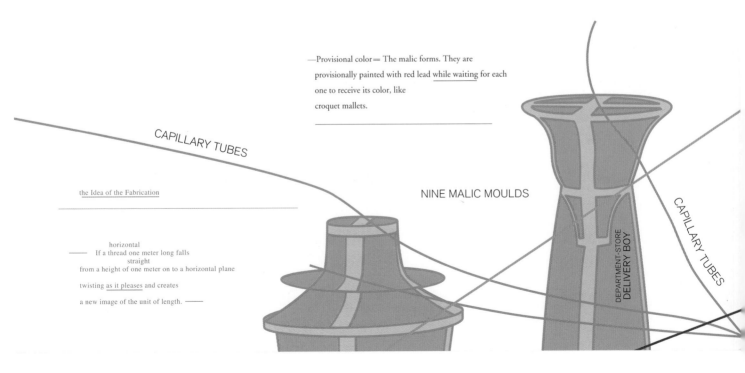

CAPILLARY TUBES

the Idea of the Fabrication

NINE MALIC MOULDS

horizontal
—— If a thread one meter long falls
straight
from a height of one meter on to a horizontal plane

twisting as it pleases and creates

a new image of the unit of length. ——

DEPARTMENT-STORE
DELIVERY BOY

CAPILLARY TUBES

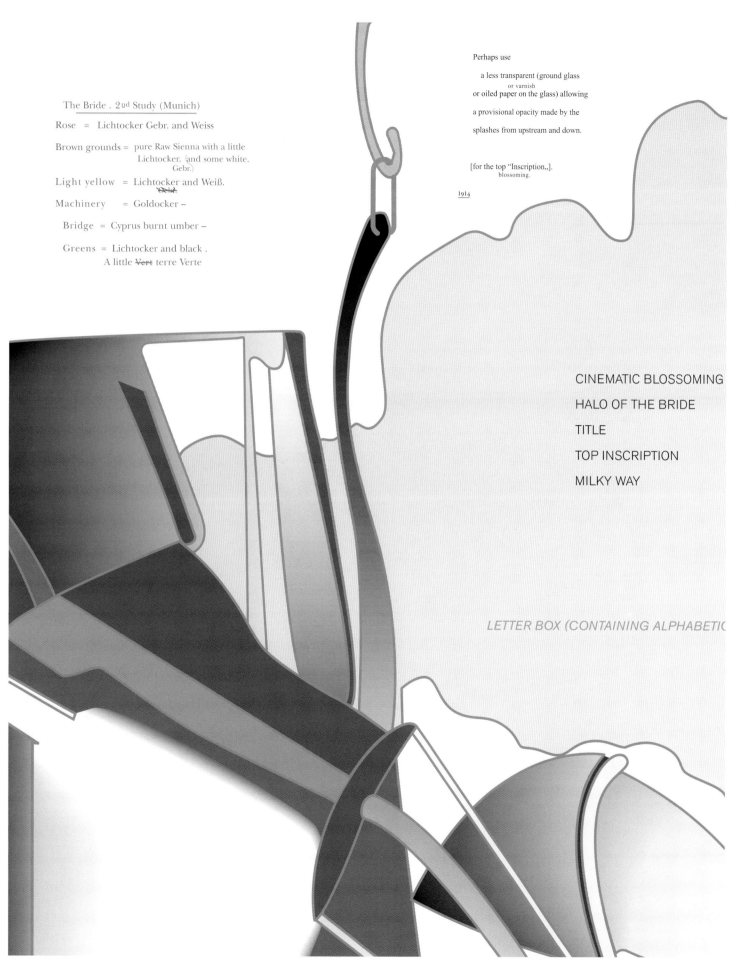

The Bride . 2ᵘᵈ Study (Munich)

Rose = Lichtocker Gebr. and Weiss

Brown grounds = pure Raw Sienna with a little
 Lichtocker. (and some white.
 Gebr.)

Light yellow = Lichtocker and Weiß.
 Oe'l²

Machinery = Goldocker –

 Bridge = Cyprus burnt umber –

 Greens = Lichtocker and black .
 A little Vert terre Verte

Perhaps use

 a less transparent (ground glass
 or varnish
or oiled paper on the glass) allowing

a provisional opacity made by the

splashes from upstream and down.

[for the top "Inscription„].
 blossoming.

1914

CINEMATIC BLOSSOMING

HALO OF THE BRIDE

TITLE

TOP INSCRIPTION

MILKY WAY

LETTER BOX (CONTAINING ALPHABETI(

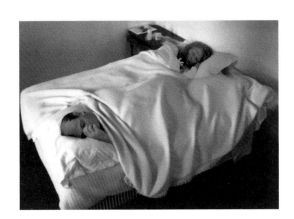

Narrator: reclined laterally, left 1998
Digital dye sublimation print
21.5 × 30 (8 ¹/2 × 11 ⁷/8)
Courtesy the artist

Bedstead 1998
Digital dye sublimation print
21.5 × 26.5 (8 ¹/2 × 10 ³/8)
Courtesy the artist

The heaventree of stars 1998–9 (no.36)
Iris digital print
53 × 37.6 (20 ⁷/8 × 14 ³/4)
Tate. Purchased 1999

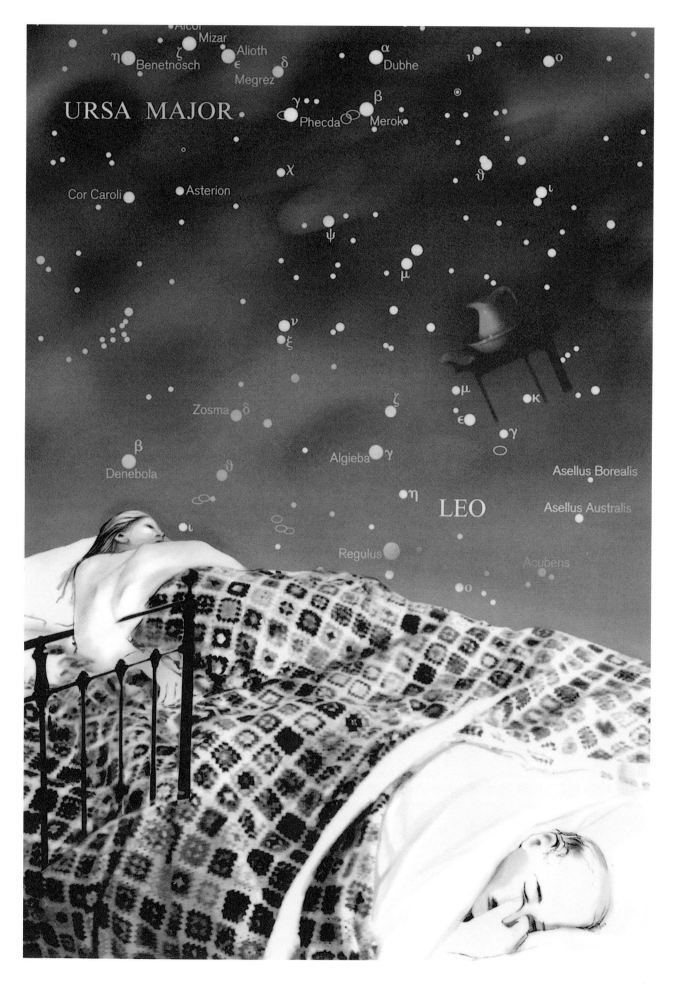

Tim Head

Tim Head was born in 1946 in London. He studied at the University of Newcastle-upon-Tyne from 1965 to 1969, where his teachers included Richard Hamilton. In 1968 he went to New York where he worked as an assistant to Claes Oldenburg, and met Robert Smithson, Richard Serra, Eva Hesse, Sol LeWitt, John Cale and others. He studied on the Advanced Sculpture Course run by Barry Flanagan at St Martin's School of Art, London, in 1969. In 1971 he worked as an assistant to Robert Morris on his Tate Gallery show. From 1971 to 1979 he taught at Goldsmiths College, London. In 1987 Head was awarded First Prize in the 15th John Moores Exhibition.

Head has exhibited widely internationally. His solo shows include MoMA, Oxford (1972); Whitechapel Art Gallery, London (1974 and 1992); British Pavilion, Venice Biennale (1980); ICA, London (1985); and Kunstverein Freiburg, Germany, and touring (1995). He has taken part in group shows including Documenta 6, Kassel (1977), *British Art Now: An American Perspective*, Solomon R. Guggenheim Museum, New York, and Royal Academy, London (1980), *The British Art Show*, Arts Council tour (1984), *Gambler*, Building One, London (1990) and *Live in Your Head: Concept and Experiment in Britain 1965–75*, Whitechapel Art Gallery, London (2000).

Tim Head's work is about instability and uncertainty: of images, of perception and of the individual's relationship with the wider world. Over the past thirty years he has made work in an extraordinary range of media – including installations, photography, paintings and now digital media – guided and underpinned by a consistent set of concerns. His work might be characterised as a search for visual equivalents for the tension between what we perceive to be the truth and what we know to be the truth.

Head first came to prominence in the early 1970s with a series of subtle installations which he referred to as 'speculations about spaces'.[1] These works typically inhabited seemingly empty spaces which were activated by Head's intervention. Initially they employed just mirrors and projected light, but in doing so focused attention on the physical nature of the space they occupied. Head's installation at MoMA, Oxford, in 1972 entailed a series of projections of photographs of the walls of the gallery with mirrors leaning against them, onto the walls themselves. For the exhibition the mirrors were moved into different positions. The combination of physical space, projected space and reflected space created a highly ambiguous experience. Head has stressed that such works were not attempts to simply create visual illusions – the projectors were fully visible, the means by which the installation achieved clearly apparent – but rather to activate a physical and psychological space and in doing so to question our experience of that space. Critic Marco Livingstone has suggested that in such works Head 'took perception as a basic premise, while simultaneously throwing into question what we see, giving form to an essential mistrust of the process of vision as a way of gaining an understanding of the world.'[2] The installations were further complicated in the mid 1970s in works such as *Displacements* 1975–6, with the introduction of both real and projected everyday objects such as ladders, buckets and clocks. Later projected works, such as *Appearance/Apparition* 1977, included the human figure.

In the 1980s Head began to focus less on the space within the gallery, and more on the tension between 'real' and 'artificial' seen in consumer culture. This was paralleled by a move towards 'pure' photography (i.e. work in which a print would be presented as an object in its own right, rather than as a projected component of a larger installation). His photographs exploited the saturated colours of cibachrome and the high production values of advertising. Sex toys, erasers, pills, pocket calculators and suchlike were combined to create future cityscapes, apocalyptic landscapes and heraldic devices. Head's 'toxic landscapes' such as *Alien Landscape* 1985 and *Petrochemicaland III* 1991 make explicit the tension between the artificial and the natural; both highly seductive and repellent, they evoke the contemporary crisis in the environment.

Towards the end of the 1980s Head made the surprising decision to start painting. That he took up painting simply as an expeditious way of achieving a particular kind of surface in his work points to an ongoing concern: that of finding the appropriate medium to test an hypothesis or present an idea. Head's paintings in flat, decorative colours used the repetition of generic motifs including a milk company logo, cuts of meat and chromosomes to evoke a world of multiples, loaded with the possibility of genetic mutation. The paintings were anticipated by his interest in different kinds of pictorial space, particularly the flat space of scanning technology (such as photocopying), and the use of machine processes in works such as *Digital Alarms* 1985. This fascination with space has led, in turn, to his digital works.

Since the late 1990s Head has been working with a multi-media developer, Simon Schofield.[3] One of his first digital works was *A Hard Day's Night* 2000.[4] It featured animated areas of saturated colours presented on a computer monitor, and clearly referenced Modernist abstractions by painters such as Josef Albers. Since then Head's research has led him to use the technology in ways that force it to its (currently) available limits. *Treacherous Light* 2002 is a projection in which each pixel of the computer screen has been enlarged to become a distinct visual element. He describes this process: 'The work explores certain features of electronic space, specifically the digital space generated on screen by a computer program. It attempts to isolate some of the intrinsic properties of this electronic space stripping it down to certain prime elements to carry a raw skeletal electronic message. Attention is focused on the peculiar and unique physical properties of the digital medium itself and specifically on the computer-generated array of light-emitting pixels that form the illusive fabric of the screen's surface.'[5] Colours are randomly generated (from a palette of over 16,000,000 colours) at the edges of the screen and then move, pixel to pixel, across the image, both horizontally and vertically. The work is 'live' – not pre-recorded or looped – and takes place in real time in front of us, never repeating itself. It resembles a vast kaleidoscope, or veils of colour which move past each other in an indeterminate space. Close up, the process is clearly visible and the sensation of movement is strong. At a few metres distance the image becomes a swarming amorphous mass. Areas of colour and density coalesce and disperse before it is possible to fix our attention on them. From further back it is a pale grey, still rectangle of light. One is reminded of the pointillist paintings of Georges Seurat, or the densely marked spaces of Mark Tobey or Jackson Pollock. Indeed, Head feels that the experience of this work is as much like looking at a picture as a film or computer screen.

The work is motivated by the search for a kind of pictorial and spatial reality which is intrinsic to the computer, and a desire to expose the 'treacherous' nature of the digital space. Head is fascinated by the supposed perfection of the computerised image and the fact that much effort is devoted to creating ever more refined images which eliminate any evidence of the pixel. However, Head is not opposed to such technology per se. *Treacherous Light* is not about subverting the computer. Rather, in common with so much of his work of the past thirty years, it is about taking a medium (or an idea) and 'laying it bare, making it transparent, showing it for what it is'.[6] It is a part of an ongoing project: a probing but non-judgemental questioning of the world we live in and the technology we surround ourselves with.

Ben Tufnell

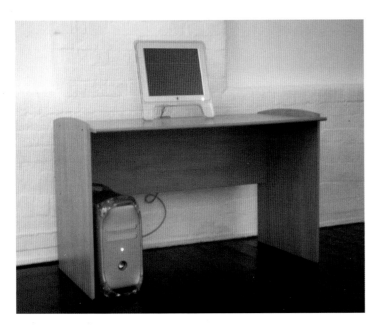

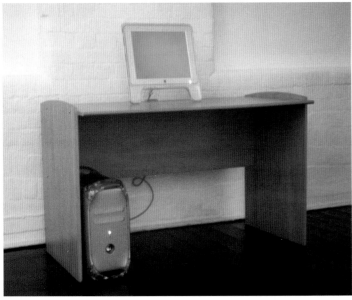

Tragic Dawn 2002
Live computer program
and monitor
Installation in *Generator*
at Spacex, Exeter

Treacherous Light 2002 (no.39)
Digital projection
(from real time computer
program)
Courtesy the artist

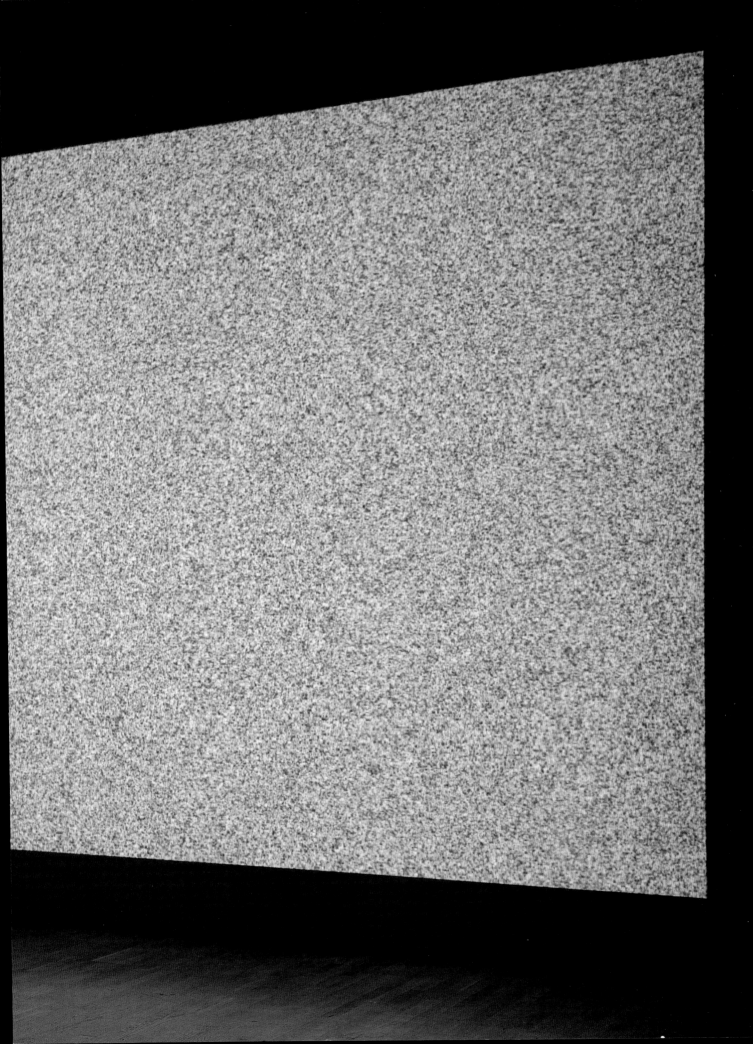

Jim Lambie

Jim Lambie was born in
Scotland in 1964. He
graduated from Glasgow
School of Art in 1994 and his
first solo exhibition, *Voidoid*,
was held at Transmission
Gallery, Glasgow, in 1999.
Subsequent solo shows have
included: ZOBOP, The
Showroom, London (1999);
Konrad Fischer Galerie,
Düsseldorf (2000); *Boy
Hairdresser*, Anton Kern
Gallery, New York (2001); *Salon
Unisex*, Sadie Coles HQ, London
(2002) and Inverleith House,
Edinburgh (2003). He has
participated in many group
shows including: *Lovecraft*,
Spacex Gallery, Exeter (1998);
The British Art Show 5,
National Touring Exhibitions
(2000); *Tailsliding*, British
Council touring exhibition
(2001); and *Early One Morning*,
Whitechapel Art Gallery,
London (2002). He was
awarded the Paul Hamlyn
Foundation Award for Artists
in 2000.

Jim Lambie finds inspiration in the ephemera of everyday life.
His chosen materials are drawn from what is most readily
to hand, yet exist at the periphery of our consciousness –
throwaway items such as plastic bags, buttons, wool, safety-
pins and magazine cut-outs. These are often combined with
obscure remnants from 1970s and 1980s youth culture such as
trashy accessories or band memorabilia – cultural detritus
that evokes an instant familiarity and a kitsch appeal.
Juxtaposing and manipulating such diverse materials,
Lambie creates assemblages that are immediately compelling
and that harbour a visual complexity that often belies the
simplicity of his gesture.

Lambie's experience as a student in the Environmental
Department at Glasgow School of Art instilled in him a respect
for context – both cultural and physical – and his works
are primarily shaped by a series of sculptural decisions
concerning space and how a given object functions within
that space. Moreover, the inherent qualities of a particular
object or material often inform the nature of his intervention.
A circle of brightly coloured plastic belts arches upwards
and outwards, serpent-like, from a central point on the
gallery floor in *All Over My Face* 2001. *Digital* 1999 comprises
a selection of armless leather jackets in various muted
shades arranged on the wall so that their waistbands form
a perfect circle.

While Lambie's works at times share the formal rigour and
pared-down aesthetic of 1960s Minimalism, they are firmly
rooted in his specific cultural environment. His involvement
in the Glasgow music scene as both musician and DJ ensures
that music, and the iconography and paraphernalia of pop,
are continual reference points. Album covers, records and
band posters have all been incorporated into his works, as
has the associated technology, customised and rebranded.
For example, *She's Lost Control* 2002 is a Donald Judd-like
configuration of eleven speakers mounted on the wall,
each recovered in a different variety of fabric. However, the
significance of music to Lambie's practice extends beyond its
physical trappings, to a desire to manipulate atmosphere and
transcend environment through his art. *Graffiti* 1999 (p.105)
and *Let it Bleed* 2001 belong to a series of kinetic sculptures in
which record decks encrusted in a sumptuous layer of glitter
spew objects from their bases; for example safety pins and
pearls or brightly coloured Alice-bands. Lambie notes that
the reflective properties of the glitter serve to soften the outer
edge of the deck and comments that 'covering an object
somehow evaporates the hard edge off the thing, and pulls

you towards more of a dreamscape. The hard, day to day,
living edge disappears.'[1] Shown in pairs rotating hypnotically,
the decks are forever in a state of transition, of
'inbetweeness'. It is this ability to conjure the abstract, to
transport the viewer into non-visible spaces, that Lambie
believes art, at its most successful, shares with music. 'You
put a record on and it's like all the edges disappear. You're in
a psychological space. You don't sit there thinking about the
music, you're listening to the music. You're inside that space
that the music's making for you.'[2]

In all his works, Lambie subtly transcends or dissolves the
boundaries inherent to a particular object or space and
attempts to move the viewer to a psychological space beyond
it. It is imperative, therefore, that his works engage, in order
that they successfully operate as vehicles through which the
abstract can be made manifest. With each work he sets
himself the challenge of how to 'get this release away from
the object, while still using the object as a doorway to get
away ... as an escape route'.[3] He is perhaps best known for
his ongoing series of psychedelic floor-based interventions
under the collective title *Zobop* (p.102–3). Following the
existing architecture of a room, Lambie applies continuous
lines of coloured adhesive vinyl tape to the floor, beginning
at the outer perimeter where the floor meets the walls. Using
strips of alternating colours, he gradually works his way in to
the centre to create a sort of distorted architectural footprint.
The influence of any structural details or idiosyncrasies, such
as pillars, alcoves or fireplaces, progressively magnifies,
sending multi-coloured tremors out across the floor until
they collide with the lines of tape originating from the
opposite side of the room. Rhythms build and the room
vibrates, at once articulating and confusing the space. The
work does not exist independently of the floor (indeed,
the tape conforms obediently to the ridges of boards below,
its plastic sheen exaggerating any dimples or dents), yet
its transformative properties are immense. It offers a
redefinition of the architectural landscape and a consequent
shift in the mood and character of the space.

Lambie skilfully recycles props grounded in the everyday,
working within existing parameters while removing
functionality, to create works that connect directly to the
viewer. Appealing to us at an almost subconscious level,
Lambie's works possess an ambient quality that avoids
intellectualisation, softening the edges between the physical
and psychological spaces we inhabit.
Lizzie Carey-Thomas

The First Wave 2001
Glove and buttons
25 × 15 (9 3/4 × 5 7/8)
Courtesy The Modern Institute,
Glasgow

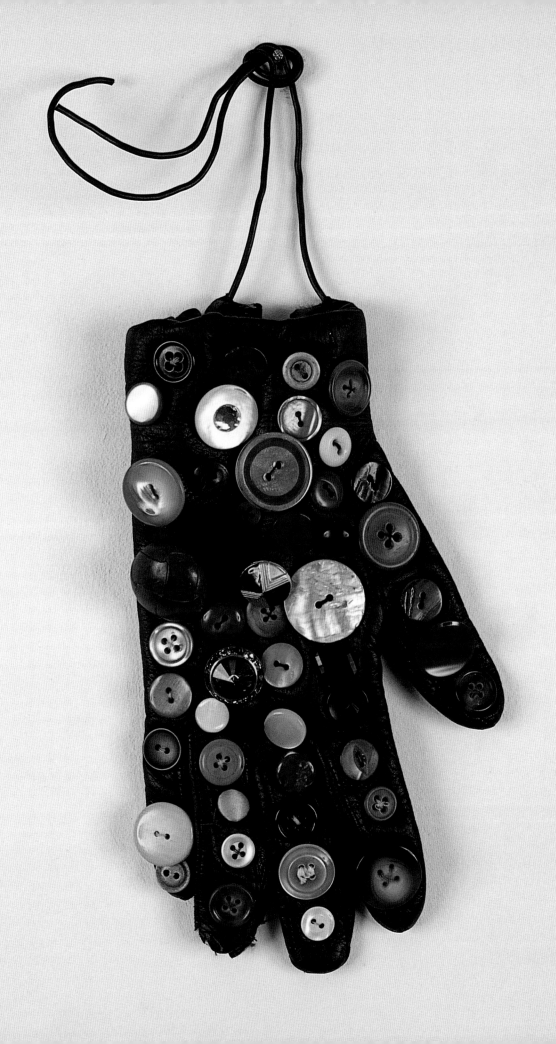

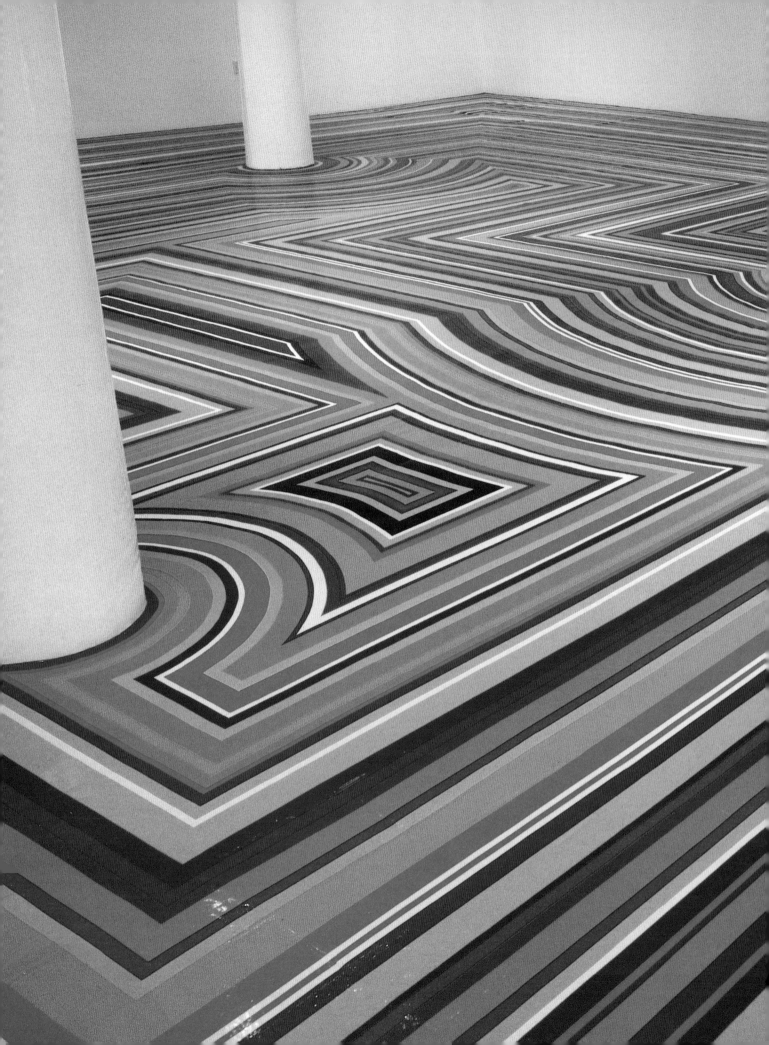

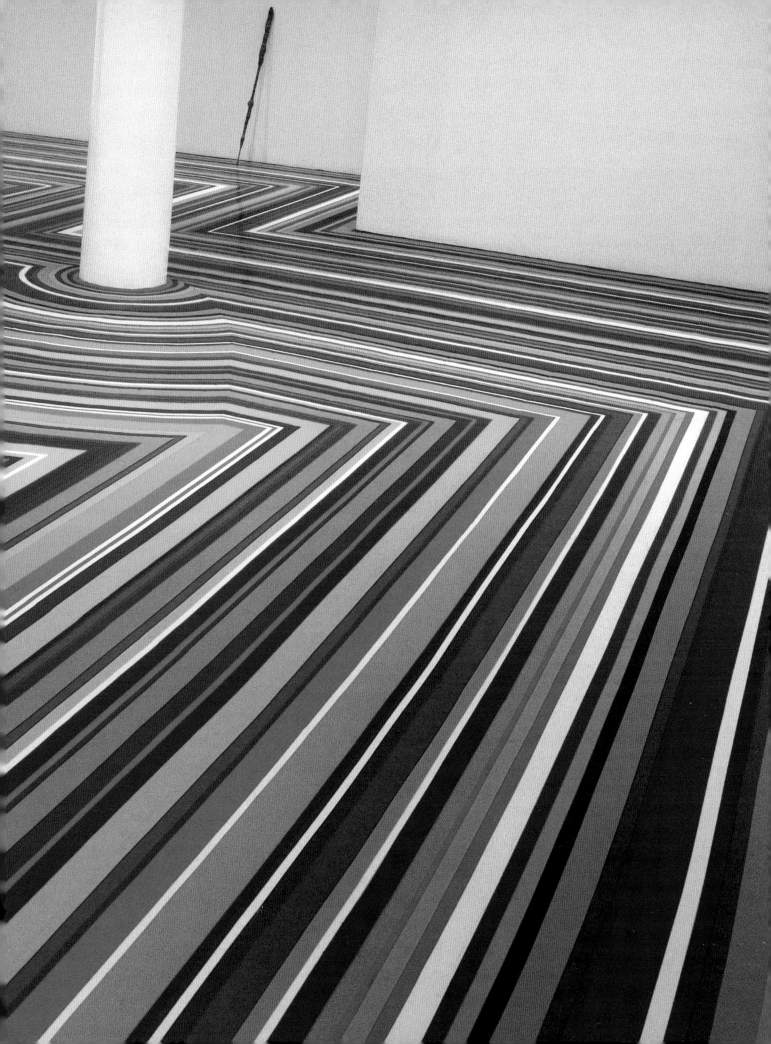

Previous page:
Zobop 1999
Multicoloured vinyl tape
Installation view, *Voidoid*,
Transmission, Glasgow
Courtesy The Modern
Institute, Glasgow

Psychedelic Soul Stick 2001
Bamboo, mixed media, thread
114 × 7 (44 ³/₄ × 2 ³/₄)
Courtesy Sadie Coles HQ, London,
The Modern Institute, Glasgow
and Anton Kern Gallery,
New York

Graffiti 1999
Record deck, blue glitter,
safety pins, pearl beads
68 × 45 × 36.5 (26 ³/₄ × 17 ³/₄ × 14 ³/₈)
Collection of Detmar and
Isabella Blow, London
Courtesy Sadie Coles HQ, London

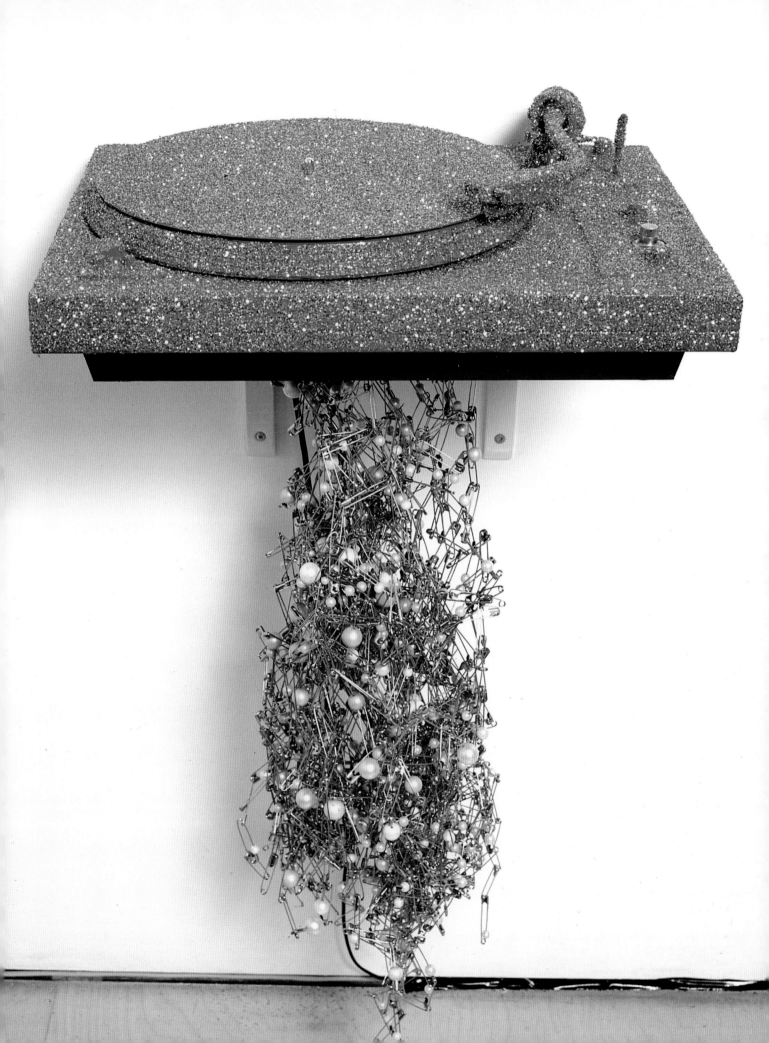

Mike Marshall

Mike Marshall was born in London in 1967. He studied at Reading University from 1987 to 1991 and at Chelsea School of Art, London from 1995 to 1996. He is currently working on a PhD at Goldsmiths College, London. His work has been shown in a number of group exhibitions both in the UK and internationally, including *Multiple Choice*, Cubitt Gallery, London (1997); *What Difference Does it Make*, Cambridge Darkroom Gallery (1998); *Every Day*, Sydney Biennale (1998); *Turn On*, Ikon Gallery Touring Exhibition, Birmingham (2000); *Somewhere Someone is Doing Something*, VTO Gallery, London (2000); *No One Ever Dies Here*, Hartware Kusnstverein, Dortmund (2002); *Say Hello to Peace and Tranquility*, Netherlands Media Art Institute, Amsterdam (2002); and *Cab Gallery Retrospective*, Essor Gallery, London (2002). His first solo exhibition, *Planisphere*, was held at The Economist Plaza, London (2001), followed by *The Earth is Flat* at the Ikon Gallery, Birmingham (2002) and *Lizard Afternoons* at VTO Gallery (2002). Marshall lives and works in London.

Mike Marshall uses video and photography to examine unremarkable or overlooked aspects of human experience. His video work in particular often focuses on occurrences or activities that appear banal and inconsequential, qualities that are reinforced by the prosaic titles Marshall gives his works. *Balancing a Pencil* 1999, for example, records the artist's efforts to balance a pencil on its end while travelling on a train.

While the titles of Marshall's works place emphasis on the experience or activity that is caught on tape, it is the mental state or attitude behind the image that is the real subject of the work. More specifically, Marshall refers to an interest in 'focused daydreaming' and a desire to locate the remarkable in potentially unremarkable situations.[1] This contemplative mood makes itself felt in *Sunlight* 2000–1 (p.109), in which a series of eleven scenes captures intricate shadows cast by the sun in a variety of urban settings. Each scene records patterns and shapes slowly coming into focus and fading away, and the repetition of this motif gradually lulls the viewer into a dreamy kind of meditation.

There is a conspicuous lack of any physical human presence in Marshall's work. A hand or the top of a head occasionally comes into view, but in general the frame is kept clear of such intrusions. Marshall thus invites the viewer to identify with the camera's point of view, allowing us the possibility of projecting ourselves into the work. *Someone, Somewhere is Doing This* 1998 explores this possibility, testing the limits of the viewer's capacity to share in the attitude behind the work. *Someone, Somewhere is Doing This* focuses on the ripples moving across the surface of an unidentified patch of water. The camera's tight framing of the water's surface encourages the viewer to share in this moment of absent minded reverie. Against this inviting scene, Marshall juxtaposes a soundtrack of distracted and tuneless humming, disturbing the meditative mood created by the image. Any sense of a shared moment of romantic contemplation is lost, replaced by the suggestion of a solipsistic desire to keep the outside world at a distance. In this instance, intensely 'focused daydreaming' risks tipping over into escapism and this tension between engagement and disengagement is often at play in Marshall's works.

The Earth is Flat 2001 features the artist running through the desert reciting jokes from memory. While the desert has traditionally been seen as an exotic and idealised romantic site, Marshall selected what he described as 'the most mundane piece of desert I have ever seen'.[2] Indeed, there are no dunes or oases to be found here, only a barren landscape stretching to the horizon. Marshall uses the vastness of the desert to invoke the notion of the sublime, throwing into stark contrast the very absurd nature of his actions. The epic nature of the landscape becomes overwhelming, and the artist has explained that the emptiness and grandeur of the desert leads, perhaps surprisingly, to an 'increase in the volume and banality of our thoughts'.[3] Marshall draws attention to our inability to shut off such incessant mental chatter as well as to the way this inability affects our experience and enjoyment of events in themselves and as they occur.

Marshall's most recent video, *Days Like These* 2002 (p.108), marks a shift in the artist's work. It is set in the grounds of a hotel garden and records the activity of a rotating sprinkler. The contemplative mood or 'attitude' is no longer so obviously expressed, and the viewer is less explicitly placed in a position of identification with the camera's point of view.

The simple soundtrack that accompanies the work is in fact as carefully engineered as the patch of nature that fills the image. Dogs bark and birds sing on the artist's cue and the generic chords and low grinding sounds are carefully orchestrated to create a sense of expectancy that is progressively undermined by the inevitability of the sprinkler's continued rotation. The erosion of expectations is a theme running throughout Marshall's work. *Days Like These* does not offer any grand finale, and the artist has expressed a desire to lead the viewer away from expecting resolution, and towards a fuller appreciation of the simple action taking place on the screen. In *Landing at Gatwick Airport* 1997, for example, the camera records the view out the window of an aeroplane as it makes its descent. As the plane banks and the ground and the sky alternately come into view, we expect a spectacularly bumpy landing or the sun to come bursting through the clouds. Instead, Marshall shuns any sudden revelation or epiphany and the plane touches down smoothly amidst the persistent beeping of cabin signals.

Many of Marshall's works are conceived, and sometimes made, while abroad. Travel may seem an unlikely source of inspiration for works that take seemingly unremarkable experiences as their focus. However, there is a sense in which the experience of travel can bring a new, sometimes fleeting perspective that makes the familiar seem strange. It is precisely this type of transformation that Marshall seeks to recreate in his work.

Kathryn Rattee

Someone, Somewhere is Doing This 1998 (no.42)
Still from video
Courtesy the artist

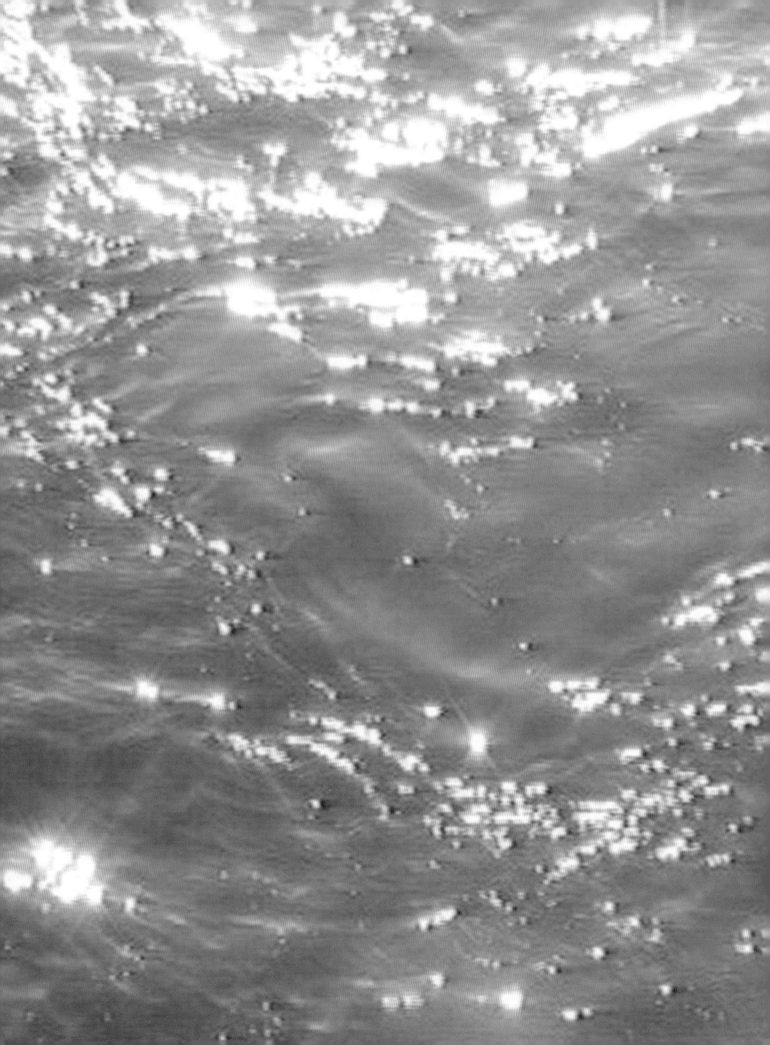

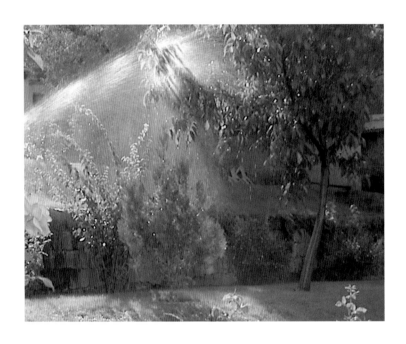

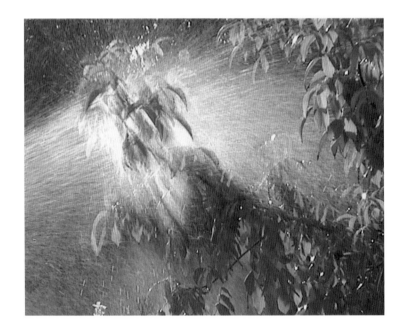

Days like These 2002 (no.44)
Stills from video projection
Courtesy the artist

Sunlight 2000–1 (no.43)
Stills from video
Courtesy the artist

Sarah Morris

Sarah Morris was born
in London in 1967.
She studied semiotics at
Brown University from 1985
to 1989 and then attended
the Whitney Museum of
American Art Independent
Study Program between 1989
and 1990. Morris has had solo
exhibitions at Le Consortium,
Centre d'Art Contemporain,
Dijon (1998), MoMA, Oxford
(1999), Galerie für
Zeitgenössische Kunst, Leipzig
(2000), Kunsthalle, Zurich
(2000), Philadelphia Museum
of Art (2000), Nationalgalerie
im Hamburger Bahnhof,
Museum für Gegenwart, Berlin
(2001), Site Sante Fe, New
Mexico (2002) and Miami MoCA
(2002). She lives and works in
London and New York.

Sarah Morris's work is concerned with decoding the built environment. Focusing on the urban experience, her paintings and films explore techniques of communication – the relationships between signs and symbols and their referents in the physical world. Morris first received international attention with a series of large text paintings made between 1995 and 1996 that explored the visual and emotive power of the single word or tabloid headline. These works – for example, *Guilty* 1995 and *Liar* 1995 – were particularly attuned to the look and language of American mass culture, expressing the artist's interest in semiotics, specifically the persuasive power of the written word. Strategies of communication remain at the heart of Morris's work. She is interested in 'the most simplified, coded way to have a conversation with the viewer'.[1] This engagement comments on society's obsession with the sending and receiving of information. The *Midtown* series (1997–9) focused on the architecture of Manhattan skyscrapers as signifiers of urban life and corporate power. Architectural qualities became de-emphasised and fragmented into large, glossy, colour-saturated grid paintings. While the works' titles refer to the original buildings on which they are based, for example, *Midtown – Condé Nast* 1999, and *Midtown – 1211 (Rockefeller Plaza)* 1998, they hover between representation and abstraction, between shimmering façades and composed colour fields through a process of graphic reduction. On one level these works recall the pictorial language of Piet Mondrian and Neo-Plasticism, where painting is reduced so that each of its component parts – line, colour, form and space – is deployed in only its most absolute, irreducible form. However, for Morris the works' formal experimentation remains the product of a distilled reference to the urban environment. Following the principles of single-point perspective, the sheer hard-edged vibrancy of the compositions and colours suggests cityscapes with looming planes of gigantic proportions.

Film and photography have always been important been important to Morris's process as an artist. She has shot a series of films located in the following American cities – Manhattan, Las Vegas, Washington D.C. and Miami. Morris's work in each medium informs each other. As the artist explains, 'The films function as an index for every painting I might have made and every painting I might make in the future. They are a condensed manifesto, a non-linear narrative of what interests me.'[2] In discussing *Midtown* 1998, a film of the same title as the paintings, the artist clarifies these two different aspects of her practice. 'The film is based on how I go about living day to day, circulating through situations and constructing a path of visual fragments ... so while the paintings and the film start at different levels they are both revealing the same set of effects. Not a description of the surface of things, but an exposure of their structure.'[3]

A filmic sense of the urban spectacle is also present in the paintings. In Morris's *Neon* series (2000) the perspective becomes even more extreme, with multiple and overlapping vanishing points. Devoted to the hotel façades, advertisements and electronic billboards of Las Vegas, these works establish a relationship between the numerous high-

rise hotels and glittering casinos, and their characteristic strategies of self-promotion – both of which are structured by a high-keyed geometric language. Morris is intrigued by the physical and psychological lure of Las Vegas as manifest in the city's architecture. While from its suburban approaches it might appear similar to any other sprawling metropolis, Las Vegas is a city designed to take money. The artist is fascinated by the extent to which an experience of the city is carefully orchestrated to seduce the visitor. 'Everyone has thought of it as chaos and it is actually the opposite of that. When they light up the MGM Grand Hotel at night it takes forty-five minutes. All these strategies are very carefully thought out. But the experience feels like the opposite of that ... you lose your sense of perspective.'[4] Morris reworks and translates her source material into paintings that create dizzying impressions, and whose impact on the viewer is felt to be as much physical as mental.

Morris's critique and the use of the aesthetics of capitalism are further developed in *Capital* 2001, which centres on the locations and personalities that define the character of Washington D.C., Capitol Hill, the White House Cabinet Room, uniformed members of the Secret Service, the President, Washington D.C. subway. By focusing on the currency of political power, Morris succeeds in revealing the inner architecture of how it is presented.

Most recently she has turned her attention to Miami, a place where the tourist industry intersects with the impacts of drug trafficking, immigration and exile. The series of paintings collectively entitled *Pools* 2002 (p.115) acknowledge the swimming pool as the ultimate emblem of Miami, encapsulating a particular lifestyle and ideology.[5] In these works Morris's fragmentation of the grid has the effect of creating concave structures reminiscent of the refraction of light through prismatic structures or water. Her choice of palette is a mix of 'Miami' colours – coral pink, suntan brown and hibiscus yellow – borrowed from the vocabulary of the location. The accompanying film, *Miami* 2002 (pp.111–14), follows the city's drift from luxurious living to a somewhat dead-end vision of what the 'good life' might mean. Morris focuses on the architecture, people and industries that define the city – the Fontainebleau hotel, an aerobics dance class, a blow-out at a hair salon, the Miami Grand Prix, a SWAT team performing bio-hazard exercises in the bankrupt Hileah Race track, geriatrics in Rascal House. The artist also locates the city's position in the production of the American dream in relation to the contradictions of US foreign policy. Clandestine police manoeuvres in a residential neighbourhood are followed by footage of a factory pumping out litres of Coca-Cola. If the police activities can be interpreted as acknowledging Miami's role in the drug industry, the images of Coca-Cola, a drink closely associated with the American ideal, hint at Miami's problematic relationship with Cuba, ninety miles to the south and its role in the history of the Cold War. As such, *Miami* is not just a portrait of a city, but continues Morris's study of artifice, surface and the covert.

Clarrie Wallis

Miami 2002 (no.45)
Still from 35mm film/DVD
projection
Courtesy Jay Jopling/
White Cube, London

Miami 2002 (no.45)
Still from 35mm film/
DVD projection
Courtesy Jay Jopling/White
Cube, London

Miami 2002 (no.45)
Still from 35mm film/
DVD projection
Courtesy Jay Jopling/White
Cube, London

Pools – Fontainebleau II [Miami]
2002 (no.46)
289 × 289 (113 3/4 × 113 3/4)
Household gloss on canvas
Courtesy Jay Jopling/White Cube, London

Paul Noble

Paul Noble was born in Northumberland in 1963 and grew up in Whitley Bay. He attended Sunderland Polytechnic from 1982 to 1983 and the Humberside College of Higher Education from 1983 to 1986. In 1986 he moved to London and became one of the founders of City Racing, an artist-run gallery in Vauxhall which closed in 1998. He has exhibited extensively internationally. Recent solo exhibitions include City Racing (1990), *Ye Olde Works*, Cubitt Gallery, London (1995), Maureen Paley Interim Art, London (2001, 1998, 1996), *Nobson*, Chisenhale Gallery, London (1998), Gorney Bravin + Lee, New York (2000), Mamco, Geneva (2001), Albright Knox Gallery, Buffalo, New York (2003). His numerous group exhibitions include *Belladonna*, Institute of Contemporary Arts (1997); *A–Z*, The Approach (1998); *Abracadabra*, Tate Gallery, London (1999), *Protest and Survive*, curated by Paul Noble and Matthew Higgs, Whitechapel Art Gallery, London (2000), *(The World May be) Fantastic*, Biennale of Sydney (2002), *Drawing Now: Eight Propositions*, Museum of Modern Art, New York (2002). In 2000 he was the recipient of a Paul Hamlyn Award. He lives and works in London.

Acumulus Noblitatus 2001 (detail, no.47)
Pencil on paper
390 × 550 (153 1/2 × 216 1/2)
Collection of John A. Smith and Vicky Hughes

It has been generally acknowledged that many New Towns, models of post-war English town planning, are intrinsically flawed. Paul Noble's drawings of *Nobson Newtown* 1996– instantly recall the peculiar experience of visiting one of these New Towns: they reflect the same air of controlled neglect and empty streets. The strange urban environment of Nobson Newtown is closely informed by Noble's personal experiences: 'The whole body of work is supported by structures of ideas. Town planning sounds like a really boring way of putting it but when you are a poor person you have a very particular experience of a city. You have a peripheral experience, particularly in London. For most of my life in London I've been in squats or short-life housing. In these conditions you tend to be on the front of a new wave of development and live in houses which are about to be knocked down. Most of the places where I've lived don't exist anymore.'[1] Nobson Newtown is a city founded by its invisible citizens on a 'knock-it-down-and start-again-spirit', motivated by the need for expedient solutions and the all-powerful force of progress – for good or bad. Rather than being a straightforward criticism of post-war town planning, Noble's project is a complex and witty portrait of a place which swings between utopia and dystopia; in other words a real urban experience.

People are never present in Noble's town; rather than existing to accommodate residents, this carefully composed environment was conceived as a way for its artist-architect to articulate the perplexing reality of a city. Nobson Newtown has twenty-seven locations to date, including individual buildings and civic spaces. Each section of the town is made into a separate drawing, reflecting its disjointed geography. There are meticulously detailed drawings of the town centre, *Nobson Central*; the Quarry; the hospital, *Nobspital*; the cemetry, *Nobsend*; the Chemical and Light Industry Plant (*C.L.I.P.O.N.*); the Public Toilet; the sewage system, *Nobwaste*; the underground system, *Nobgo Travel*; a slum area, *Nobslum*; the swimming pool, *Lidonob*; the job centre, *nojobclub*. Just out of town, there is *Nobpark* and *Nobcamp* with two tents forming the letters 0 and T.E.N.T.; the various commemorative villas, Trev, little trev, Carl, Jem, Paul's Palace; the archaeological site and the sea. Each building is constructed from a unique typeface, with groups of structures spelling out their name or describing their function. Language and visual representation are condensed into a concise and effective method of presenting ideas and information.

Acumulus Noblitatus 2001 (p.120) depicts the squatter camp on the outskirts of town. This vast drawing shows a group of modest single-storey buildings which spell out their own function, SQUATTER CAMP, nestling in the foothills of enigmatic soaring peaks. The absent squatters have made the place self-sufficient and homely. In fact the camp is better maintained than most parts of Nobson Newtown, with a garden allotment, a well, a kitchen, dairy cows, musical instruments for home entertainment and a communal eating area. The camp and hills are surrounded by tree stumps, remnants of the forest destroyed to make Nobson Newtown. To the left, wind-carved rock formations in a mud swamp

spell out the words of Gerrard Winstanley, a leader of the proto socialist seventeenth-century Digger movement: 'And the nations of the world will never learn to beat their swords into ploughshares, and their spears into pruning hooks, and leave off their warring, until this cheating device of buying and selling be cast out among the rubbish of kingly power.'[2] Motivated by his religious beliefs, Winstanley advocated the occupation of common land by the poor. One such group existed for a year in Cobham, Surrey, despite opposition from town people and, eventually, intervention from the army and law courts. The rallying cry of this early socialist leader provides the motivation for the Nobson Newtown squatters to take control of their own surroundings and create something positive out of the legacy of ruined forests and the ugly squalor of the neighbouring town. The political ethos of the community is indicated by the mausoleum decorated with a wreath in the form of the Anarchy logo and the Ying and Yang signs which stand in for the cows' faces, a discreet promotion of vegetarianism.

Squatting as a political activity relates to Noble's own experiences in the late 1980s, when he was involved in the protests at the proposed M11 link road in East London which required knocking down a number of roads and houses, home at that time to a large artists' community. Squatting was used as a pragmatic and efficient means of political activism, with protesters quickly taking over houses as the inhabitants left, preventing the demolition teams from entering. Unfortunately the successes were as short-lived as Winstanley's earlier example. However in *Nobson Newtown*, a place where the town centre was deliberately designed as a wasteland and in which there is an unspoken belief that 'the only perfect thing is a flawed thing',[2] the squatter camp appears to be the most permanent and flourishing part of town.

Noble admits that the project is itself a struggle to make sense of his surroundings, and his chosen medium accentuates this challenge. 'Making old fashioned-looking work that is anti-avant garde and takes six months to make is a perverse position but it gives me pleasure.'[3] He uses a technical device called oblique projection as a way to organise information, giving the particular 3D effect found in all Nobson drawings. The basic perspective, reminiscent of early computer games, and the order of ruled straight lines, careful shading and microscopic detail, draws the viewer in. Such deceptively simple means allow Noble to present complex works rooted in a political and social awareness of the governing forces behind our surroundings. The artist comments, 'I want to find an impoverished aesthetic for *Nobson Newtown*. That's why I treat these lowly places in such a monumental and grand manner. I choose to make drawing because I see it as the most commonplace and least problematic art practice.'[4] The artist employs drawing as a democratic, non-judgemental means of presenting his ideas. Noble's aesthetic, as well as his ironic and subversive take on the urban environment is reflected in Nobson Newtown's twin motto: 'No style, only technique. No accidents, only mistakes.'[5]

Katharine Stout

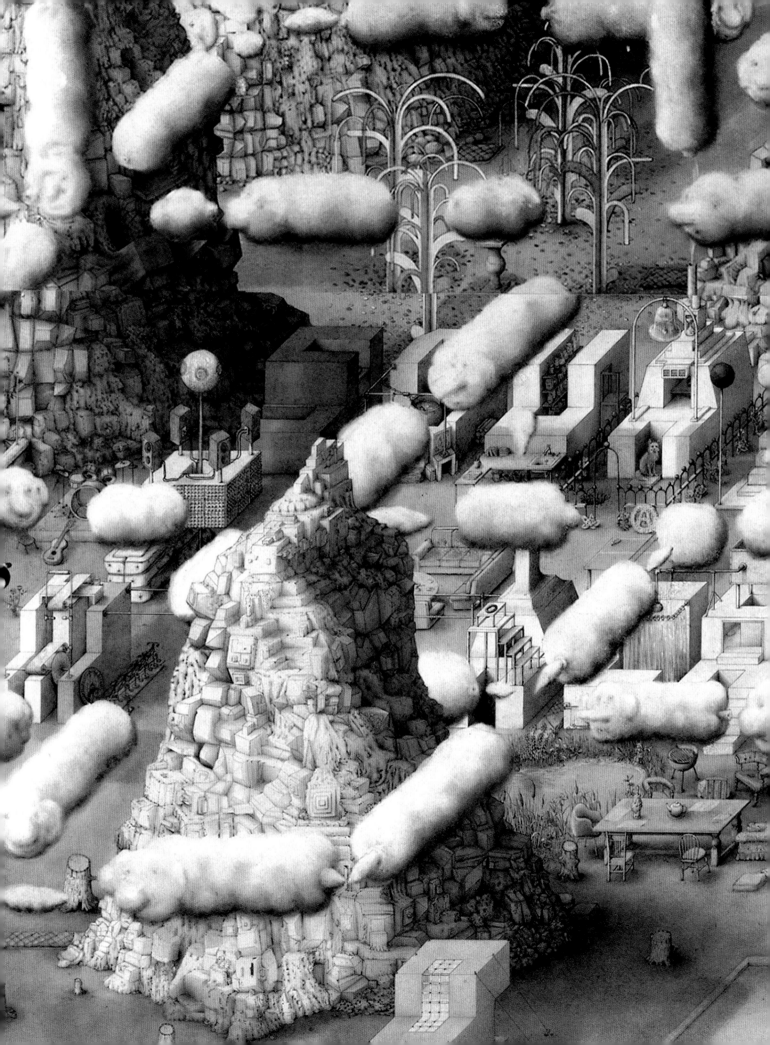

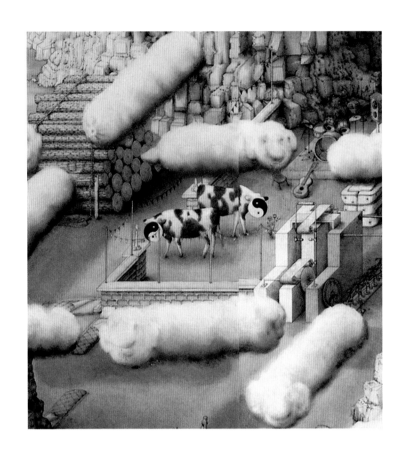

Acumulus Noblitatus 2001
(details of no.47)

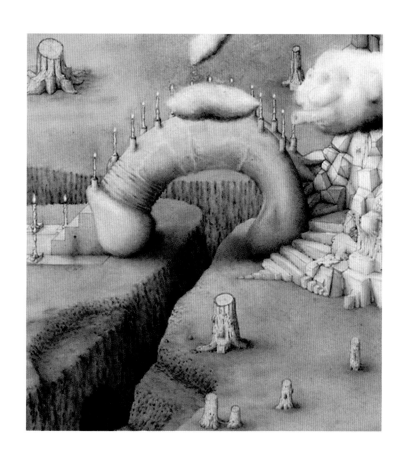

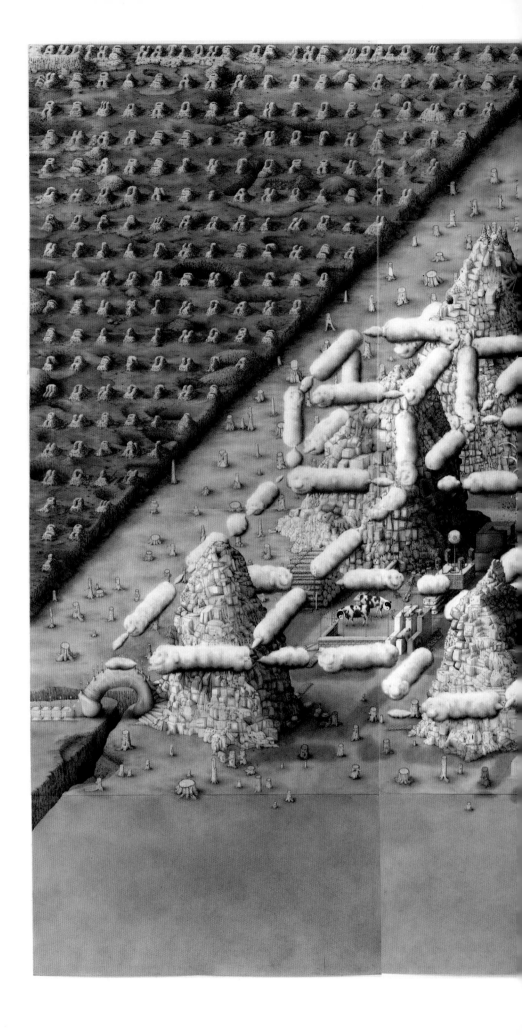

Acumulus Noblitatus 2001
(no.47)

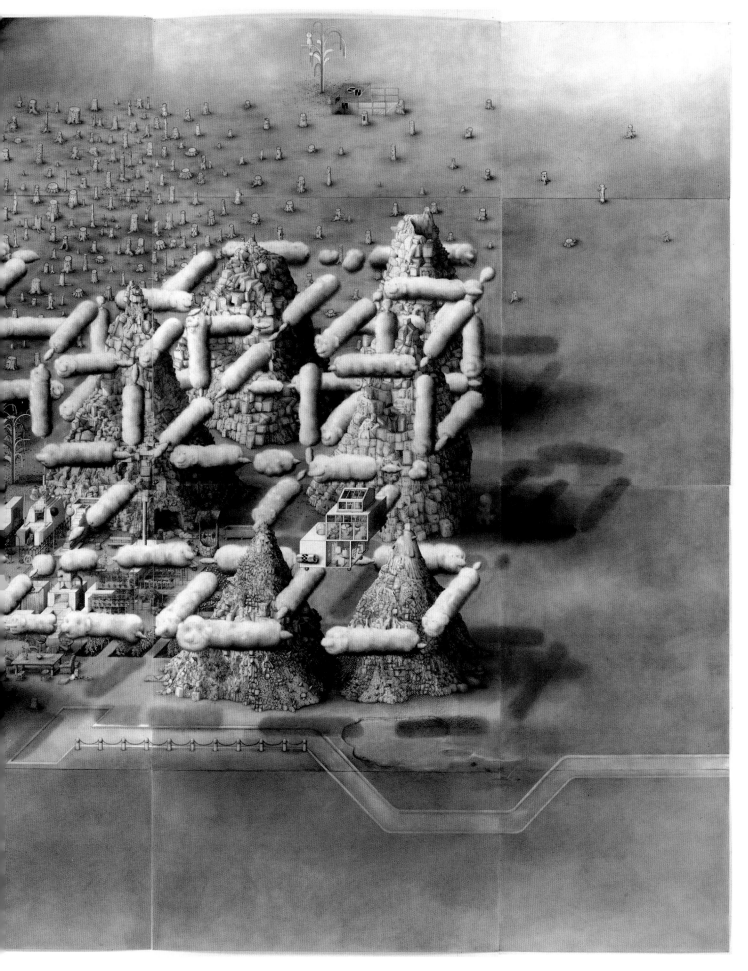

Cornelia Parker

London-based Cornelia Parker was born in 1956 in Cheshire. She studied at Gloucestershire College of Art & Design in 1974 and then attended Wolverhampton Polytechnic from 1974 to 1978. From 1980 to 1982 she studied for an MFA at Reading University. Parker has had numerous solo exhibitions including the *The Maybe*, Serpentine Gallery, London (1995); ICA, Boston, Massachusetts (2000); *Avvistamenti – Sightings*, Galleria d'Arte Moderna e Contemporanea, Turin (2001). She has participated in many group shows, including *Material Culture* at the Hayward Gallery, London (1997); *Postmark: An Abstract Effect*, Site Santa Fe (1999) and *Between Cinema and a Hard Place*, Tate Modern (2000). In 1997 she was shortlisted for the Turner Prize.

Cornelia Parker is concerned with investigating the nature of matter. Her approach to making sculpture has been likened to that of a particle physicist, yet her particular line of enquiry does not rely on fixed meaning for effect but rather conjures up a rich series of visual and verbal connections. Parker describes her work as being 'akin to a chemical reaction between the artist and the stuff of the world' – whereby the artwork exists as a by-product of the initial encounter but also acts as catalyst, sparking off its own reactions within the viewer.[1] The work ranges in scale from the monumental to the microscopic; from *Exhaled Schoolhouse* 1990 in which she covered the entire exterior of a school house in chalk marks, to *Einstein's Abstracts* 1999 (p.126), traces of chalk from the blackboard used by Albert Einstein to illustrate his theory of relativity.

The artist has described how as a child she was fascinated by encyclopaedias. In particular, she collected old copies of *The Popular Science Educator*, a weekly-illustrated magazine devoted to exploring popular science, the realms of history, nature and technology. Published in the 1930s for children and young adults, it sought to clarify a wide variety of subjects and concepts, from demystifying topics such as the 'marvels of modern science to dangerous exploits of intrepid adventures'.[2] Thematically arranged, it attempted to give the reader insight into the universe by measuring it on a human scale. It is this curiosity about the things that you cannot see, such as hidden measurements or volumes, that underpins many of her investigations. Parker is interested in the possibility of taking something familiar and subverting it in an attempt to describe the indescribable.[3] For example, with *Measuring Niagara with a Teaspoon* 1997 she has stretched a teaspoon into a fine wire whose length equals the height of Niagara Falls.

The work often pivots around the idea of an act of violent transformation. She is fascinated with processes that seem to mimic cartoon 'deaths' and cites the tragic-comic cartoon world of *Tom and Jerry* as a source of inspiration.[4] Under her charge objects explode, combust, collide or are compressed only to re-emerge in new and surprising forms. For example, in *Thirty Pieces of Silver* 1988-9, a collection of silver-plated objects including trophies, teapots, spoons and candlesticks were flattened by a steam roller and then suspended in groups, hovering just above the gallery floor. The title refers to the money for which Judas betrayed Christ and the piece involves symbolically killing off one set of values (pretensions of grandeur) to reveal another – in this instance, the base metal which is resurrected as sculpture. Meanwhile, *In Cold Dark Matter: An Exploded View* 1991, a garden shed and its contents were blown to bits with the help of the British Army and then reconfigured as a sculptural interpretation of the 'Big Bang'.

Cold Dark Matter: An Exploded View is Parker's first work to actually involve an explosion. It also reflects the artist's interest in cosmology and her fascination with gravity as a basic force. Another work, *Words that Defy Gravity* 1992, underlines how an appreciation of the behaviour of mass in space is essential to the physical sense of Parker's work and its metaphorical interpretations. Here, she cast the

dictionary's definition of gravity in lead. Then, in an act which rendered the invisible visible, each word was thrown off the White Cliffs of Dover. The crushed elements were subsequently recovered and displayed suspended from fine wires in order to present their transcendence of the earth's gravitational pull. This spirit of playful scientific exploration is also present in Parker's on-going attempts to enlist the assistance of NASA in sending a meteorite back into space.

The piece titled *Mass (Colder Darker Matter)* 1997 marks an important development in Parker's series of 'exploded works'. The installation is constructed from the charred remains of a Texas church that was struck by lightning. 'I went down and asked the Baptist minister if I could have the charcoal to make a charcoal drawing – which is what I consider this to be.'[5] Here the artist is no longer seen to be the protagonist; rather *Mass (Colder Darker Matter)* uses 'an act of God' as the explosive device which in turn formalises a temporal event. Moreover, it prefigures a number of installations, objects, drawings and photographs that draw upon natural and super-natural destructive forces. These range from *Edge of England* 1999 (p.127), in which she used wire to suspend chalk retrieved from a cliff fall at Beach Head, to *Untitled* 1999, a cabinet full of relics from a poltergeist case including objects that allegedly spontaneously combusted and a teapot that danced on its own.

The found or modified object has always played a key role in Parker's practice. Her investigation of the 'secret lives' of objects and materials owes much to the artist's interest in Dada and Surrealism. For example, *Feather that went to the Top of Everest (in the jacket of Rebecca Stevens, the first British woman to climb Mt. Everest)* 1997, is one of a number of photograms of feathers associated with famous people and places.

Elsewhere Parker's engagement with the conventions of museum display and taxonomy highlights how she delights in the frisson of language against object. She is more interested in the history or provenance of specific items than with any material value. There are the Rorschach blots made with ferric oxide extracted from pornographic videotapes that had been seized by customs, and a loaf of bread sliced in half by the guillotine blade that beheaded Marie Antoinette. These ideas are also reflected in *The Maybe* 1995, a collaboration with the actress Tilda Swinton. Swinton was presented sleeping in a glass vitrine surrounded by a collection of labelled objects that used to belong to historic figures. Parker is intrigued by the clichéd symbolic properties of everyday objects and the presence they acquire through associations; her matter-of-fact titles indicate historical origins and Parker's juxtapositions. For example, the brain of Charles Babbage, inventor of the computer, is placed next to the scientist Michael Faraday's electric spark apparatus. Through the crisscrossing of different histories and associations, *The Maybe* suggested a strange reliquary of everyday objects, which in turn were transformed into symbolic representations. In this way the work underwent a process of transubstantiation and triggered new layers of meaning that extend across history, science and literature.[6]
Clarrie Wallis

Blue Shift 2002
Polaroid
8 × 8.5 (3 1/8 × 3 1/4)
Courtesy the artist and
Frith Street Gallery, London

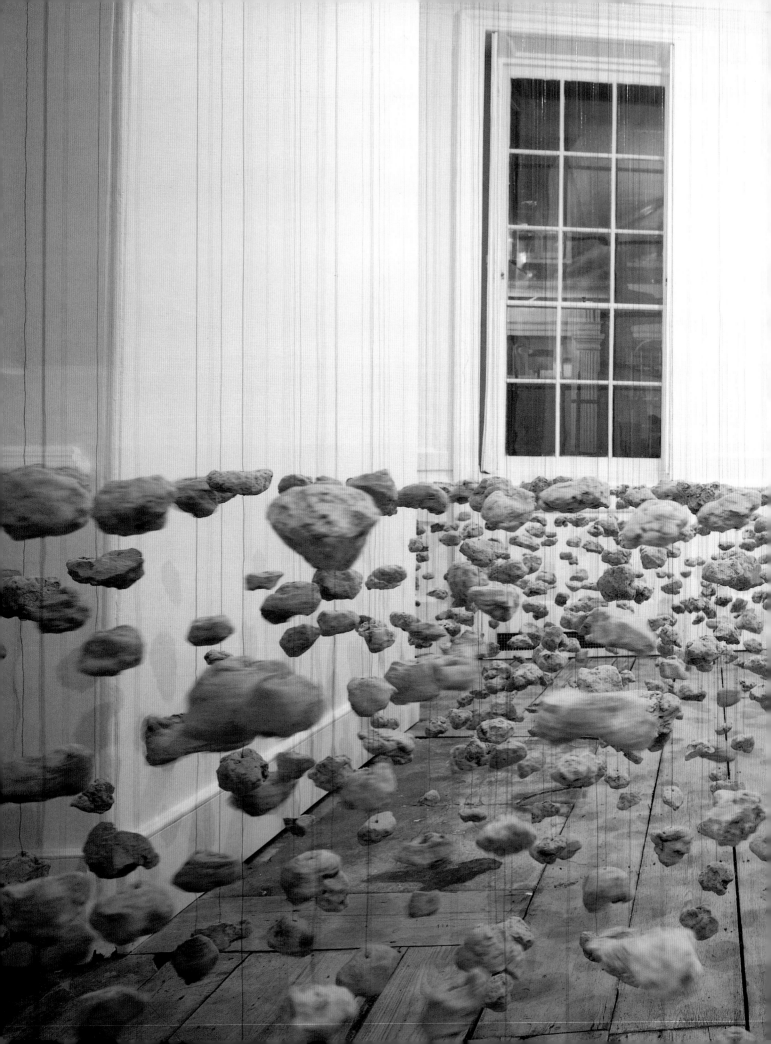

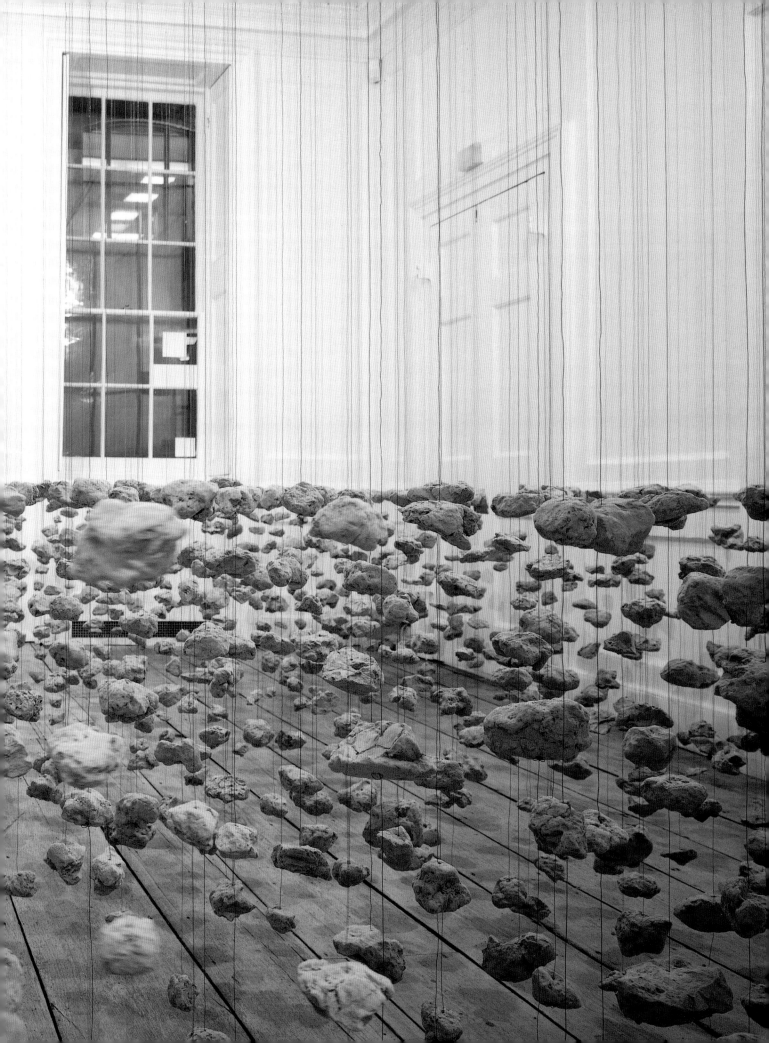

Previous page:
Subconscious of a Monument
2002
Soil excavated from beneath
the Leaning Tower of Pisa, wire
Dimensions variable
Courtesy Frith Street Gallery,
London

Einstein's Abstracts 1999
Photomicrograph (×50) of the blackboard
covered with Einstein's equations from his
lecture on the theory of relativity, Oxford, 1931
Cibachrome on aluminium
58.5 × 75.5 (23 × 29 3/4)
Courtesy the artist and Frith Street
Gallery, London

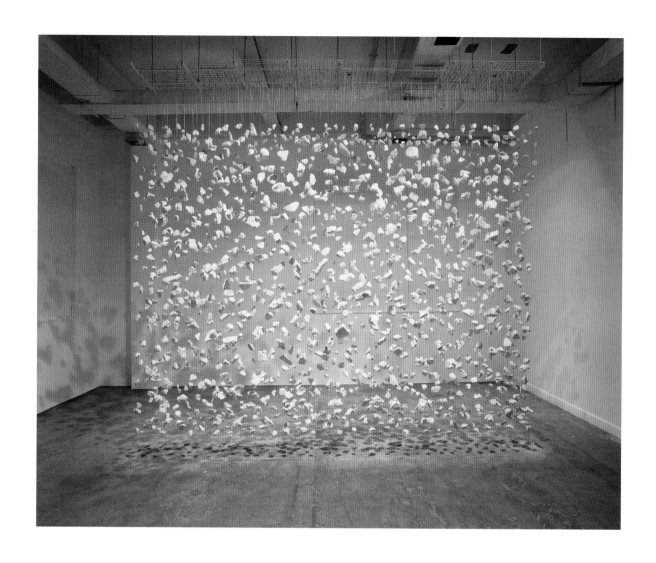

Edge of England 1999
Chalk retrived from
cliff fall at Beachy Head,
South Downs, England
Chalk, wire, mesh
Dimensions variable
Collection of Milwaukee
Art Museum

Susan Philipsz

Susan Philipsz was born in 1965 in Glasgow. She studied at Duncan of Jordanstone College of Art, Dundee (1989–93) and the University of Ulster (1993–4). Philipsz worked in New York on a P.S.1 fellowship between 2000 and 2001, and in Berlin, on a residency at Kunst-Werke in 2002. She was shortlisted for the Glen Dimplex Artists Awards, Irish Museum of Modern Art, Dublin, in 2001. Philipsz has exhibited widely, including solo shows and public commissions at The Old Museum Arts Centre, Belfast (2000); Consortium Gallery, Amsterdam (2000); Temple Bar Gallery, Dublin (2002); Triskel Arts Centre/Cork Midsummer Festival, Cork (2002); DAE, San Sebastian, Spain (2002); 38 Langham Street, London (2003); and ArtPace, San Antonio, Texas (2003). She has taken part in a number of group exhibitions, including The Melbourne International Biennial (1999); *My Eye Hurts*, Cornerhouse, Manchester, and Thread Waxing Space, New York (1999); *Girl*, The New Art Gallery, Walsall, and Angel Row Gallery, Nottingham (2000); Manifesta 3, Ljubljana, Slovenia (2000); Tirana Biennial, Albania (2001); *Loop*, P.S.1, New York, and Kunsthalle, Munich (2001); *Glen Dimplex Artists Awards Exhibition*, IMMA, Dublin (2001); and *New York, New Sounds, New Spaces*, Museum of Contemporary Art, Lyon (2002).

Susan Philipsz uses sound – particularly her own voice – to create simple, subtle artworks. Yet her work presents us with an intriguing paradox. While evoking memories and emotions, the artist is also interested in the way that sound, and music in particular, can stimulate a heightened sense of the present and of architectural space. In contradiction to the commonly held notion that music and song embody a form of escape from the world around us, Philipsz does not aim to take us out of ourselves, but rather to return us to a sense of self. She explains: 'My work deals with the spatial properties of sound and with the relationships between sound and architecture. I'm interested in the emotive and psychological properties of sound, how meaning changes through its delivery and context, and how it can be used as a device to alter individual consciousness. I have used sound as a medium in public spaces to interject through the ambient noises of the everyday. Using my own voice I attempt to trigger an awareness in the listener, to temporarily alter their perception of themselves in a particular place and time.'[1]

Philipsz achieves this shift of perception by creating carefully considered site-specific installations in which her subtle aural interventions are smuggled into the consciousness of the audience. Bill Drummond has written of his admiration for the way her work mingles 'with life's moments as they pass by, being consumed by people who have no idea that they are in the process of consuming art'.[2] Her characteristic way of working is to record herself singing unaccompanied versions of popular or folk songs – songs with a freight of cultural and emotional baggage – in her 'fine but endearingly fallible' voice.[3] These songs are replayed in public spaces, or in the gallery. Her work entitled *Filter* exemplifies this approach. Originally created for the Laganside Bus Centre, Belfast, in 1998 (although subsequently presented in a number of galleries including Thread Waxing Space, New York, Cornerhouse, Manchester, and at the Tirana Biennale, Albania) the work consists of Philipsz singing *a cappella* renditions of songs by Radiohead, Marianne Faithfull, Nirvana and The Velvet Underground, played through the public address system of the bus station. The forlorn and melancholy songs articulate feelings of loneliness and longing. Given the context of the bus station, a scene of departures and arrivals, they become emotional triggers and a possible response for the audience is to reflect on their personal reasons for, and feelings about, being in that particular place at that particular time. The quality (or character) of the place (both public and personal) is thus thrown sharply into relief.

The work that Philipsz made for Manifesta 3 in 2000 in Ljubljana had a similarly simple and moving premise. Her solo *a cappella* version of the old socialist anthem 'The Internationale' was played through a single trumpet speaker situated in a public underpass, to be discovered by unsuspecting passers-by. Given the recent history of Slovenia this was a potentially loaded scenario, both evocative and provocative. But Philipsz chose to highlight the ambiguity of the piece, pointing out that her rendering of the song was 'neither passionate nor sorrowful' and that 'it could be interpreted as either a lament for something that has past or, as the song suggests, a clarion call for political action'.[4]

More recently Philipsz has made work that doesn't rely only on her voice. In *Company* 2001 we hear a tune being absentmindedly and falteringly picked out on a piano. The tune is the theme from Nicolas Roeg's seminal psychological thriller *Don't Look Now* (1973). Whether or not we recognise the music it evokes a specific set of emotional responses through the triggers in the score and the very particular way in which it is being played. Philipsz has said that *Don't Look Now* was of interest as it contains thematic motifs which are akin to themes which run through her own work, including 'loss, longing and memory', thus offering another dimension for interpretation.[5] Other recent works have used film, including *The Dead* 2001 (in this case a blank projection), and *Victory* 2001, which features a recording of a tuba imitating a Viking horn, installed on the boat that cruises the River Lagan in Belfast. In the summer of 2002 she created a site-specific work in Cork, *Cast Together in 'C'*, using bells rung in the two towers of St Finbarr's and St Anne's Shandon Churches. If her voice is not the primary medium, sounds (or music), and their associative and emotive qualities nonetheless remain at the heart of her work.

And herein lies the paradox. While Philipsz can claim that 'with my work I am trying to bring an audience back to its environment, not the opposite', and that 'what I am trying to do is make you more aware of the place you are in while heightening your own sense of self', and without denying that this is undoubtedly one effect that the work has, the songs she sings *do* offer the possibility of transcendence and escape, even in her pared down, intensely private and personal renditions.[6] For they do evoke memories, people, states of mind and different times and places within our own histories. Yet perhaps it is these very unresolved tensions and contradictions – between history and the here and now; the present moment and the remembered moment; public and private; architectural space and personal space – and the possibility of such a varied range of responses, that make her work so rich and rewarding.
Ben Tufnell

Filter 1998
Sound installation at
Laganside Bus Centre, Belfast
Courtesy the artist

Overleaf:
Wild as the Wind 2002
Sound Installation at
San Sebastian, Spain
Courtesy the artist

Nick Relph and Oliver Payne

Oliver Payne (born 1977) and Nick Relph (born 1979) are both based in London and occasionally New York. Oliver Payne studied at Kingston University Fine Art, Intermedia BA from 1997 to 2000 (failed). Nick Relph studied at Kingston University Fine Art, Intermedia BA from 1998 to 2000 (expelled). Exhibitions in 2002 include *Mixtape*, Gavin Brown's enterprise, Corp., New York, *Videodrome II*, New Museum of Contemporary Art, New York, *Shoot the Singer: Music on Video*, Institute of Contemporary Art, Philadelphia, USA, and *Non-Places*, Frankfurter Kunstverein, Frankfurt, Germany (both 2002). Nominated for 2002 Beck's Future Prize, ICA, London, UK. Exhibitions in 2001 include *Humid*, The Moore Building, Miami, *Sound and Vision*, Institute of Contemporary Art, London, UK, *The Essential Selection*, Gavin Brown's enterprise, Corp., New York, *Atelier Something*, London, UK, 8th Annual New Toronto Works Show, Cinecycle, Toronto, Canada, Pandaemonium Festival, The Lux Centre, London, UK. In 2000, Relph and Payne took part in *Protest and Survive*, Whitechapel Gallery, London, and *Fig-1*, London.

Gentlemen 2003 (no.51)
Stills from video projection
Courtesy the artists and Gavin Brown's enterprise, Corp., New York

Between 1999 and 2001, Nick Relph and Oliver Payne made three films entitled *Driftwood* 1999, *House and Garage* 2000 (pp.136–7) and *Jungle* 2001, a trilogy based on London, its suburbs and the surrounding countryside.

Driftwood begins in the Waterloo area, around the South Bank Centre whose concrete ramps continue to draw skateboarders despite the authorities' attempts to put obstacles in their way. The film then takes us on a journey through London's new found financial district in Canary Wharf to the former home of the English upper classes in Mayfair. Narrated by the artist's close friend Ben Keyworth, the film then outlines the history of Soho which, in the early eighteenth century, saw an influx of refugees, among them Greek Christians fleeing Ottoman persecution. The carnival of artists and revolutionaries who came to settle there over the subsequent years further established the district as a somewhat sleazy watering-hole that later attracted figures such as Francis Bacon and Lucian Freud. Having mapped out the city's psycho-geography, *Driftwood*'s conclusion is that present day London is in the throes of unwelcome corporate strategies.

The title of *House and Garage* is a reference both to desirable home ownership and popular music genres. It opens with an ambient soundtrack accompanying a blurred image of a nondescript teenager. Interspersed with images of parkland deer, the teenager's emerging identity appears to be at the juncture of childhood and adulthood, drawing comparison with the emergence of the suburbs from the juncture of town and country. Adopting a home-movie format, *House and Garage* depicts a space where imported cultures rub shoulders with middle-England. A man in a cowboy hat performs a country and western line-dancing routine in a domestic interior, while another scene captures a group of youngsters rapping to drum and bass music. Teenage nonconformity is captured by a boy ritualistically lacing his school tie into an unorthodox knot. In his den-like bedroom another teenager relays an elaborate story about a friend's run-in with the police and is interrupted by his mother shouting up the stairs 'Your tea's ready!' The closing scene of the film shows fireworks replayed backwards to a muffled recording of The Sex Pistol's 'God Save the Queen' (1977). The anti-climax of the imploding as opposed to exploding fireworks emphasises the air of teenage nihilism.

Jungle opens on an area of sky in which a local claims to have sighted a UFO. The eye-witness account seems even more spurious when all we can see is thin air. There follows a frenetic scene of a man rolling a burning barrel up a narrow street packed with onlookers. Filmed at the festival of fire at Ottery St. Mary in Devon, which takes place every year on 5 November, the strangeness of the re-enactment of this ancient ritual evokes a sense of collision between local customs and present day rural politics. The Countryside Alliance, a recent addition to the British political landscape, are filmed on a march through Leamington Spa. This group came to the fore in the late 1990s as a result of rural communities' increasing frustrations with central government, notably over its attempts to ban fox hunting. While the Alliance's membership is drawn from all walks of life, the landed gentry also make up many of its numbers which makes for the unusual sight of a parade of aristocratic dissenters.

A number of references run throughout Relph and Payne's trilogy. *Driftwood* has been compared favourably to Patrick Keiller's *London* (1994), which also examines the city through the eyes of its lone narrator. Both *House and Garage* and *Jungle* recall films by Harmony Corine, as well as the likes of John Maybury and Derek Jarman whose use of collage techniques coincides with Relph and Payne's own.

Mixtape 2002 (pp.134–5) takes as its starting point a recording by experimental musician Terry Reily entitled 'You're No Good'. Originally recorded in 1967, Reily's soundtrack involves the meshing together of layer upon layer of sampled music, starting with a beating monotone which steadily increases in pitch and intensity. As the camera draws back from a close-up of a teenager holding a sparkler in his mouth, the scene widens further to reveal birds of prey on pedestals and a large floral wreath saying 'Besht Mate'. As the music reaches a crescendo, black paint starts running down the walls and the entire set is covered in a shower of confetti. The music loops into a 1960s soul track accompanying scenes of a kids' garage band and a girl dancing gracefully in an underpass. A bejewelled tortoise and a Rastafarian in the street tapping the pavement with a hammer are both symbolic references: the first to J.K. Huysmans' novel *Against Nature* (1884), the latter to reggae musician Lee Scratch Perry who reportedly hammered the streets of Jamaica in an attempt to goad the devil. The line-dancer featured in *House and Garage* returns, this time under vivid strobe lights. Images of English wildlife and parkland deer form a background to a couple making out on a sofa, at which point the film unexpectedly cuts to footage of American rifle clubs out hunting.

Relph and Payne's most recent film to date, *Gentlemen* 2003, takes us on a journey into the subterranean world of public toilets. Owing to severe local authority cut backs, London's public lavatories are by no means as public as they once were. The first underground convenience opened in 1852 in Fleet Street in an attempt to stop the populous from fouling the streets. Many were designed in the Victorian era and were constructed from sturdy ceramic basins and copper-pipes. At street-level they were encircled with an iron fence and crowned with arches or pergolas. By the mid twentieth century, these shrines to public civility had become synonymous with the seedier side of life as depicted in *Prick Up Your Ears* (1987), Stephen Frears's film of the 1960s playwright Joe Orton's late-night lavatory trawls in search of sexual gratification. By the late-twentieth century, London's mostly neglected toilets had become drop-in centres for illicit sex and drug consumption. Marking the decline of this public service, Relph and Payne make the analogy that the deterioration of public toilets is like London's underground culture, on the wane in the face of more upmarket tastes and values.

Gregor Muir

Mixtape 2002
Stills from video projection
Courtesy the artists and
Gavin Brown's enterprise,
Corp., New York

House and Garage 2002
Stills from video projection
Courtesy the artists and
Gavin Brown's enterprise,
Corp., New York

George Shaw

George Shaw was born in
Coventry in 1966. He attended
Sheffield Polytechnic from
1986 to 1989 and the Royal
College of Art from 1996 to
1998. He has exhibited widely
and recent solo exhibitions
include *Of Innocence: Scenes
from The Passion*, Anthony
Wilkinson Gallery (1999);
Morrissey vs Francis Bacon,
Nunnery Gallery, London
(2000); *The New Life*, Anthony
Wilkinson Gallery (2001); and
Ikon Gallery, Birmingham
(2003). His numerous group
exhibitions include
Interesting Painting, City
Racing, London (1997);
A–Z, The Approach, London
(1998); *New Contemporaries*,
Tea Factory, Liverpool; Camden
Arts Centre, London; Hatton
Gallery, Newcastle (1998);
EAST International, Norwich
Art Gallery (1999); *as it is*,
Ikon Gallery, Birmingham
(2000); *Fear it do it anyway*,
Vilma Gold, London; *Air
Guitar*, Milton Keynes Gallery
and Cornerhouse, Manchester,
(2002); and *Face Off*, Kettle's
Yard, Cambridge (2002).
He lives and works in
Nottingham.

It could be said that George Shaw lives in the past and spends too much time reflecting on his seminal teenage years, *c*.1976–85. Yet the apparently straightforward nostalgia present in his work is not as simple as it at first appears. Shaw's haunting paintings depict landscapes from about twenty years ago, but they are based on photographs of the present. The theme of these paintings is only in part the urban landscape of his upbringing. The other subject is memory, our reliance on and fondness for it, as well as its inherent failings.

Shaw grew up in Tile Hill, one of the first post-war council housing estates in Coventry; the city is surrounded by the Forest of Arden which stretches all the way to Stratford-Upon-Avon. Having left the area in his late teens, Shaw has now returned to paint the ordinary scenes of his childhood: the identical terraced houses, the communal grassy areas between blocks of flats, the local pub, a row of derelict garages, all found within a short walk of his family home. Shaw uses Humbrol Airfix enamel model paint in a range of just seven colours, which gives his work a distinct look and texture. The use of this unusual paint, reminiscent of boyhood obsessions, allows Shaw to render in meticulous detail the red brickwork, the grass in the foreground and the leaves on the trees, drawing the viewer in to these compelling portraits of familiar urban settings.

Shaw works from hundreds of snapshots that undergo a careful editing process. He omits details that will pin the scene down to a specific date or time, especially recent additions such as recycling bins or satellite dishes. He leaves in features which are triggers for particular memories, for example an old-fashioned red telephone box on the corner of the street. It is through this editing procedure that the failings of memory are exposed. Shaw tells a story of how his brother looked at a painting and pointed out a building which wasn't there in the late 1970s, but Shaw was so accustomed to it that it had become part of his recollection of that time. The absence of people adds to the timeless quality of the paintings. Just as we expect a fifteen-year-old George to appear from around the corner, we can also imagine ourselves in the present, walking down the paths. For as well as representing specific locations, these paintings offer generic images of a typical English town.

Surprisingly green for depictions of a housing estate, the paintings invariably focus on the periphery of the area: the fence holding back the trees on the edge of the road, the path through the woods, the underpass covered in graffiti and smelling of urine. Despite the unusual subject matter, the classical compositions provide a satisfying order, with the perspective often suggesting a destination far in the distance. Shaw comments that his paintings depict 'places I knew as a child: the park, the end of the street, some shops, the woods, a pub or two. There are paths and roads leading in and out. They are as much about what has been forgotten, lost, swept away as much as they are about what is remembered. They are illustrations to and signposts on a journey. But I am unsure whether the journey is in or out, backwards or forwards.'[1] These are the zones in which the historic Forest of Arden, the setting for Shakespeare's play *As You Like It* (1598–9), meets the more recent history of English modernity in the form of social housing. But Shaw's paintings are not depressing images in the way television documentaries insist on characterising the legacies of these post-war housing solutions: these paintings are beautiful. Created by someone who has lived there, the images remind us that we are so used to condemning these estates that we forget people have been happy growing up in them and are indeed fond of their neighbourhoods, in spite of their failures. Shaw's works follow a tradition of English landscape painting, found in Thomas Gainsborough, John Constable and Stanley Spencer, which is dedicated to recording a way of life. These are realistic paintings, not just in style, but in their truthfulness to the reality of the experience of this place. This is not rose-tinted nostalgia, but it is nevertheless sentimental.

If the paintings are memories of past places, Shaw also makes drawings which depict the people who occupied his life at that time. These are the people we can imagine Shaw thinking about as he sloped home after school; Ian Curtis of Joy Division, James Dean, Peter Sutcliff, characters from Doctor Who, the kid from Ken Loach's film *Kes* (1969). The sketches have a recognisable quality, the kind of accomplished drawing that would have made Shaw stand out at school. Then as now, Shaw made his observations both as an insider, and looking in from the outside, separated from his peers by his unusual interest in art – not a common career path at his school. Shaw is perhaps more clearly influenced by literary figures than other artists. Among the icons he draws are Philip Larkin and Samuel Beckett. Indeed Shaw also uses writing as a means of expressing himself; commenting, 'Because there can be no-one else to talk to … I have written it down in small books and scraps of paper, in pubs and public places, sober and pissed.'[2] Shaw has a very specific project which is to record the identity of his home town – a dedication similar to that found in the Ken Loach films, Dennis Potter plays and Philip Larkin's writing that his father introduced him to at an early age. He has absolutely no interest in painting anywhere else; for Shaw there is enough life and meaning in this small and seemingly insignificant part of the world to offer endless inspiration. As Philip Larkin commented about Coventry, and as Shaw's paintings show, 'nothing, like something, happens anywhere'.[3]
Katharine Stout

*Scenes from the Passion:
Late 2002* 2002 (no.52)
Humbrol enamel on board
91 × 121 (35 3/4 × 47 5/8)
Tate. Presented by the
Patrons of New Art
(Special Purchase Fund) 2003

Scenes from the Passion: The Middle of the Week 2002 (no.53)
Humbrol enamel on board
77 × 101 (30 1/4 × 39 3/4)
Courtesy Anthony Wilkinson Gallery,
London

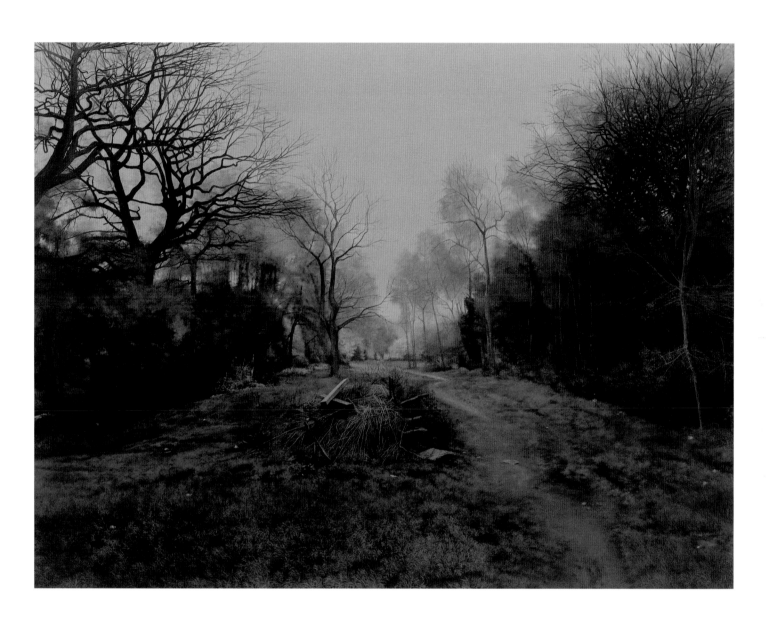

Scenes from the Passion: The Fourth of November 2002 (no.54)
Humbrol enamel on board
77 × 101 (30 $^1/_4$ × 39 $^3/_4$)
Purchased by the Contemporary Art Society Special Collections
Scheme on behalf of Birmingham Museums & Art Gallery
with funds from the Arts Council Lottery, 2003

Man, Boy and Kestrel
1999–2000
Pencil on paper
42 × 59.5 (16 ½ × 23 ³/8)
Private Collection, London

Scenes from the Passion:
The Hawthorne Tree 2001
Humbrol enamel on board
92 × 121 (36 1/4 × 47 5/8)
Private Collection, London

Rachel Whiteread

Rachel Whiteread was born in London in 1963. She studied painting at Brighton Polytechnic from 1982 to 1985 and sculpture at the Slade School of Fine Art, London from 1985 to 1987. Since the early 1990s Whiteread has been a prominent figure in British sculpture. In 1993 she was commissioned by Artangel to realise *House*, a cast of a Victorian terraced house in the East End of London. The same year she won the Turner Prize. In 1995 she won the prestigious commission for the *Holocaust Memorial* 2000, Judenplatz, Vienna, her first permanent, public sculpture. The concrete cast of a library is intended as a monument and memorial to the Austrian Jews who died at the hands of the Nazis. In 1997 she represented Britain at the Venice Biennale. Whiteread has had important solo exhibitions including *Shedding Life*, Tate Liverpool (1996), the Serpentine Gallery, London (2001) and most recently *Transient Spaces* at the Deutsche Guggenheim Berlin (2001). She lives and works in London.

Untitled (Rooms) 2001
(detail, no.57)
282 × 726 × 1343
(111 × 285 3/4 × 528 3/4)
Mixed media
Tate. Purchased with funds provided by Noam and Geraldine Gottesman and Tate International Council, 2003

Rachel Whiteread's work can be described as an investigation into sculpture as form, material and process. She typically uses materials such as plaster, resin and rubber to cast the space underneath, around or inside objects, creating negative impressions of each chosen item. Through this process, inside becomes outside and space becomes solid form. This approach to making work has been consistent since her undergraduate days yet the method of construction has become more refined over time. Her first casts were of found objects – such as mattresses, baths, sinks and chairs – that she had discovered in second-hand shops or through advertisements in newspapers. Whiteread has described how early works such as *Closet* 1988 were made. 'I simply found a wardrobe that was familiar, somehow rooted in my childhood. I stripped the interior to its bare minimum, turned it on its back, drilled some holes in the doors and filled it with plaster until it overflowed. After the curing process the wooden wardrobe was discarded and I was left with a perfect replica of the inside.'[1]

Whiteread's work has been related to Minimalism and post-Minimalism, in particular to a number of works by Bruce Nauman. Yet the artist can also been seen in the context of a number of leading contemporary sculptors, including Doris Salcedo and Miroslaw Balka, whose concerns encompass the body, absence, mortality, memory and abjection. On the one hand Whiteread's work appears minimal in its simple forms, while on the other it is steeped with associative meaning that draws on common experience. While her casts vary in scale, her constant reference remains the human body. The objects she chooses to work with all have an intimate, physical relationship to the body's shape and function and experience of space. Closet, for example, stemmed from a particular childhood memory of sitting inside wardrobes whereas *Shallow Breath* 1988 represents the space underneath a bed.[2] This line of enquiry suggests a link to the French philosopher Gaston Bachelard's *The Poetics of Space* (1957), a critique on the subliminal codes of found and composed spaces. Bachelard argued that our childhood experience of spaces, in particular the home, form a psychological base that we use throughout life in order to evaluate our place in the world. Whiteread's work interprets space, its perception and representation in a similar manner.

The choice of materials has always been important to the artist. She was originally attracted by the surface sensitivity of plaster and for this reason has often likened her works made in this material to frescoes. For example, with *Yellow Leaf* 1989 – a cast of a kitchen table – the history of the object and method of casting is much in evidence in the surface of the final sculpture. In addition to the surface dust and dirt, the plaster picked up the yellowish residue of the cooking oil used as a release agent. Whiteread first began to use materials such as rubber as an alternative to plaster in 1991. She has described how the limitations of plaster had begun to frustrate her so it was liberating to work with a more robust material and to find ways of introducing colour, which can be seen in works such as *Untitled (Black Bath)* 1996.[3] The desire to realise a work that had an inherent transparency which

revealed its internal and external structure led Whiteread to embark on a series of works in resin, including *Monument* 2001. This temporary sculpture for the empty plinth in Trafalgar Square was unusual for the artist in as much as it was a positive cast of an object shown in relation to its source object, the plinth on which it stood.[4]

In 1990 Whiteread realised her first architectural work. *Ghost* was cast from the living room of a deserted Victorian terraced house in North London. Assembled with the positive side facing outwards, the four walls created an impenetrable space. This familiar yet strange form emphasises the private aspects of domestic life and evokes strong feelings of absence, loss and remembrance, all of which are suggested by the work's title. Whiteread has described how she wanted to 'mummify the air in a room'. Elsewhere the artist has likened the process of casting to the making of a death mask, as traces of the past – soot from the fireplace, paint and scraps of wallpaper – cling to the surface plaster and reinforce the sense of *memento mori* for the lives that had been spent within these those walls. As a memorial to everyday existence, *Ghost* anticipated *House* 1993, a concrete cast of the entire interior space of a house, the last remaining from an otherwise already demolished terrace in the East End of London. Hailed as a monument to a lost community, this temporary work generated intense debate. Standing for only a few months during the winter of 1993–4, *House* attracted tens of thousands of visitors.

The same year that *House* was unveiled Whiteread realised *Untitled (Room)*, a negative cast made from a fictional space constructed in the artist's studio. Devoid of architectural decoration, it paved the way for casts of large architectural spaces. While earlier works had been steeped with associative meanings, these works are more concerned with formal issues that explore relationships between architecture and the body. For example, Whiteread has recently made a group of works cast from a London building she has acquired. *Untitled (Rooms)* 2001 (pp.146–8) comprises of a series of rooms leading off a main corridor. Its fabrication involved the complicated process of casting a multi-room structure, requiring Whiteread to solve the problem of how to depict the gaps in the structure where the walls once existed. As the artist explains, 'With *Apartment*, everything was cast around the architectural elements and the casts removed in sections. So when you look at the piece, there is a space between the rooms where the wall once was.'[5] The work's austere purity emphasises the simple geometry of the structures they were cast from. This is further reinforced by the artist's use of a blank release agent which left the surfaces of the sculpture free from the traces of past occupancy that exist in much of her previous work. *Untitled (Rooms)* and its companion *Untitled (Stairs)* 2001 (p.149) a cast of a staircase reoriented by being set on its side, can both be seen in the lineage of projects involving architectural scale that have spanned Whiteread's career. Together they highlight the ongoing refinement of her sculptural vocabulary and engagement with spatial transformation.
Clarrie Wallis

Untitled (Rooms) 2001
(detail, no.57)

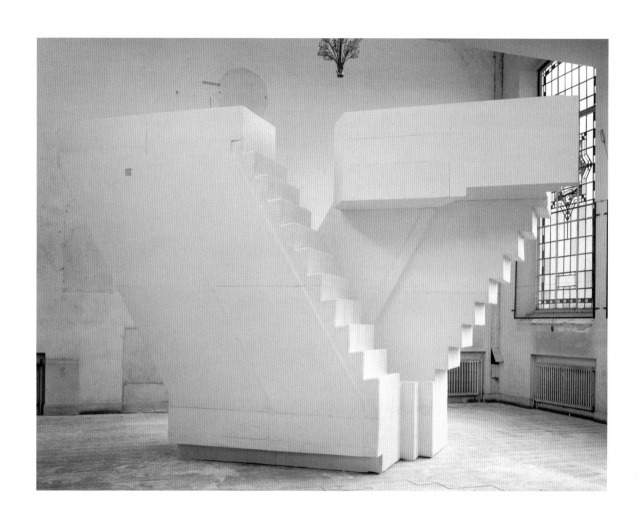

Untitled (Rooms) 2001
(detail, no.57)

Untitled *(Stairs)* 2001 (no.58)
Mixed media
375 × 220 × 580 (147 $^5/8$ × 86 $^5/8$ × 228 $^1/4$)
Tate. Purchased with funds provided by the National
Art Collections Fund and Tate Members, 2003

Shizuka Yokomizo

Shizuka Yokomizo was born in 1966 in Tokyo, and currently lives and works in London. She completed an MA at Goldsmiths College, London in 1995. She has exhibited at Coam, Leslie + Browne, New York (2001), The Approach, London (2002), and the Museo d'Arte Contemporaneo di Rome, Rome (2002). She has also participated in many international group exhibitions including *Articulate Voice*, Yokohama Civic Art Gallery, Yokohama City (2000), *Present Future*, Artissima Internazionale d'Arte Contemporanea, Turin (2001), *Spectator*, Galerie Fotohof, Salzburg (2002) and *Reality Check*, The Photographers' Gallery and British Council touring exhibition (2002).

Strangers 1999 (pp.152–3) is a photographic series by Shizuka Yokomizo that demands an intimacy many might find intrusive. The artist wrote to participants asking them to allow themselves to be photographed anonymously in their home for a duration of ten minutes by a stranger viewing them from the street. The resulting series of twenty-four images shot in London, Berlin, New York and Tokyo, explores the construction of personal space and identity in the city, and how this is altered through human interaction. In her letter Yokomizo asked the subject to relax – it is an honest self-portrait that she desired. She waited for a feeling of equality, mutual observation, a sense of the subject relaxing into themselves as they watch her at work. It was the subject who decided whether or not to open their curtains or turn on the light, revealing themselves and their home as they wished to be seen, while the artist stood on a dark street, encumbered by equipment, vulnerable to passers-by. How many participants started to doubt the wisdom of their decision over the course of ten minutes, as Yokomizo took the photographs? How many no longer felt in control, not knowing where to look? Just as Yokomizo watches the subject, so the subject watches her: the watcher and the watched co-existing, creating a strange and shifting symbiosis of subject and object.

Yokomizo's photographic series, *Untitled* 2002, marked a departure in terms of the artist's relationship with her subjects. In this series Yokomizo photographed people that she knew well in what appear to be perfectly banal situations: changing a light bulb, waiting by the car, looking at their reflection in a darkened window. The ease of friendship was essential to the project because Yokomizo collaborated with her subjects to recreate instances when they felt the world to be disappearing around them. The subjects of the images appear to have forgotten her presence and have drifted into a somnambulant state of self-reflection.

Yokomizo describes this photographed moment as somehow spiritual, a rare experience of feeling at one with the world. It is an ephemeral, even esoteric instant that is arguably impossible to recreate, let alone photograph. However, photography possesses a mysterious capacity to encapsulate aura and aspect, time and duration. Walter Benjamin observed, 'Whereas it is commonplace that, for example, we have some idea what is involved in walking, if in general terms, we have no idea what happens during the fraction of a second when someone steps out. Photography, with, its devices of slow motion and enlargement, reveals the secret. It is through photography that we first discover the existence of this optical unconscious.'[1]

Benjamin implies that photography offers us a greater level of perception than that of everyday visual awareness. He argues that, like psychoanalysis, photography can reveal things not seen by the naked eye. *Untitled* is a haunting and strangely curious series of images. There is an inherent stillness and claustrophobic introversion: the photographs appear drenched with memory and dream-like reflection. The recurring use of directional light, whether from a bedside lamp or open refrigerator, and reflections in windows and mirrors, create an ambience that strikes visually at pathways and openings onto the soul. The camera and subject become porous to one another, penetrating beyond external appearance. In some cultures the camera is feared as a device that steals the soul, leaving the subject bereft of spirit. Here it allows a secret innocence to be revealed, indicating the potential for spiritual encounter at seemingly insignificant times.

Yokomizo's latest work, *When You Wake* 2002, is a study of old age. This is the artist's first video, and reveals her wish to overcome the durational strictures of photography. The piece is a dual video projection divided into three sections. In the first we are taken into the greying bedrooms of a man and a woman. In a murky light, the camera focuses on their heads and faces, creating an unnerving intimacy. We are intruders, watching them both at their most vulnerable: while asleep. The sound of breathing fills the space of each bedroom. At different moments of each projection the scene shifts and we find ourselves underwater. The image of the woman is replaced by footage taken looking up at the sun from under the surface of the sea. The colours of the work alter from grey to blue, pink, lilac; the clarity of the sun remains constant. When the scene shifts back to the sleeping woman, she regains consciousness and seems to be adjusting to the realisation that she is still alive. On other the screen the sleeping man fades to a seabed. Our gaze moves with the camera as it sways apathetically with the current. The sound of breathing conflicts with the sensation of being underwater. The image becomes claustrophobic, and we need to break the surface for air. The old man moves suddenly, rolling over to face the camera, and wakes up.

In the second section, we witness the inherent dependency of old age. An elderly woman wakes up in a hospital bed, struggles to cough, is given medication, relaxes and closes her eyes. She appears unable to move or speak and indicates her thanks with a heart-warming smile. On the other screen, we see the view out of her window. It is sunny and bright. We hear a bird singing. The scene then moves through the bedrooms of a number of people, men and women. Some are waking, some rising. In each the sun shines through their windows. And in each the simple movements needed to get out of bed, walk to the bathroom, or undress become demanding actions. All the while, on the other screen a budgie chirps and flutters in its cage, and the sun shines outside the window. Yokomizo presents an image of old age that is poignant, undiscriminating and dignified.

The final section of the work is upbeat and metaphorical. One screen presents images of women chatting over cups of tea, while the other shows the view from the window of a aeroplane as it takes off from a London airport at night. The roar of the engine is mixed with gypsy melodies. A voyage through life. A perspective as broad as an aerial cityscape – the film suggests that these are the inherent qualities of being old. Yokomizo's portrayal of old age is neither euphemistic nor brutal, but like all her work, quietly intimate and deeply affecting.
Louise Hayward

When You Wake 2002 (detail)
Still from two screen video projection
Courtesy The Approach, London

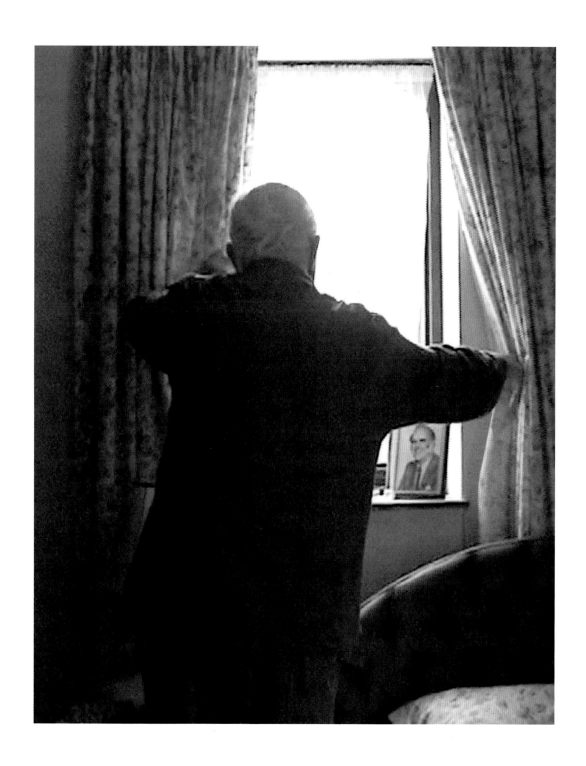

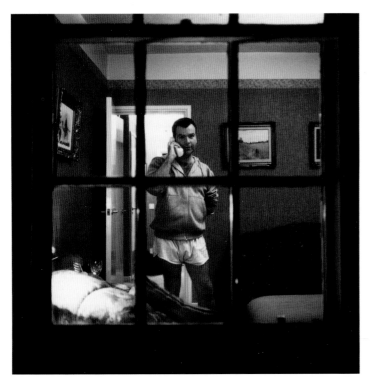 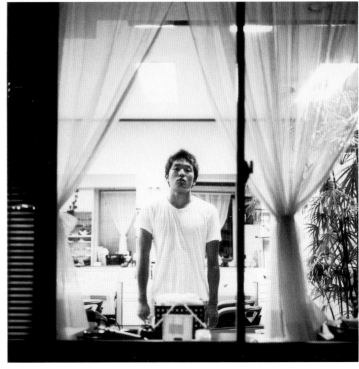

Left to right:
Stranger (1) (no.59), *Stranger
(10)* (no.64), *Stranger (2)*
(no.60), *Stranger (15)* 1999
From the series *Strangers*
C-type prints
108 × 127 (42 ¹/₂ × 49 ⁷/₈)
Courtesy The Approach, London

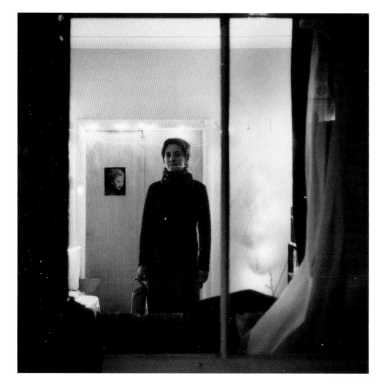

Notes

Jonathan Watkins

1 'Have Trojan Horse, will travel. A conversation between Jonathan Watkins and Ceal Floyer', *Ceal Floyer*, exh. cat., Ikon Gallery, Birmingham 2001, p.8.
2 *Richard Deacon*, exh. cat., Whitechapel Art Gallery 1988.
3 In a letter to Peter and Alison Smithson, written in 1957, Hamilton defined Pop art as 'Popular (designed for a mass audience); Transient (short-term solution); Expendable (easily forgotten); Low cost; Mass produced; Young (aimed at youth); Witty; Sexy; Gimmicky; Glamorous; Big business.' *Richard Hamilton: Collected Words*, London 1982, p.28.
4 Ibid., p.105.
5 *First Papers of Surrealism*, organised by Duchamp and André Breton, at the Premises of the Coordinating Council of French Relief Societies, New York, Oct.–Nov. 1942.
6 *Thirty Pieces of Silver* and *Cold Dark Matter* are both in the permanent collection of Tate. *Breathless* was commissioned by the Victoria and Albert Museum in 2001.
7 This was the strong message of *The Maybe* (collaboration with Tilda Swinton, Serpentine Gallery, London, 1995) which involved a number of everyday objects exhibited in vitrines. Great value was conferred on them almost entirely through association with famous people such as Queen Victoria, Sigmund Freud, Charles Dickens and Winston Churchill.
8 Dave Hickey, *The Invisible Dragon*, Los Angeles 1993, p.12.
9 David Batchelor, *Chromophobia*, London 2000, p.97.
10 Ibid., pp.98–100.
11 Conversation with the author, 7 October 2002.
12 Hamilton explains, 'First James Joyce and later the greatest artist of his period, Marcel Duchamp, have been my teachers … Their genius pervades my life.' Richard Hamilton, 'Words on Images', *Imaging Ulysses*, exh. cat., The British Council 2002, p.99–100.

Judith Nesbitt

1 This experiment by David L. Rosenhan, from which I have taken the title, 'On Being Sane in Insane Places', is published in Paul Watzlawick (ed.), *The Invented Reality*, New York and London 1984, pp.117–44. My thanks to Guy Claxton for telling me of this experiment.
2 Ibid., p.123.
3 On this project, Nathan Coley worked with Angela Weight, Keeper of the Department of Art, and was supported by a grant from the Art Commissions Committee, Imperial War Museum.
4 Kamp van Zèist, Nathan Coley interviewed by Giles Sutherland, *Sculpture Matters*, no.11, Spring 2001, pp.6–8.
5 'Interview with Louisa Buck', *The Art Newspaper*, no.105, July–August 2000, p.71.
6 'Sarah Morris interviewed by Michael Tarantino and Rob Bowman', *Sarah Morris – Modern Worlds*, exh. cat., Museum of Modern Art, Oxford 1999, unpag.
7 'Morris Lapidus, Architect of the American Dream', www.goodbyemag.com/jan01/lapidus
8 Correspondence with the author, 29 Oct. 2002.
9 T.W. Adorno, *Aesthetic Theory* (1970), trans. C. Lenhardt (1972), London, Boston, Melbourne and Henley 1984, p.6.
10 Paul Noble, *Introduction to Nobson Newtown*, Cologne 1998, p.29.
11 Ibid.
12 The Digger Archives, The (English) Digger Writings, www.diggers.org/digger_tracts.htm
13 Adorno 1984, p.7.
14 Ceal Floyer, interview in *The Times*, 6 May 2002, p.19.
15 Rosenhan 1984, p.140
16 Ibid.

Caoimhín Mac Giolla Léith

1 Walter Benjamin, 'The Storyteller', *Illuminations* (1939), trans. Harry Zohn (1968), London 1973, pp.89–90.
2 Thyrza Nichols Goodeve, 'To Sit With the Speed Addict', *Parkett*, no.61, 2001, p.99.
3 Jonathan Crary, *Suspensions of Perception: Attention, Spectacle, and Modern Culture*, Cambridge, Massachusetts 1999, p.13.
4 Marc Augé defines as 'non-places' those 'spaces in which neither identity, nor relations, nor history really make sense; spaces in which solitude is experienced as an overburdening or emptying of individuality'. Marc Augé, *Non-Places: Introduction to an Anthropology of Supermodernity* (1992), trans. John Howe, London and New York 1995, p.8. A list of the the 'non-places' featured in Morris's most recent short film, *Miami* 2002 would include plazas, foyers, poolsides, marinas, diners, gyms, hairdressers, freeways, supermarkets, carwashes, train stations, nightclubs, firing ranges and factory floors.
5 Quoted in Jon Slyce, 'Paul Noble: Nobwaste', *Flash Art*, vol.34, no.217, March–April 2001, p.84.
6 Quoted in Caoimhín Mac Giolla Léith, 'Susan Philipsz', *The Glen Dimplex Artists Awards Exhibition 2001*, exh. cat., Irish Museum of Modern Art, Dublin 2001, unpag.
7 See Alex Farquharson, 'Drastic plastic', *Frieze*, issue 68, pp.78–81.
8 See Parker's interview with Bruce Ferguson in *Cornelia Parker*, exh. cat., The Institute of Contemporary Art, Boston 2000, p.54.

Margaret Barron
1 Email to the author, 1 Oct. 2002.
2 Email to the author, 12 Oct. 2002.
3 Ibid.

David Batchelor
1 Conversation with the author, 25 Sep. 2002.
2 *I Love America and America Loves Me* 1974 was a performance by Joseph Beuys in which he spent a week living enclosed with a coyote in a New York gallery.
3 'I knew a wise-guy who used to make fun of my painting, but he didn't like the Abstract Expressionists either. He said that they would be good painters if they could only keep the paint as good as it was in the can.' Frank Stella, 'Questions to Stella and Judd', reprinted in Gregory Battock (ed.), *Minimal Art: A Critical Anthology*, New York 1968, p.157.
4 See David Batchelor, *Chromophobia*, London 2000, p.100.
5 See *Colourlove*, exh. leaflet, Johnson County Community College Gallery, Kansas 2002.
6 Robert Venturi, Denise Scott Brown and Steven Izenour, *Learning from Las Vegas*, Cambridge, Massachusetts 1972; revised edition 1977.
7 See *Colourlove*, 2002.

Gillian Carnegie
1 Georges Bataille, *Manet*, 1955, pp.36–7.
2 Ibid., p.52.
3 Malevich claimed to have painted a black square on white ground as early as 1913. Extant versions are later, for example, Kasimir Malevich, *Black Square* 1913 (1923–9), State Russian Museum, St. Petersburg.
4 Rodchenko quoted in Yve-Alain Bois, 'Painting; The Task of Mourning', 1986, repr. in Douglas Fogle (ed.), *Painting at the Edge of the World*, exh. cat., Walker Art Center, Minneapolis 2001, p.37.

Nathan Coley
1 John Ruskin, *The Seven Lamps of Architecture* (1849), London 1998.
2 Conversation with the author, 10 Dec. 2002.

David Cunningham
1 David Cunningham, 'Listening and the Listening Room', http://www.stalk.net/piano/listen.htm
2 Karl Marx and Frederick Engels, The Communist Manifesto', (1888), London 1985, p.83.

Dexter Dalwood
1 See *Late Picasso*, exh. cat, Tate Gallery, London 1988, pp.223 and 229.
2 All quotations are taken from a conversation with the author, 29 Aug. 2002.

Ian Davenport
1 Norman Rosenthal, 'Introduction', in *Ian Davenport*, exh. cat., Waddington Galleries 1990, unpag.
2 Ian Davenport quoted in *Broken English*, exh. cat., Serpentine Gallery 1991, unpag.
3 Ian Davenport, 'Notes on Painting', in *The British Art Show*, exh. cat., National Touring Exhibitions 1990, p.50.
4 Ibid.

Richard Deacon
1 Penelope Curtis in *Richard Deacon*, London 2000, p.181.
2 Richard Deacon in *Richard Deacon*, exh. cat., Kunstverein, Hanover 1993, p.120.
3 Curtis 2000, p.175.
4 *Ceramics*, Richard Deacon, Dec., 2002
5 Lynne Cooke, *Richard Deacon*, exh. cat., Whitechapel Art Gallery 1988.

Peter Doig
1 Johanne Sloan, 'Hallucinating Landscape, Canadian-style', *Peter Doig*, exh. cat., Morris & Helen Belkin Art Gallery, Vancouver 2001, p.12.

2 Matthew Higgs, 'Peter Doig – 20 Questions', *Peter Doig* 2001, p.18.
3 There is a later version in the collection of the Centre Pompidou, Paris.
4 Peter Doig quoted in Morgan Falconer, 'Lost States', *What's On*, 17 April 2002, p.23.
5 Ibid.
6 Ibid.

Ceal Floyer
1 Jonathan Watkins (ed.), 'Have Trojan Horse, will travel: a Conversation between Jonathan Watkins and Ceal Floyer', *Ceal Floyer*, exh. cat., Ikon Gallery, Birmingham 2001, p.9.
2 Peter Osborne, *Conceptual Art*, London 2002, p.14.
3 Joseph Kosuth, 'Art after Philosophy', *Studio International*, vol.178, Dec. 1969, p.82–3.
4 Ibid., p.85.
5 Watkins 2001, p.11.
6 Ibid., p.9.
7 Ibid., p.7.

Richard Hamilton
1 Richard Hamilton quoted in Richard Morphet, 'Richard Hamilton: The Longer View' in *Richard Hamilton*, exh. cat., Tate Gallery, London 1992, p.13.
2 David Sylvester, 'Seven Studies for a picture of Richard Hamilton', *Richard Hamilton*, exh. cat., Anthony d'Offay Gallery, London 1991 p.9.

Tim Head
1 Tim Head quoted in Marco Livingstone, 'The Return of the Body-Snatcher', *Tim Head*, exh. cat., Whitechapel Art Gallery, London 1992, p.19.
2 Ibid., p.22.
3 With initial support from DA2 and the Slade Centre for Electronic Media.
4 Published by www.eyestorm.com.
5 Tim Head, unpublished statement, 2002.
6 Conversation with the author, 19 July 1992.

Jim Lambie
1 Jim Lambie interviewed by Andrea Tarsia, *Early One Morning*, exh. cat., Whitechapel Art Gallery, London 2002, p.111.
2 Jim Lambie in *Tailsliding*, exh. cat., The British Council, London 2001, p.11.
3 Jim Lambie in *Early One Morning* 2002, p.112.

Mike Marshall
1 Conversation with the author, October 2002.
2 Ibid.
3 Ibid.

Sarah Morris
1 'Interview with Louisa Buck', *The Art Newspaper*, no. 105, July–Aug. 2000, p.71.
2 Sarah Morris interviewed by Michael Tarantino and Rob Bowman, *Sarah Morris, Modern Worlds*, exh. cat., Museum of Modern Art, Oxford, 1999, unpag.
3 Sarah Morris in conversation with David Daniel, *Sarah Morris*, exh. cat., Kunsthalle Zürich, 2000, p.66.
4 Sarah Morris interviewed by Michael Tarantino and Rob Bowman, *Sarah Morris, Modern Worlds*, 1999.
5 Martin Gayford, 'Viva Las Vegas!', *The Independent Magazine*, 8 July 2000, p.30.
6 Conversation with the author, 21 Nov. 2002.

Paul Noble
1 Paul Noble interviewed by John Slyce, *Flash Art*, Mar./Apr. 2001.
2 Paul Noble, *Introduction to Nobson Newtown*, Cologne 1998.
3 Noble interviewed by Slyce, 2001.
4 Ibid.
5 Noble 1998.

Cornelia Parker
1 Cornelia Parker in *Something the Matter*, exh. cat., The British Council, London 1994, p.8.
2 Conversation with the author, 22 Aug. 2002.
3 Cornelia Parker in *British Art*

Show, exh. cat., The South Bank Centre, London 1990.
4 Conversation with the author, 22 Aug. 2002.
5 Ibid.

Susan Philipsz
1 Susan Philipsz, unpublished statements, 2002.
2 Bill Drummond, *Please Play Me*, Penkiln Burn 2001, unpag.
3 Caoimhín Mac Giolla Léith, 'Susan Philipsz', *The Glen Dimplex Artists Awards 2001*, exh. cat., Irish Museum of Modern Art, Dublin 2001, unpag.
4 Philipsz 2002.
5 Philipsz 2002.
6 Susan Philipsz quoted in Mac Giolla Léith 2001.

George Shaw
1 Statement by the artist, Aug.1998.
2 Statement by the artist, 2000.
3 Quoted in Gordon Burn, 'England, My England', *The Observer Magazine*, 21 Oct. 2001.

Rachel Whiteread
1 Rachel Whiteread quoted in Christoph Grunenberg, *Rachel Whiteread*, exh. cat., Kunsthalle, Basel, 1994, p.12.
2 Rachel Whiteread in *British Art Show*, exh. cat., The South Bank Centre, London 1990, p.114.
3 Rachel Whiteread quoted in *Rachel Whiteread*, exh. cat., The British Council, London 1997, p.32.
4 See also *Water Tower* 1998, a public art project in New York commissioned by the Public Art Fund.
5 Rachel Whiteread quoted in 'If Walls Could Talk: An Interview with Rachel Whiteread', *Transient Spaces*, exh. cat., Guggenheim Museum, New York 2001, p.50.

Shizuka Yokomizo
1 Walter Benjamin, 'A Little History of Photography', *Walter Benjamin: Selected Writings Volume 2 1927–1934*, Cambridge, Massachusetts 1999, p.510–11.

List of exhibited works

Kutlug Ataman

1 *The 4 Seasons of Veronica Read* 2002
Four DVD multiple screen video projection
Produced by Yalan Dünya Productions in London
Collection of Anita and Poju Zabludowicz, New York, courtesy Lehmann Maupin Gallery, New York

Margaret Barron

2 *As it was is now* 2002–3
Fifteen paintings, oil on vinyl
Courtesy the artist

David Batchelor

3 *The Spectrum of Brick Lane* 2003
Steel shelving, found lightboxes, fluorescent light, acrylic sheet, vinyl, cable, plugs and plugboards
1487 × 90 × 31
(585 $^3/8$ × 35 $^1/2$ × 12 $^1/4$)
Courtesy Anthony Wilkinson Gallery, London

Gillian Carnegie

4 *Mabel* 1999
Oil on board
22.9 × 33 (9 × 13)
Private Collection, New York

5 *Untitled* 2001
Oil on canvas
22.9 × 22.9 (9 × 9)
Courtesy Andrea Rosen Gallery, New York and Cabinet, London

6 *Flora Verte* 2002
Oil on board
47.9 × 38.1 (18 $^7/8$ × 15)
Collection of Ranbir Singh, New York

7 *Black Square* 2002
Oil on canvas
193 × 193 (76 × 76)
Courtesy Andrea Rosen Gallery, New York and Cabinet, London

Nathan Coley

All works courtesy the artist
Supported by the Art Commissions Committee, Imperial War Museum, London

8 *Lockerbie Witness Box (exhibition version)* 2003
Rosewood, laminates, aluminium, steel, carpet, plywood, electrical components and chair
112 × 166 × 185
(44 $^1/8$× 65 $^3/8$ × 72 $^7/8$)

9 *Lockerbie Interviews* 2003
DVD, two monitors

10 *Lockerbie Evidence # 3* 2003
Pencil on paper
84 × 59.5 (33 $^1/8$ × 23 $^1/2$)

11 *Lockerbie Evidence # 4* 2003
Pencil on paper
59.5 × 84 (23 $^1/2$ × 31 $^1/8$)

12 *Lockerbie Evidence # 5* 2003
Pencil on paper
84 × 59.5 (33 $^1/8$ × 23 $^1/2$)

13 *Lockerbie Evidence # 15* 2003
Pencil on paper
59.5 × 84 (23 $^1/2$ × 31 $^1/8$)

14 *Lockerbie Evidence # 16* 2003
Pencil on paper
84 × 59.5 (33 $^1/8$ × 23 $^1/2$)

15 *Lockerbie Evidence # 18* 2003
Pencil on paper
84 × 59.5 (33 $^1/8$ × 23 $^1/2$)

16 *Lockerbie Evidence # 19* 2003
Pencil on paper
84 × 59.5 (33 $^1/8$ × 23 $^1/2$)

17 *Lockerbie Evidence # 20* 2003
Pencil on paper
59.5 × 84 (23 $^1/2$ × 31 $^1/8$)

18 *Lockerbie Evidence # 22* 2003
Pencil on paper
84 × 59.5 (33 $^1/8$ × 23 $^1/2$)

19 *Lockerbie Evidence # 24* 2003
Pencil on paper
59.5 × 84 (23 $^1/2$ × 31 $^1/8$)

20 *Lockerbie Evidence # 30* 2003
Pencil on paper
59.5 × 84 (23 $^1/2$ × 31 $^1/8$)

21 *Lockerbie Evidence # 31* 2003
Pencil on paper
59.5 × 84 (23 $^1/2$ × 31 $^1/8$)

David Cunningham

22 *Colour 0.8* 1996
Computer program
Courtesy the artist

23 *A position between two curves* 2003
Amplified space
Courtesy the artist
Supported by the Arts and Humanities Research Board through the AHRB's Fellowships in the Creative and Performing Arts scheme

Dexter Dalwood

24 *Nixon's Departure* 2001
Oil on canvas
257 × 231 (101 $^1/8$ × 90 $^7/8$)
Courtesy Gagosian Gallery, London

25 *Ceaucescu's Execution* 2002
Oil on canvas
268 × 347.5 (105 $^1/2$ × 136 $^7/8$)
Courtesy Gagosian Gallery, London

26 *Grosvenor Square* 2002
Oil on canvas
268 × 347 (105 $^1/2$ × 136 $^5/8$)
Courtesy Gagosian Gallery, London

Ian Davenport

27 *Untitled Poured Lines (Tate Britain)* 2003
Household emulsion
483 × 1430 (190 $^1/4$ × 563 $^1/8$)
Courtesy Waddington Galleries, London

Richard Deacon

28 *Tomorrow, tomorrow, tomorrow B* 1999
Ceramic
161 × 110 × 72
(63 $^3/8$ × 43 $^3/8$ × 23 $^3/8$)
Courtesy Lisson Gallery, London

29 *Lotus* 2002
Ceramic
75 × 71 × 98
(29 $^5/8$ × 28 × 38 $^5/8$)
Courtesy Lisson Gallery, London

30 *Like You Know (1)* 2002
Ceramic
80 × 135 × 114 (31 $^1/2$ × 53 $^1/8$× 44 $^7/8$)
Courtesy Marian Goodman Gallery, New York

31 *Like You Know (2)* 2002
Ceramic
91 × 117 × 106 (35 $^7/8$ × 46 × 41 $^3/4$)
Courtesy the artist

Peter Doig

32 *100 Years Ago* 2000
Oil on canvas
200 × 295.5 (78 $^3/4$ × 116 $^3/8$)
Collection of Beth Swofford, Los Angeles

Ceal Floyer

33 *Bucket* 1999
Bucket, CD, CD player and loudspeaker
Courtesy Lisson Gallery, London

34 *Time Piece* 2003
CD, CD player and loudspeakers
Courtesy the artist

Richard Hamilton

35 *Preparatory Studies for 'The heaventree of stars'* 1998
Computer and monitor
Courtesy the artist

36 *The heaventree of stars* 1998–9
Iris digital print
53 × 37.6 (20 $^7/8$ × 14 $^7/8$)
Tate. Purchased 1999

37 *Typo/Topography of Marcel Duchamp's Large Glass* 2001–2
Laminated inkjet print on aluminium, two panels
266.5 × 170 (105 × 67)
Courtesy the artist

Marcel Duchamp and Richard Hamilton

38 *The Bride Stripped Bare by Her Bachelors, Even (The Large Glass)* 1915–23, replica 1965–6
Mixed media
277.5 × 175.9 (109 $^1/4$ × 69 $^1/4$)
Tate. Presented by William N. Copley through the American Federation of Arts 1975

Tim Head

39 *Treacherous Light* 2002
Digital projection (from real time computer program)
Courtesy the artist

Jim Lambie

40 *Psychedelic Soul Stick no.38* 2003
Bamboo, sunglasses, bottle corks, buttons, twenty Marlboro Lights, badges, chewing gum box, multicolour thread, wire and tape
Courtesy Sadie Coles HQ, London and The Modern Institute, Glasgow

41 *Zobop* 1999–2003
Multicoloured vinyl tape
Dimensions variable
Courtesy Sadie Coles HQ, London and The Modern Institute, Glasgow

Mike Marshall

42 *Someone, Somewhere is Doing This* 1998
Video, monitor
Courtesy the artist

43 *Sunlight* 2000–1
Video, monitor
Courtesy the artist

44 *Days Like These* 2003
Video projection
Courtesy the artist

Sarah Morris

45 *Miami* 2002
35mm film/DVD projection
Courtesy Jay Jopling/ White Cube, London

46 *Pools – Fontainebleau II [Miami]* 2002
Gloss household paint on canvas
289 × 289 (113 3/4 × 113 3/4)
Courtesy Jay Jopling/White Cube, London

Paul Noble

47 *Acumulus Noblitatus* 2001
Pencil on paper
390 × 550 (153 1/2 × 216 1/2)
Collection of John A. Smith and Vicky Hughes

Cornelia Parker

48 *The Distance* 2003
Marble and string
182 × 102 × 183
(71 3/4 × 40 1/4 × 72 1/8)
Courtesy the artist

Susan Philipsz

49 *Company* 2001
CD, CD player and speakers
Courtesy the artist

50 *Songs Sung in the First Person on the Themes of Release, Sympathy and Longing* 2003
CD, CD player and public address system
Courtesy the artist

Nick Relph and Oliver Payne

51 *Gentlemen* 2003
Video projection
Courtesy the artists and Gavin Brown's enterprise, Corp., New York

George Shaw

52 *Scenes from the Passion: Late 2002* 2002
Humbrol enamel on board
91 × 121 (35 7/8 × 47 5/8)
Tate. Presented by the Patrons of New Art (Special Purchase Fund) 2003

53 *Scenes from the Passion: The Middle of the Week* 2002
Humbrol enamel on board
77 × 101 (30 3/8 × 39 3/4)
Courtesy Anthony Wilkinson Gallery, London

54 *Scenes from the Passion: The Fourth of November* 2002
Humbrol enamel on board
77 × 101 (30 3/8 × 39 3/4)
Purchased by the Contemporary Art Society Special Collection Scheme on behalf of Birmingham Museums & Art Gallery with funds from the Arts Council Lottery, 2003

55 *Scenes from the Passion: A Few Days Before Christmas* 2002–3
Humbrol enamel on board
77 × 101 (30 3/8 × 39 3/4)
Courtesy Anthony Wilkinson Gallery, London

56 *Scenes from the Passion: The Slide* 2002–3
Humbrol enamel on board
77 × 101 (30 3/8 × 39 3/4)
Courtesy Anthony Wilkinson Gallery, London

Rachel Whiteread

57 *Untitled (Rooms)* 2001
Mixed media
282 × 726 × 1343
(111 3/4 × 285 3/4 × 528 3/4)
Tate. Purchased with funds provided by Noam and Geraldine Gottesman and Tate International Council, 2003

58 *Untitled (Stairs)* 2001
Mixed media
375 × 220 × 580
(147 5/8 × 86 5/8 × 228 1/4)
Tate. Purchased with funds provided by the National Art Collections Fund and Tate Members, 2003

Shizuka Yokomizo

Nos.59–64 from the series *Strangers:*

59 *Stranger (1)* 1999
C-type print
108 × 127 (42 1/2 × 50)
Courtesy The Approach, London

60 *Stranger (2)* 1999
C-type print
108 × 127 (42 1/2 × 50)
Courtesy The Approach, London

61 *Stranger (6)* 1999
C-type print
108 × 127 (42 1/2 × 50)
Collection of Simmons & Simmons

62 *Stranger (7)* 1999
C-type print
108 × 127 (42 1/2 × 50)
Courtesy The Approach, London

63 *Stranger (9)* 1999
C-type print
108 × 127 (42 1/2 × 50)
Courtesy The Approach, London

64 *Stranger (10)* 1999
C-type print
108 × 127 (42 1/2 × 50)
Collection of Simmons & Simmons

65 *When You Wake* 2002
Two screen video projection
Courtesy The Approach, London
Supported by The British Council

Credits